"Making the decision to get away from violence while physically trapped in a foreign country, Paula quickly learned her American freedoms had not traveled with her. These pages draw readers deep into her experience, and we witness her intuition carrying her through. Just when we think she is safe, the story turns, and she is on the run again with her three sons. It's an unforgettable memoir, and a teacher for us all."

Gavin de Becker, Bestselling Author, *The Gift of Fear*

"Paula Lucas escaped with her sons from desperate circumstances and with incredible will and resourcefulness became an internationally respected leader in victim advocacy. Her work and the organization she founded is a lifeline for countless abused women and men around the world who find themselves alone or isolated in unfamiliar surroundings. In *Harvesting Stones*, this extraordinary woman shares her personal story. Much more than a cautionary tale, it's an inspiration and a model for anyone who seeks to transform their lives and help others in the process."

Jackson Katz, Ph.D., Author, *The Macho Paradox*, creator of the award-winning documentary *Tough Guise*

"*Harvesting Stones* describes one woman's descent into an inferno of violence, with escape complicated by her living in a foreign country. Hats off to Paula Lucas, who then created AODVC, a ground-breaking US-based nonprofit association with a solid global safety net to help abused Americans abroad."

Dorothy van Schnooneveld, Former Executive Director, American Citizens Abroad

"An amazing journey of strength and determination to survive against seemingly insurmountable odds."

Dawn Schiller, Author, *The Road Through Wonderland*

"Terrifying, unimaginable, harrowing, chilling – thankfully this engrossing book ends triumphantly. Paula Lucas' cautionary story of survival is the stuff of news headlines, full of international intrigue, betrayal, domestic violence and virtual servitude in a foreign land. Barely escaping with her sons, she helps them heal while on the run from her abusive spouse, and despite poverty goes on to create the much-needed *Americans Overseas Domestic Violence Crisis Center* to aid others in similar straits. *Harvesting Stones* is a testament to Lucas' strength, bravery, tenacity and will to thrive. Her tale is the very hallmark of resilience."

Linda Janssen, Author, *The Emotionally Resilient Expat: Engage, Adapt and Thrive Across Cultures.*
www.TheEmotionallyResilientExpat.com

"In the voice of a close friend, Paula Lucas shares her shocking, unimaginable personal story – of domestic abuse in an exotic foreign land, of a mother's strong will to survive for her children, and of a woman's determination to rise above her fate to help others. Paula Lucas' story highlights the special challenges faced by Americans living overseas who are victims of domestic violence. She founded the *Americans Overseas Domestic Violence Crisis Center* to help others in the same situation. Hers is an enthralling story of courage and perseverance with a powerful and inspiring ending."

My-Linh Kunst,
President, Federation of American Women's Clubs Overseas

"Paula Lucas takes us on a journey into an expat marriage with a shockingly abusive man, her plight compounded by the circumstances of her vulnerability. Scalps will tighten as she is terrorized along with her three boys and discovers they are unable to flee. This is not a book to put down and forget."

Laura J Stephens, Author *An Inconvenient Posting, an expat wife's memoir of lost identity*, www.laurajstephens.com

"The 'harvest' Lucas continues to make of the many stones that almost buried her and her sons in Dubai is now saving other women and children every day. Her story, that might simply have read like a good thriller (which it does), is far more powerful because it is the true story of one woman, stranded with no natural support network in a life-threatening situation, turning misfortune and near disaster into a fierce mission."

Lucy Stensland Laederich,
President, Association of Americans Resident Overseas

"Paula Lucas has courageously recounted the harrowing tale of her more than a decade-long marriage to a man who terrorized her and their three small sons by abusing them verbally and physically on a daily basis while they were literally imprisoned by him. Living in Dubai, far from family and friends, Paula found herself with no support, not even from the American authorities, who were sympathetic to her pleas for help but who could do nothing legally to help her escape.

Lucas has done a masterful job in recreating the agonies she and her sons suffered at her husband's hands, and the frustration and pain of her seemingly helpless situation. Finally, she was able to escape to the United States, only to be confronted by him again.

Her journey from an abused wife and mother to a beacon of light to other women who find themselves in similar situations overseas through her *Americans Overseas Domestic Violence Crisis Center* is both riveting and an example to others showing the power of one individual who is determined to save herself and her children, and to provide the help to others that she was denied."

Lee Sorenson,
President, FAWCO ALUMNAE USA (FAUSA)

Harvesting Stones

An American woman's
international journey of survival

by

Paula Lucas

Harvesting Stones:
An American woman's international journey of survival
by Paula Lucas

First published Great Britain 2013 by *Summertime Publishing*

ISBN 978-1-909193-48-2

Cover and layout by Owen Jones Design
www.owenjonesdesign.com
Photography by Faris Photography
Makeup by M'chel Bauxal

Disclaimer

"I have done my best in this memoir to provide anonymity to the innocent and the guilty. The names of most individuals have been changed and their physical attributes altered so they cannot be identified. Most of the names of characters appearing in this book are fictitious. Any name of a real person, living or dead, which I used fictitiously, is purely coincidental. This is to protect the innocent, especially those who still live within the grasp of the madness, and to prevent the guilty from suing me.

Cities I lived in or visited have also been scrambled to ensure further anonymity. Names of many companies, restaurants, and hotels are fictitious or mixed up. What I can assure you is that this memoir is a true account of the terror my sons and I lived through as Americans overseas, and the struggles we faced after fleeing back to the USA trying to seek safety at home.

I thank you, the reader, for purchasing my book. I will be donating a portion of net sales to AODVC and the SASHAA program to help the services continue, as government funding to serve Americans overseas is bleak in the current economic environment. I want my book to provide hope and encourage others who are suffering anywhere in the world to reach out for help to whatever resources are available. If this book ignites a spark of passion to help victims, please join us in being a voice for those who have no voice, those who are still suffering in silence and desperately need help."

Paula Lucas

Dedicated to my three sons,

Faris, Samer and Tariq

Table of Contents

HARVESTING STONES

Introduction

SOMETIMES YOU FIND YOURSELF IN THE MIDDLE OF A ROAD, a metaphoric road not an actual road, or maybe an actual road if you and I have a similar sense of direction, and you wonder, "How the hell did I end up here?" Thirty years ago my life took on a trajectory I would have never imagined. As a young American woman I was bored and uninspired searching for more than a life on the central coast of California could offer. I grew up an isolated Catholic farm girl, and when I met a wealthy, international photographer in San Francisco my life transformed. I began a journey that took me around the world for fourteen years to Europe, the Middle East and the Far East. But it almost cost me my life and the lives of my three little boys. Be careful what you wish for.

This book is about finding my inner strength to survive, when I was certain the only way I was going home to the USA was in a body bag. A thief unknowingly set in motion a chain of events that enabled me to escape (one person's thief is another person's angel), and live to tell the story. I am blessed to harvest the stones we were pummeled with; emotionally, psychologically and physically, which caused so much pain and suffering, to build something that makes a difference in the world for others. Because, really, that's all that matters when you die – how is the world a better place because you were in it?

During the writing of these pages I had to go back and submerge myself in the deepest, darkest hours of my life and the lives of my three sons. This time I rose back up through those terrible times not as a victim but as the victor – a cathartic process that

sometimes felt like an exorcism. I hope I have woven enough love and light in these pages for you to finish the book feeling motivated and inspired to harvest your own stones.

This book is written for my sons, Faris, Samer and Tariq, wonderful young men each making their own path through life. Despite all the suffering of their early childhood they are not broken, bitter and cruel, but whole, loving and compassionate. I am proud and honored to be their mother; they are the greatest gifts God bestowed upon me.

I am fortunate to have a caring family who helped us emotionally and financially, especially during the early years of our escape back home. I am beyond grateful for being given the strength, perseverance and resources to be the founder of the Americans Overseas Domestic Violence Crisis Center, AODVC, and the Sexual Assault Support & Help for Americans Abroad Program, SASHAA. Every day I get to work with our amazing crisis center team, board members and volunteers – passionate, dedicated and experienced people who put their hearts and souls into the mission of the organization. I have friends around the world who are a source of inspiration as I observe the great work they are doing to help others. I re-married and have a wonderful husband who is the love of my life. Sorry, no spoiler alert, you have to read the story to find out who he is.

I want to thank Louise Bauschard, the first person outside of my family who believed in my vision when I didn't have two dimes to rub together, homeless with three little boys living in a shelter and on welfare. Louise served as President of the Board of Directors of the Americans Overseas Domestic Violence Crisis Center from 1999-2012, and remains one of my dearest friends. I would also like to thank Karen Lewis who stepped up and took over as President in January 2013. Karen was the co-founder of the Ending Violence Against Women and Children Task Force of the Federation of American Women's Clubs Overseas, FAWCO, and remains our

liaison to FAWCO. FAWCO clubs, FAUSA (the alumni branch of FAWCO), American Citizens Abroad, ACA, and Association of Americans Resident Overseas, AARO, are American expat clubs that have provided support and helped us spread our mission around the world. I am grateful for their belief in our programs.

I want to thank our amazing crisis center staff who work around the clock with American victims in foreign countries during the worst times of their lives – providing a safety net for them. I want to thank my board of directors for their dedication and support, my brother and sisters, my friends, my sons and my husband for believing in me and this book. I would also like to thank my parents. Although they passed over to the other side when I was in my twenties, I believe they watched over the boys and me as guardian angels.

I want to thank God, who I admit I had an on/ off relationship with during the difficult years, for the divine intervention that saved our lives, and for the 'you get to come back from the dead' ticket. When you get one of those it's better than winning the lottery!

I would like to thank my editor, Jane Dean, for her kind words, encouragement and patience, my publisher, Jo Parfitt, of Summertime Publishing, for believing in the importance of telling my story as a way to help others, and Owen Jones for the lovely design work.

Now for the nitty gritty. I have done my best in this memoir to provide anonymity to the innocent and the guilty. The names of most individuals have been changed and their physical attributes altered so they cannot be identified. Most of the names of characters appearing in this book are fictitious. Any name of a real person, living or dead, which I used fictitiously, is purely coincidental. This is to protect the innocent, especially those who still live within the grasp of the madness, and to prevent the guilty from suing me.

Cities I lived in or visited have also been scrambled around to ensure further anonymity. Names of many companies, restaurants, and hotels are fictitious or mixed up. What I can assure you is that this memoir is a true account of the terror my sons and I lived through as Americans overseas, and the struggles we faced after fleeing back to the USA trying to seek safety at home.

I thank you, the reader, for purchasing my book. I will be donating a portion of net sales of this book to AODVC and the SASHAA program to help the services continue, as government funding to serve Americans overseas is bleak in the current economic environment. I want my book to provide hope and encourage others who are suffering anywhere in the world to reach out for help to whatever resources are available. If this book ignites a spark of passion to help victims, please join us in being a voice for those who have no voice, those who are still suffering in silence and desperately need help.

Paula Lucas

HARVESTING STONES

HARVESTING STONES

CHAPTER 1
Sweet, Silent Darkness

THIS IS NOT WHAT I WAS EXPECTING. NO BRILLIANT TUNNEL OF light or conversant ghostly figures of dead relatives beckoning me with wide smiles and angelic faces. No, all I get is darkness. Sweet, warm, darkness and deafening silence.

You'd think at least my mother would show up, arms folded across her chest, her Catholic toe tapping impatiently, eyes fighting back tears.

"I knew there was something wrong with that man," she would say, barely audible. "It's okay, *kudka*." She'd unfold her arms before gently but firmly hugging me like only a mother can. Then she'd guide me towards the light. "Come with me. Your father is waiting. Everything's going to be fine." Nope, nobody, nada, zero.

This must be limbo. Why did I get limbo? I was baptized the day I was born, the runt in a premature twin birth. Didn't that ensure my entrance into the kingdom of heaven? The story goes the doctor said I only survived by the grace of God. I went to Catholic school all the way through 7th grade. Attended Sunday mass religiously, confession afterwards. Since the age of eight I was good at making up lies of sins I had committed, to satisfy the mysterious priest in the boxy confessional that I was truly sorry for what I had done, and God would absolve me of my sins after I silently recited three Our Fathers and five Hail Marys as my penance.

I think overall I was a good person. I kept the Ten Commandments – for the most part. Okay, I admit, there were

the wild years, but I was in my early twenties. It was the 1980's. Got a bit on the crazy side for a Catholic girl, but I reined it back in. No arrests, and I made it through college. That's all you can hope for right? That and not burning the house down, which almost happened once. And who didn't make mistakes? What was that about simple sin and mortal sin? I can't remember. No one in my family has ever been murdered that I know of.

How could I have been so stupid? Sometimes I caught a flicker of something dark and foreboding about him. But no, I got caught up in the allure and excitement of living in foreign countries, not knowing it was only scaffolding I was seeing, scaffolding built by lies and deceit and self-loathing. And I fell for it – young, naïve and stupid. Year after year of living with him I saw glimpses, then one day the scaffolding came crashing down and I saw the truth, but it was too late. I was trapped with no way out. How naïve I was to think that American freedoms traveled with me overseas. I thought, *Oh, I'm American, I can go home anytime I want.*

"There's nothing we can do to help her. She'll have to find her own way out." My family couldn't believe the words of the consular officer at the American embassy. When my brother told me I was dumbfounded. My children and I are American – only American. We want to go home, back to our country of citizenship. I didn't commit a crime. Our basic human rights to safety and security in our own home have been invalidated by a mad man. We are prisoners, and the people I thought would help, the ones who whisper amongst themselves about our plight, now pretend they don't see or hear and have turned their backs on us.

So I am alone trying to protect my three beautiful sons I can't even keep safe in their own beds. Their sweet, innocent faces shine at me from silver picture frames, smiles hiding the wreckage of their short, traumatic lives. Mothers are supposed to keep their children from harm. I tried so hard every damn day, but I failed. Their little voices telling me they wanted to leave, tired of the anger and the rage that ravaged their small bodies, and I kept promising them we would. I promised the boys we would go back to California and have a puppy and a kitty and a

backyard with grass for them to play in. We would run back to the place I ran away from so many years ago looking for something better. I promised them we would go. I lied an unintentional lie.

My life is not flashing before my eyes. Isn't that supposed to happen? I should be seeing the ranch, cowboy boots, dirt roads, my horse, my big 80's hair, past lovers, best friends, cities I've traveled to, and major life events rushing in front of my eyes like Technicolor tickertape. I am not seeing St. Peter opening the pearly gates for me either. All I see is darkness. Maybe when you are murdered there is a different heavenly protocol the nuns didn't teach us in catechism.

But it won't look like murder will it? He will probably throw my body off the balcony, call the police and say I was depressed, killed myself, and that will be that.

I saw a woman murdered like that in this country before. A murder made to look like suicide. She was a young housemaid. Splattered like a bug on a windshield face down on the concrete, her long black hair a tangled mass of blood and shattered flesh, the contents of her purse scattered yards away, barefoot. That seemed suspicious to me. Who thinks, *I'm so depressed I'm going to go throw myself off this balcony now. Oh wait, I forgot my purse?*

From the window of the fourth floor of my office I watched as her sister came to identify the broken, contorted body. She physically collapsed, wailing in emotional agony. No going to the morgue here. Let's traumatize the next of kin by having the body identified at the bloody scene, after it has been left for hours in the scorching midday sun in front of a gawking, sweating crowd. A morbid circus sideshow. I felt the sister's anguish, and the tears I had been holding back finally burst forward. I sat sobbing, not only for her and her sister, but for all of us who were trapped by their own personal tyrant in this country.

A customer, a local, came into the office to meet with me. He said he spoke to the police on his way up. The police said her 'sponsor' had said she was depressed and committed suicide. No confidentiality here either, I guess. I asked him what they would do next.

"Well, they'll have to get a new housemaid," he replied. His exact words.

I stared at him in stunned disbelief. He said it with same emotion you do when you need to replace a can opener. A disposable woman, simply go get a replacement off the shelf. I hid the nauseous feeling in my stomach and disgrace for his lack of humanity.

When the meeting ended I moved back to the window to check and see whether the splattered housemaid was still there. She was. The sun had moved enough around the building so at least she was in the shade, and someone had finally covered her remains with a sheet. I couldn't work. I closed the office early making a wide circle around the thinning crowd to go home and hug my three precious boys.

When I walked to the office the next morning they had picked up the housemaid's torso and limbs but the blood splatter, now dried, and pieces of her flesh that had scattered on impact, remained. Two little boys on bicycles, maybe eight years old, rode around in circles clinging onto strands of her long black hair swinging it through the air, pieces of scalp still attached to the ends, laughing. I felt repulsed by their young disregard for a woman's life. I wanted to grab them by the shoulders and scream at them though my tears, but I didn't dare. They were riding next to a mosque where an *imam* was slaughtering a sheep with more reverence than was given to the dead housemaid.

Perhaps because I am an American woman and not a housemaid, I will get a little more respect after he throws my already dead corpse off the balcony? Maybe they will cover my body sooner or at least pick up all of my splattered bits off the concrete? Maybe the American embassy would call for further investigation? My family has been to them so many times begging for help. My death would certainly be suspicious to them. My family would know. They would know. Thank goodness I had told them.

But most likely the police report will be what he said happened; she committed suicide. My dear boys will be left alone

with the monster – the murderous monster who will now play the grieving widower to the hilt. Silently smug knowing he had fooled everyone, reveling in the outpouring of pity and sympathy like a pig wallowing in mud.

My mind comes back to the still, silent, liquid darkness. Oh crap. Am I in someone else's womb already? Is reincarnation that instant? Can I get some down time here? Maybe sit out a decade or two? A new life will be welcome after years of insanity in this one. The rage, the anger, the threats. At least I don't have to see his contorted mouth spewing insults at me or feel his two hundred and fifty pound body slamming into mine with fury. His killing me is no surprise. It happened remarkably quickly. But he called in my baby, my sweet, innocent seven-year-old son to watch.

Oh my God. My boy just watched him kill me. The thought is agonizing. How can I be dead if I'm having thoughts? Can a soul think? This is all so confusing. Maybe I'm not dead, merely held in suspended animation. Maybe it is a gift from God giving me a momentary reprieve from the daily madness of existing with a psychopath. The one minute a boxer gets between rounds.

Do I want to go back into the ring for yet another round of the fight for our daily survival? I am so damn exhausted, I feel like I am crawling on my belly, too weak to stand up. I don't know what God wants from me anymore. How much more suffering must we take before he sends us an angel, an intervention, a miracle? I think of the words of Anais Nin: *I postpone death by living, by suffering, by error, by risking, by giving, by losing.* What if I don't want to postpone death any longer? Who will protect my beautiful boys if I give into the sweet, silent darkness?

HARVESTING STONES

CHAPTER 2

Catholic Farm Girl

THE SUMMER HEAT IN SAN JOAQUIN VALLEY OF CALIFORNIA bears down like hell's fire onto bone-dry earth. Dirt so hard the pounding of a round-nosed farm shovel into the hardpan makes the shovel shudder, emitting a loud tinny sound, but barely makes a dent in the ground. If you manage to keep your hands on the handle your whole body vibrates and your nose tickles. As I peer through the dining room window, past yellow wallpaper with dainty orange flowers and white lace swag country curtains, a Chevy Camaro speeds by sending clouds of dust rising and twirling into the hot air. Mom and Dad keep hoping the county will pave the road one day. I hear Mom lamenting again that the dust from those darned sports cars makes it impossible to keep the furniture looking freshly polished.

As the dust dissipates and settles I daydream while I look at the oat field across the road, tall, dry and thin, waiting for the harvester to come make hay bales. In the spring, when the oat stalks are young and green, my twin brother Paul and I run through the vast fields and play hide and seek with our German shepherd, Prince. Earlier this year we came across one of those flying saucer nests made by an alien spacecraft, like the one in Australia in 1966. We excitedly ran back home to report our findings. Mom stopped pulling weeds in the vegetable garden, looked at us and sighed. Dad dismissed us.

"Just jack rabbits having a pow-wow," he said, turning back to twisting a wrench on the motor of the farm tractor, which stopped working while he was tilling the soil.

"Then, maybe they were alien jack rabbits?" I suggested, standing beside him on my tiptoes to see what he was doing to the tractor and breathing in his strong smell of sweat and motor oil.

Dad looked at me expressionlessly and walked down the gravel path towards the implement shed to get more tools, wiping his tanned brow with the white handkerchief he keeps in his front pocket.

"Go help your mother pull weeds," he ordered back over his shoulder.

We know Dad and Mom don't believe any of this because they could not see the tween, the enigmatic being only seen and heard by Paul and me until we were about five years old.

"The tween, it's the tween!" we would randomly shout out.

After a few years my parents, exasperated, gave up inquiring what the tween was and told us there was no such thing. Eventually we stopped seeing it too.

Mobilizing them to trek half a mile to see the flying saucer nest was futile. We had lost our credibility at a tender young age.

My attention turns to our side of the road. Old garden and cultivated roses, bursting with color and fragrance, proudly ramble along the freshly painted, white in the spring, split-rail fence surrounding our perfectly manicured lawn. So beautiful some folks drive by, slow down and sometimes stop. You can drive for miles and see nothing but orange groves and the occasional old farm house, paint peeling, hens scratching in the yard, an old farm dog or two lazing on a dilapidated porch. Suddenly out of nowhere a three-bedroom, two-bath ranch house fit for *Better Homes and Gardens* magazine pops up like a shiny new penny. Painted a beautiful sky blue with white trim, our home is an attractive backdrop for begonias and pansies growing in pretty wooden window boxes, also painted white, and used-brick flower beds. Yes, every shrub and bush perfectly trimmed.

From the road you can see through the breezeway between the house and the garage to the pool area, enclosed by a newly stained six-foot panel redwood fence. To the right of our garage is the family orchard with one of each tree – plum, peach, Indian

peach, nectarine, pomegranate, avocado, fig, lemon, plus two types of apple and two types of cherry trees.

As my father takes pride in a beautiful yard, my mother's pride and joy are cooking and her ability to keep a home spotless. We have to take our shoes off outside so as not to soil the wall-to-wall shag carpeting. A poolside bathroom ensures we don't run though the house in sopping wet swimsuits. Everything in order. Everything in its place.

This afternoon I am content sitting in central air conditioning with Mom. My father and Paul are still out in the scorching midday heat working on our orange ranch. Pulling sprinkler lines and spraying pesticides. I worked outside too in the morning, but in the afternoon was sent back to the house to help Mom. We are in the dining room alcove shelling what seems like thousands of pea pods. Peas so sweet and crisp from our garden I am eating two for every three I toss into the glass bowl.

"Mom, what are we going to be doing tomorrow?"

"Tomorrow we'll be shucking and freezing corn. Karen will be home to help us."

My sister Karen is in high school and isn't home much. She worked this morning on the ranch too, but went somewhere with friends this afternoon.

"And the day after that?"

"Making peach cobbler."

"And the day after that?"

"Making strawberry jam."

"Yum. That's my favorite!" I announce. "When will we make rhubarb pie?"

"Rhubarb should be ready to pick next week." Mom always knows what time of year all the fruits and vegetables will be ready.

Bored after an hour of shelling peas, I am squirming in my chair, hoping for a break, dreaming of going into town to the lunch counter at Woolworths for all-you-can-eat fried clams and a chocolate malt. But Mom is wiping her tears with her worn yellow apron that matches the wallpaper, and retrieving her red and white Betty Crocker cookbook from the pantry. She

is a petite, strong, but somehow vulnerable woman, 5'1", Rita Hayworth style dark brown hair, green eyes, probably a hundred pounds soaking wet, but not skinny. She is well proportioned with a pretty face, especially when she smiles.

I am nine years old in 1968, an isolated Catholic schoolgirl and my mother's reluctant confidante. Sequestered to a life on an orange ranch in the boondocks between Porterville and Terra Bella, California, I am the sole audience for her daily summer afternoon monologues of coulda, shoulda, woulda.

Mom sits down across the table from me, tears and regret swimming in her eyes. She grabs a handful of pea pods, starts shelling and talking.

"I want to bring one of those kids from the State Hospital here a couple of days a week. It's so sad they're locked up in that big grey building all the time. But your father won't hear of it. All I do is work like a dog, day in and day out, and he doesn't listen to anything I say or appreciate anything I do. Did you know I was mowing the front lawn the other day, and Earl Rogers from down the road drove by, stopped his car, and asked me why such a beautiful woman is mowing a lawn? I was such a mess, all dirty in my yard work clothes. Anyway, he told me that if I was *his* wife I wouldn't be mowin' no lawns. Your father hasn't complimented me since before I had you and your brother. Now that Earl, he knows how to talk to a lady."

Mom's eyes sparkle and she smiles now. I think she may have a little liking for Earl Rogers.

"You know I used to sing opera? I had the most beautiful voice until I got a paralyzed throat. Now I sound like an old bullfrog croaking on top of a lily pad. I don't know why the good Lord punished me like that. I could have been on *The Tonight Show*. Now, that Johnny Carson, he's a real man."

Mom recites her heartbreaking saga in a loop, afternoon after sweltering afternoon. I love her and Dad and want them to be happy. I want everyone to be happy. As happy as the people who stop to look at our beautiful home think we are.

"Hey Mom, do you want to play Parcheesi?" I ask in an effort

to change the subject. Mom loves Parcheesi. Mom, Paul, Karen and I usually play it in the winter when it is cold and raining on a Saturday afternoon. Mom makes grilled cheese sandwiches with sweet pickles and tomato soup.

"Not today, *kudka*." She sighs deeply as if she has the weight of the world on her shoulders. *Kudka* is her nickname for me. It means 'little chicken' in Polish.

I return my attention to the peas momentarily, then the window. Not a cloud in the sky.

"Mom, can I go pick up the mail?" I burst out suddenly as if the house is on fire. She nods without looking up from a recipe for chicken potpie she is reviewing. I slide off my chair, open the door from the kitchen to the breezeway, consider the assortment of shoes neatly arranged by the concrete step and slide on worn blue rubber flip flops.

"Be right back," I call over my shoulder.

I scurry down the breezeway in a tank top and shorts. The rays of the sun assault my skinny but tanned arms, legs, scarred knees and scraped up elbows. I make a right in front of the pool, its coolness glistening and beckoning in the midday heat, past the poolside bathroom and cold storage room. I pull the twine to open the latch of the redwood gate, skip across the crunchy gravel driveway, in between the Ford truck with a camper shell to my left, and the silver tank for our well water on my right, and into the ever-so-organized implement shed. I back out the red Honda 55 parked next to the ski boat, hop on and give it a quick kick-start.

Living on a rural route we have to pick up our mail from a mailbox on Teapot Dome Road, about half a mile away. In seconds I am happily weaving past fences, idle farm animals, our sprawling vegetable garden, the shack – where my father sleeps sometimes – and the two-story barn until I am zigzagging through rows of orange trees. Prince, woken from a nap under a shade tree by the sound of the motorcycle, barks but then puts his head back down in lazy indifference. On a cooler day he would have chased me the whole way to the mailbox and back.

Paul and I take turns picking up the mail. Once when Paul picked up the mail he looked through the pockets of an old, tattered jacket someone left on the side of the road and found a $20 bill in a pocket. As I approach Tea Pot Dome Road I scout out the area for more jackets or other possible loot, but come up empty. I open our mail box among a bank of dented metal mail boxes, and empty the contents into the ragged leather saddle bag hanging on the back of the Honda. I pause for a moment and watch the cars go by on Highway 65. Then I turn around and start for home, a little slower on the return journey, back to my sad, tired mother.

I have seen evidence of a more exciting life, a more fashionable time, for Mom. A long, elegant, cigarette holder lays idle on the large wooden mantel of our floor to open beam ceiling used-brick fireplace, next to antique German beer *steins*. Fancy hats in hat boxes, abandoned long ago, hide on the shelf in the back of her closet, above stylish 1940's tailored women's suits all neatly arranged, smelling like moth balls. A mink stole – head and all with beady little eyes, is banished to the corner along with several elegant dresses and classy high-heeled shoes – all ancient history. Precisely folded handkerchiefs with lace trim, monogrammed with the letter W for Wanda, are neatly tucked away in the back of her lingerie chest next to silk stockings. Other drawers stash a selection of elbow length gloves, sequined evening bags and real pearls mixed in with costume jewelry. Pretty perfume bottles from Chanel and Lanvin are carefully arranged on a mirrored vanity tray, with filigree gold trim, on her dresser. Her favorite perfume is *Arpège* by Lanvin. At one time she lived in another world.

Mom is from Ipswich, Massachusetts. Her East Coast accent detectible but faded after living in California almost half her life. She took the train in 1945 from Boston to Hollywood, at twenty-six years old, to discover the California dream. Found a job in a restaurant as a waitress and later became a telephone operator working the graveyard shift. At forty-eight she is old enough to be my grandmother; my father is fifty-eight, old enough to be my grandfather.

Originally from Port Arthur, Ontario, Canada, my father, Arthur, is a hardworking, no nonsense man. White hair, 5'11", blue eyes, tough and suntanned from outdoor work. He is a closed book that one. We learned early on not to expect much sympathy from him for broken arms, heat stroke or dog bites. He is a good provider. Lucky to have the things we have because of his hard labor.

Before meeting my mother, my father was a widower with three sons – Art, Norm and Pete, and one daughter, Mary. Rumor has it his first wife died in childbirth with twins, and they were given up for adoption. My widowed mother had two daughters, Rebecca and Karen. Her first husband was a polygamist with three other children who supposedly offed himself. Who knows really? We live in the era of 'children should be seen and not heard'. Paul and I weren't exactly planned and my father pushed for an abortion, but my mother, Catholic to the core, refused. He wasn't even convinced we were his children. When our teeth came in we had the famous Lucas Family Gap so there was no denying paternity. Lots of skeletons rattle in the closet for those two. A widow and a widower brought together by their tragic lives, now blaming each other for their unhappiness.

I am really happy when Rebecca comes home for a few days from college. I carry an aluminum folding chair out to the road and put it smack dab in the middle, sit down, and watch for her car to turn in from the highway a quarter mile away. Rebecca doesn't come home that often so her visits are particularly special.

During the summer our main social contact is with my father's sons and their families. Those boys were married and had children of their own by the time Paul and I came along. On the weekends they drive up from Los Angeles for three fun-filled days. Mom shines in her role as hostess and Dad is happy drinking beer, discussing business and hanging out with his adult sons by the pool.

"Mom, how are we all related?" Paul and I enquire.

"You're all kissing cousins, it's best just to leave it at that," she responds firmly.

I wonder if that means I am supposed to kiss them. Yuck. The ten of us cousins, age six to twelve, spend the weekends in the pool, ride go-carts, motorcycles and bicycles. Some Saturdays Dad hitches the boat up to the pickup. We all jump in the bed of the truck and go up to Lake Success for a day of swimming and waterskiing. Sometimes my sister Karen lets us ride her horse Pepper. My horse, Pepper's foal Lady Angelina, is too young to ride.

Saturday nights too much beer and sun retire the men by nine. That is when Mom and my brother's wives giddily gather in the dining room alcove to get loose – Mom in her conservative flannel nightgown draped over her ample braless breasts, red nail-polished toes tucked into fuzzy slippers, Dot in her Hawaiian print *muumuu* that accentuates her year-round Southern California tan, Martha in a flowery pajama set and Betsy in a fluffy bathrobe. They arm themselves with cup after cup of fresh coffee and deliciously gossip about scandalous family secrets into the wee hours of the night. All of us cousins fight sleep in wall-to-wall sleeping bags in the living room to overhear their murmurs, but exhaustion usually wins out over curiosity.

On Sunday mornings we wake to a veritable feast of pancakes, bacon and eggs, and fresh squeezed orange juice before quickly dressing in Sunday clothes and being whisked off to Mass, followed by confession in true Catholic tradition. We impatiently stand in line, shuffle into the confessional, make up sins, get absolved from our made up sins by the priest, shuffle back to the pew, say our Hail Marys and Our Fathers, and pile into the back of the 1966 Dodge station wagon packed in like sardines. No seatbelts required.

The men skip church but redeem themselves by preparing the next feast of the day, a full-on poolside barbeque from the built-in brick pit on the patio, on the backside of the indoor fireplace. Hamburgers, hotdogs, steaks, baked potatoes, corn on the cob and baked beans. We stuff ourselves and wait impatiently for permission to swim.

"Alright, you can get in the pool," Dad finally announces.

Ten cousins race to climb the ladder of the pool slide one by one and push each other down, as Prince excitedly barks and jumps in after us. The adults join us in the pool for a little while. All the women wear flowery swim caps and matching fashionable one-piece swimsuits. We spend the afternoon racing, jumping and doing flips off the diving board and playing Marco Polo.

Hours later as the sun starts to sink in the sky it's time to get out. We reluctantly emerge from the water sunburned and waterlogged. Mom sets a feast of watermelon and grapes on the picnic table. We indulge in the fruity sweetness and spit watermelon seeds at each other when the adults aren't looking, and laugh hysterically.

"Get your swimsuits off and get dressed! Time to go home," Dad makes the dreaded announcement. The cousins argue with their parents, but the time to leave is carved in stone.

Dad, Mom, Paul and I stand in the driveway waving goodbye as the convoy of relatives drive off, like munchkins waving goodbye to Glenda, the good witch.

When visitors leave it is back to the dreaded silence. Mom and Dad retreat to their respective Lazy Boy recliners, Dad's is brown pleather, Mom's is fuzzy orange cloth, strategically placed at opposite ends of the living room, turned towards the television minimizing any accidental eye to eye contact. Dad dozes off then gets up and goes to bed. Then Mom chain-smokes the newly marketed Virginia Slims cigarettes, desperately sucking in the smoke as if sucking in their slogan, '*You've come a long way, baby*'. She chews on sunflower seeds and works on crossword puzzles until it is time to watch her man, Johnny Carson.

Sometimes Mom and Dad are forced into a dialogue about things relative to basic survival.

"I have to go into town to get a new pool filter. Too many frogs getting sucked up in the pool vacuum." Dad will inform Mom. "Do you need anything from town?"

"Call the sheriff's department! Thieves are stealing gas from the wind machines again! I saw the headlights!" Dad shouts,

running out the door with his shotgun, Mom frantically dialing the kitchen wall phone.

When I'm not engaged as my mother's confidante, I am busy positioning myself as daddy's little girl, desperate for his approval. I think I can fix everything if he is happy.

"Hey Dad, can I go with you on your walk?" I ask, as I see him heading out the door after dinner.

"Okay," he says, but keeps walking and doesn't wait for me.

I grab some tennis shoes from the breezeway, quickly tie the laces, run, catch up with him and hold his hand, Prince prancing at my heels.

"Mom sure is a good cook isn't she?"

"A woman should know how to cook and keep a home."

"I like it when she makes that Yorkshire pudding stuff. Do you like that Dad?"

"Yes, I do."

"Dad, do you think dogs think? I think Prince thinks, but I wonder what he thinks about." I am skipping to keep up with his wide strides.

"My, you are a talkative one darling. Let's just walk without speaking for a while."

I get bored of the silence and tired from skipping. I let go of his hand and find sticks for Prince to chase, while Dad continues his walk up the road alone.

Sometimes I watch television with Dad or play Marco Polo in the pool with him. Most of the time, it is fun. But, from my mother's and brother's accounts of my father's verbal tirades, and the few I had seen, I know my father is fairly quick to anger. I learn to be cheerful and happy and chatty, creating the harmony in short bursts that I long for as the norm for our lives.

A few summers we take road trips up to Campbell River on Vancouver Island. These are fun times, salmon fishing and meeting new people. These vacations still don't dent my parent's loathing for one another. What they lack in conversation, affection and love, they make up for in cleanliness, organization and hard work. Rather than putting their time and energy into

developing a loving, supportive, harmonious family unit, they put their energies into creating the illusion of one.

So it goes on, year after cookie-cutter year, until I am fourteen.

I am devastated in 1973, when we sell the ranch because of my father's health. His body is engulfed in pain most days and the doctors don't know what is wrong with him. He can't do the type of work the ranch requires any longer. We are moving to Santa Maria on the central coast of California, where the weather is less damp. When we drive away from the ranch for the last time, Ford truck laden down with moving boxes, Prince, and a token garden rake rattling in the wind, my heart sinks: goodbye to the possums that have midnight feasts on grapes from the vines outside my bedroom window; goodbye to our 4H – Head, Hands, Heart and Health – project lambs and the county fair; goodbye to the junk yard down the road where my brother and I spend hour after hour rooting through junked cars in hopes of finding money and hidden treasures, searching despite the fear of discovering a dead, decomposing body; goodbye to the irrigation reservoir where we chose to dive and swim in dirty, slimy, tadpole infested water, my mother shaking her head in disgust unable to understand why we choose to swim in pond scum when we can swim in a pristine inground swimming pool in our back patio. I am exiting life as I knew it.

HARVESTING STONES

CHAPTER 3
Bored and Uninspired

DAD RENTED AN UNINVITING BROWN RANCH HOUSE EMBEDDED in a labyrinth of informal, impersonal abodes in Orcutt, an unincorporated town in Santa Barbara County, just south of Santa Maria.

The sandy-soiled fenced backyard backs onto a green space with towering eucalyptus trees. The smell of the air here is strange. Living in a subdivision is strange. Between nine o'clock in the morning and five o'clock in the evening, robotic fathers go to work and bored housewives stay at home.

No more Catholic school uniforms and I have no sense of style or how to dress beyond cowboy boots, t-shirts and jeans. I feel insecure. On the ranch I knew who I was. I had the same friends since first grade. Here I don't know anyone, I feel lost.

It's the first day of school in September. I get up, wash my face, brush my long blond hair and practice smiling with my mouth open reveling newly brace-free teeth. Dad has blue eyes and Mom has green eyes. Mine are green some days and hazel others. Today they are greener. Freckles. Ugh...

Paul and I walk down the concrete sidewalk past sprinkler-watered lawns and asphalt to the bus stop. We exist only where our feet touch the ground trapped in the awkward silence of being the new kids. The brakes of the bus screech to announce its arrival. The school is a massive maze of concrete classrooms – this is all very confusing for someone with no sense of direction. The girls wear makeup and have boobs. Living on the ranch I

never really thought about the social value of boobs, but here, boobs reign supreme.

"Mom, all the girls at school wear makeup. I need to get makeup. I look so plain next to the other girls," I plead upon returning home.

"Makeup is ridiculous for someone your age! You look perfectly fine the way you are."

"Mom, please! And I need a padded bra."

"A padded bra?" Mom asks, looking at me quizzically.

"Yes, Mom, a padded bra. You don't know what it's like to not have boobs."

"I wasn't born with boobs darling. You're perfectly fine the way you are."

"I don't feel fine the way I am. I'm plain and flat chested, Mom."

"Why do you care what other people think? Your true friends won't care."

"I don't have any friends here, Mom. But if I wore makeup and had boobs I would."

"That's ridiculous. No makeup, and your bras are just fine. Now go feed the dog."

Mom has sealed my fate, unknowingly damaging my social existence. Faked headaches, period cramps and sprained ankles can only get a girl, who is avoiding 8th Grade like the plague, so far. I don't fit in anywhere. I am awkward, ordinary and miserable. Paul adapts. But that's because there is an inverse boob expectation for boys. So not fair.

I need a horse to solidify some type of distinctiveness. My guilt-provoking running commentary to my father about leaving the ranch, and coming to a place I didn't know anyone, leads to a compromise with Dad. He will buy me a horse when we move from the home we are renting into the one we are having built. My father will not live in a house someone has lived in before, unless it is temporary while the new house is being constructed.

"You never know what happened in there," he always says.

The next few months pass in agony. Graduating junior high school is the happiest day of my life – the same day we move

into our new home, in a new rural subdivision in Nipomo, on one acre. Our ranch home is smaller than the one I grew up in and we don't have a pool. But, as promised, I get my horse in July. He is a fiery black gelding with a white diamond on his forehead named Honky Chateau after the Elton John album. The rest of the summer I am on my horse, racing boys on motorcycles and girls on horses from our neighborhood. I always win against the other horses. I am the girl with the fastest horse who rides bareback like the wind. I have an identity to grasp onto by the time high school begins.

Mom allows me to wear a little makeup now I am in high school, but I still look twelve at the age of fifteen. I think I look a little prettier with makeup.

I have a few good friends, Sandy, Theresa, Margery and Vicki. I am a good student, come home after school every day, clean the house, do my homework. Mom and Dad are old-fashioned compared to my friends' parents so I don't go out much, and when I do it has to be in a group and my curfew is always earlier than anyone else's.

But this summer, now I am seventeen, my horse finds himself with a lot more free time. I am dating the town's bad boy, a John Travolta look alike with piercing blue eyes and an old pickup truck with a broken muffler. My parents are beside themselves, but aging, health concerns, and pharmaceutical pain management have weakened their resistance to my budding teenage rebellion. While my upbringing is dysfunctional, Johnny's is a train wreck, with an alcoholic mother and a father who I believe is the most arrogant man on earth. This is why I believe his mother is an alcoholic.

Probably in an effort to get me away from Johnny, we are taking a cross-country road trip this summer. It is 1976, our country's 200th anniversary, and we are heading from California to the East Coast. Dad drives, Mom is in the front passenger seat, Paul and I are in the back seat. We need to sue whoever came up with the family vacation as the epitome of family togetherness, for falsely glamorizing the all-American family road trip in *Parade Magazine*.

We are not a car full of beaming, happy faces excited to discover all the USA has to offer. We are hot, sweaty and cranky.

Mom is making peanut butter and jelly sandwiches in the station wagon, on top of the Styrofoam ice chest, spreading the goo on the bread with her finger, because she forgot the knife back at the Motel 6 we stayed at the night before, cigarette dangling from her mouth.

"Oh no!" Mom shouts, while pulling the cigarette out of her mouth. "My favorite kerchief flew out the window! We need to turn around and get it, Art!" she begs my father.

Paul and I look through the back window of the car in unison and see the kerchief Mom was wearing on her head flapping in the wind like a wounded bird in the middle of the freeway.

"I'm not turning around to get your kerchief, come hell or high water!" Dad barks, staring straight ahead, ignoring my mother's pleas. You don't see this scene on billboards advertising the all-American family road trip. Ever.

As soon as we get back from our six-week drive I reunite with Johnny, dashing any hopes my parents have of sabotaging our young romance.

The last year of high school flies by. I graduate and start working at the Mark Eden Bust Developer factory, out on the Nipomo mesa, making pink plastic clamshell-like devices that promise to improve the size of a woman's breasts. Ironic.

I start my first year at Hancock community college and I like it so much better than high school. We downsize again, moving from the house in Nipomo to a four-bedroom condo in Santa Maria, because Dad can't do the yard work anymore. No yard this time, just a small front patio with enough room for a barbeque and a couple of chairs. I begin working managing commercial real estate, with flexibility to work around my school schedule. My boss is a sweet older, gregarious man, Pete, who made his fortune buying and selling real estate on the central California coast.

After I get my Associates degree from the community college I apply to several universities and wait for the admission letters to come back in the mail.

"Mom! Look, I got my acceptance letter to Berkeley University!" I am ecstatic. It is a dream come true for me. I hand the letter to Mom, she barely reads it and hands it back. I feel her heart sink.

"*Kudka*, I know you're happy, but I think you should wait and see what the other universities say. California Polytechnic State University in San Luis Obispo is closer," Mom utters as she closes my bedroom door.

I know what that means. Mom doesn't want me to move so far away. She needs help with Dad. I decide to live at home another year and commute the half-hour each day to Cal Poly.

Just after my 21st birthday in 1980, I move in with Johnny into a small duplex in San Luis Obispo. This lasts all of three months, coming to an ugly end involving my life flashing before my eyes and a restraining order. I move into an apartment in old town Arroyo Grande with Sara, a girl I met at Hancock college, who was the only other non-senior citizen in an evening pottery class. Sara is a pretty blonde with big blue eyes and a knockout figure. She works as a waitress at Spy Glass Inn, a fancy restaurant and bar in Pismo Beach, right on the sparkling Pacific Ocean, and makes a lot of money in tips.

I am still working at the real estate management company in my senior year, going to my parent's condo several times a week to help with cooking and cleaning. Dad's health is slowly declining. He spends most days in his bathrobe. Mom spends most days worrying about, or wishing for – I am not sure which – his death. She has become his caretaker.

On the weekends when I am not in classes, working, or at my parents, I am going out with friends and experiencing the central California coast 1980's feral dating and social scene; my conservative Catholic upbringing blowing away like the wind. There are the pretty college boys who spend so much time looking at their reflection in the mirror I feel I am dating twins. I dabble in short lived romances with cocaine dealers, struggling musicians, beach bums and sweet but going nowhere construction workers. The pickin's on the central California coast are mighty slim.

I finish Cal Poly, except for my senior project, quit the real estate management company and get a job working full time at Diablo Canyon Nuclear Power Plant. I am torn. Had I sold out after standing in solidarity with Jackson Browne protesting nuclear power at the entrance of Diablo Canyon in Avila Beach, California, in 1981? Yes, I had. Sorry Jackson, but *The Pretender* is still the best song of all time.

The office I work in is a trailer out on the lot above the two nuclear power plant reactor domes that houses twelve girls. We work entering documents, maps, construction drawings, and so on into computer databases. We are family. We support each other through heartaches and tragedy and watch each other's backs. Laughing and cursing like sailors and telling dirty jokes one minute, crying on each other's shoulders the next.

"Randy's such a jerk. He's see'n' that girl Crystal behind my back," Sherry is crying. She is a sweet girl with light brown, shoulder length hair and a southern accent caught up in a bad relationship.

Remy jumps up from her chair. "Nobody messes with one of my girls!" Remy is a tough cookie, a big girl with an even bigger mouth that gets her in trouble sometimes. "D'you want me to rearrange his face for him?" she asks Sherry, as serious as a heart attack.

"No, Remy. I'm going to break up with Randy today."

"Do you want us to be there?" I ask.

"No, but thank ya'll for bein' my friends." Sherry spends the rest of the afternoon crying, eyes swollen, sleeping at her desk and not working. We take turns entering data under Sherry's login so when the report is run at the end of the day it looks like she was working. When Bob, our supervisor, comes into the trailer for his afternoon check and sees Sherry sleeping, we tell him she is on a break.

Finally past living as a poor college student, Sara and I move from the apartment into a big, old Victorian house about a mile from the beach in Oceano, christened Hotel California by the local riffraff and misfits. Word, it seems, has spread and the house

is slowly evolving into a party house. Most parties are fun and mostly on the weekends.

This morning is Thanksgiving 1982 and we get a call from Betsy. My brother Pete died, unexpectedly, earlier this morning, of a massive heart attack. He was forty years old. I answer the phone downstairs at Mom and Dad's condo, not knowing Dad picked up the phone upstairs. I go to tell Mom and she says not to tell Dad, but he already knows from listening in on the call. Pete's death sends Dad into another health tailspin. He is crying, saying it should have been him instead of Pete. It is a difficult time for our family.

A few weeks after Pete's death I come home late on a Wednesday night after a day of working and cooking dinner for Mom and Dad, and there are people I don't know smoking, drinking and doing cocaine lines in the living room. I walk into my bedroom to discover a couple I don't know having sex in my bed. Gross. I kick them out, change the sheets on my bed, lie down as flat as possible and cover myself, even my head, with blankets and pillows.

"Hey, Paula. You in your room?" I hear Sara knock on my bedroom door. She walks into my room and calls for me.

"Yes, I'm right here," I answer from beneath the covers.

"That is so weird. I can't even tell you're there."

That makes me happy. I want to be nowhere and if she cannot see me, that means I am nowhere. Pete's death made me realize how short life is and I know this is not the life I want. The party scene is old. I don't think I like who I am becoming. I feel bored and uninspired. Beam me up Scotty. I didn't care where, anywhere but the central California coast.

The universe heard. Within weeks I mercifully receive a job offer from a land far, far away – San Francisco. It drops in my lap. I drive up with Mom for the interview with a corporation in the utilities industry. They offer me the job on the spot and I accept it before I can blink.

I leave after my 24th birthday in January 1983. The guilt of leaving my aging, health-issue ridden, don't-like-to-speak-

to-each-other parents is enormous. I love them both dearly. My mother finds her refuge in the Catholic church and roaming the mall shops day after day. My father has become too sick and too medicated to care about much of anything. In contrast, the excitement of living in San Francisco is intoxicating. Full of life, bright lights, sushi, cable cars and colorful people, it is too much to resist. Paul lives in Arroyo Grande and Karen lives in San Luis Obispo. They will help my parents and I vow to come home at least once a month.

Primed with an almost BS in Business, Human Resource Management, padded shoulder business suits, big 80's hair, an over-inflated sense of confidence and an undeniable absence of worldly experience, I leave my small town incubator and launch myself into the sophisticated, yuppie-blooming, urban culture of San Francisco.

It is hard to imagine culture shock happens a mere 264.16 miles from home, but it slams me right upside the head. What is over-inflated, quickly deflates. I don't know a soul in San Francisco. I temporarily stay with Emma, a co-worker and new best friend. Emma is a lovely Cuban woman a few years older than me, with a mischievous smile and amusing sense of adventure. She promises my parents she will look after my welfare. Within a few weeks I find a garden studio in the back of a house converted into apartments on Valley Street in Noe Valley, around the corner from Emma. It is comfortable, bright and safe. I have a separate small kitchen with an eating area, and a bathroom. I keep a window part way open so my kitty, Kiesja, can enjoy the backyard garden. Although the backyard garden is a community space for the three-story building, no one ever goes out there, so it feels like my own little retreat.

Working in the city I must be wearing my naivety like a scarlet letter. I am intimidated by the backstabbing, claw your way to the top, nail-biting attitude of people in the corporate world. I miss the camaraderie of the girls in the trailer on the lot at Diablo Canyon. I start doubting if I am cut out for a corporate path in life, but the money is good.

The J Church MUNI stops one block from my house on Church Street, across from St. Paul's Church. Emma and I catch it early for our commute to work, thankful for the warmth of the coffee and pastry shop, right next to the stop, on freezing cold mornings. I am learning my way around the city with Emma usually in tow. I am pleased with my decision to move to San Francisco.

HARVESTING STONES

CHAPTER 4

Miss Manners

EMMA AND I ARE HAVING BRUNCH AT HORIZONS IN SAUSALITO, ON the deck outside on a truly glorious day. Sailboats and white caps dot the bay, San Francisco sparkling in the background in the warm sunshine.

"Have you noticed we're in yummy yuppie land?" Emma's eyes are focused on two good-looking guys who walk over and start chatting with us. Mark and Seth are self-proclaimed consultants, although they don't elaborate. We enjoy brunch together and they invite us to a party at a private nightclub, Mums in San Francisco, later in the week. How could we resist? They hand us private invitations and say they will meet us there.

Preparations are made, checked and double-checked. Makeup. Check. Dress. Check. Shoes. Check. Handbag. Check. Taxi money. Check.

Emma and I meet at her house and take a taxi down to the club. Outside Mums drop-dead gorgeous men and women pose for other drop-dead gorgeous men and women as they gracefully slip out of limousines. Giant, muscle-bound, bald doormen with earrings, like Mr. Clean, check membership cards and invitations. Emma and I wave our invitations in front of the doormen and glide into the swankiness.

Inside champagne flows on the dance floor and cocaine flows in the bathroom. It is a high end version of the reason I left the central California coast, only here people have more money, designer clothes, expensive cars, are more educated and

articulate. We amuse ourselves emulating our new sophisticated party style.

"Would you like another glass of champagne, daaahling?" Emma coos.

"Why yes, that would be just lovely Emma, you're too kind," I coo back.

We both find Mums exceedingly pretentious. When Emma and I get off of work we put on jeans and sweatshirts with hoodies and stroll down to Noe Valley Bar and Grill or one of our haunts on 24th avenue.

Mums is not our usual cup of tea, but we are enjoying our adventure. One sharp dressed man asks us if we want to ride around the city in his limousine. We innocently take him up on his offer without realizing he is expecting a hand job from me within minutes of leaving the club. I guess we missed the 'Ass, gas or grass, nobody rides this limo for free' bumper sticker. I decline and he signals the driver to return to the club. A quick U-turn sends Emma and her glass of champagne flying onto my lap. Sleazy. Ick.

We dance and laugh the night away leaving in the early hours. We never did see Seth or Mark. We have to be at work by seven so we barely get four hours sleep. Several men gave us their business cards that night. At work during lunch, Emma and I sort through the cards trying to match the names to the faces we remembered from Mums.

In the midst of our efforts I receive a call from a man who says he met us at the club. His name is Tysir Dasanti. We quickly spread out the cards but cannot find his name.

Emma is sucking in my oxygen straining to hear him on the phone. Neither of us remembers him. He is very polite and proper on the phone and speaks with a peculiar, not quite French but I can't tell what else it could be, accent.

He invites me to dinner that evening. Emma's eyes widen begging, "Take me too, take me too!" I ask Tysir if I can put him on hold for a minute.

"I want to go too!" Emma singsongs.

"That's not such a bad idea as we can't remember this guy at all,

so it's like a blind date and he might a serial killer or something," I respond. "But not tonight. Tomorrow, okay?"

Emma excitingly nods, yes. I take Tysir off of hold.

"Hello, Tysir. Sorry about putting you on hold. I can go out tomorrow night. Do you mind if my friend Emma comes along?"

"Not at all, can you come by at six?" He gives me an address for a penthouse on Russian Hill. Oh, fancy schmancy.

I pick up Emma and drive to a beautiful 1920's Mediterranean Revival apartment house on Russian Hill. We park, stroll to the front door, press the intercom, get buzzed in, walk into the marble entryway and step into an antique cast iron and wood elevator that creaks and moans up to the top floor. On the landing there are two doors.

"Tysir said to knock on the door on the right," I instruct Emma. She taps lightly three times. The door opens.

"Hello, I'm Tysir but call me Ty. Please come in." Ty stands back and waves us through the doorway, gesturing with his perfectly manicured hand. Ty is about six feet tall, longish straight black hair and green eyes, distinctive looking in a foreign way, elegantly dressed in a double-breasted navy blue jacket and trousers, blue striped dress shirt, paisley red tie, black dress shoes flawlessly polished. He has the same accent as the man on the phone.

"I prepared Kir Royales for you." Ty hands us two chilled, fluted champagne glasses. Fancy schmancier.

"Can you excuse me one moment please? I'm on a phone call in the other room."

"Is he the butler?" Emma whispers to me once Ty is out of earshot. "He's so polite and proper."

I laugh and accidently snort Kir Royale up my nose. Emma rolls her eyes, shushes me and teasingly pokes me in the ribs with her elbow.

"Maybe we met the real Ty at the club, but after years of indentured servitude, the butler disposed of him and is assuming the identity of his nemesis," I whisper in Emma's ear.

"Let's look for clues." Emma playfully glances around the room.

"I thought you said you called the restaurant and the dress was casual," I ask Emma.

"I did. I don't know why this guy is dressed like he's going to meet the Queen of England."

We are dressed in nice jeans and sweaters. I added my signature cowboy boots to my ensemble.

Ty walks back into the room and hands me his card, Tysir Dasanti. No company or title, only a telephone number. I have not seen this card before.

The penthouse is spectacular. Two walls of the main room are floor to ceiling windows revealing both a western and northern clear view to the brilliant evening sun setting over the Golden Gate Bridge, the marina and Coit Tower. Furniture is sparse – a queen sized bed with an abundance of pillows and a blue geometric patterned bedspread, one bull whip on the wall (curious), one chair, one floor lamp and a café set for two. There isn't a full kitchen, but along one side of the room there is a bank of cabinets with a sink, stovetop and microwave. There is a room that Ty, or whoever this fellow is, has turned into an office, but it looks like it was intended to be the bedroom – definitely a bachelor pad. Michael Jackson's *Billie Jean* followed Hall & Oates' *Maneater* playing on the sound system.

"How did you get my phone number?" I ask Ty curiously.

"My friend Tommy, who you met at Mums, gave it to me. I was with him. Don't you remember?"

I don't. There are several explanations. Both Emma and I had indulged too much that night at the club and our memories are fuzzy, he didn't leave much of an impression on us, he was lying, or a combination of the three.

There are numerous magazines arranged around the room in a 'just so' manner for affect.

"What are all of these magazines for?" I ask Ty, changing the subject.

"I'm a professional photographer. I've worked for many famous news magazines around the world."

The more he speaks, the more legit he seems, negating our butler

conspiracy theory. Emma notes the time, we leave and Ty banishes his tie on his way out the door, noticing the dress code disparity.

We take a taxi to Caffé Sport, a delightful Sicilian style Italian restaurant in San Francisco's bustling North Beach neighborhood. Ty pulls out a large stack of $20 bills and pays the taxi.

"This guy is going to get robbed one day, pulling money out like that," I whisper to Emma.

"Yah. By me!" Emma laughs.

We arrive in time for their seven o'clock family style seating. The decorations and the noise are a bit overwhelming, but Emma and I are having a great time.

"Have you been here before?" Ty asks.

We shake our heads no.

"Shall I order for us?"

We nod our heads yes, like a couple of bobble head dolls.

Ty is an eloquent host, ordering for us and making sure we have everything we need.

"Have you ever been to Paris?" Ty asks us.

"No, but I had sex with a French guy once," Emma offers as an alternative, straight faced, testing Ty's composure.

I try hard not to bust out laughing. Ty looks perplexed.

"*C'est une ville tres jolie!*" Ty continues. "You should go sometime."

Ty tells us engaging stories of worldly adventures and name-drops important people who he refers to as friends.

"One of my photos is in President Regan's Oval office," Ty asserts.

We stuff ourselves with succulent giant prawns in white garlic sauce with pasta, garlic bread and red wine until we turn into food zombies. After dinner Ty is disappointed we do not want to go to his apartment for coffee, but it is after ten and Emma and I have to work the next morning. Ty hugs me goodnight under Emma's protective watch. On the way home Emma and I can't decide if this guy is eccentric or peculiar or both. He is so different from anyone I have ever met, intriguing really.

The next day at work flowers arrive on my desk from Ty.

Emma occupies my personal space and fusses.

"Ohhh, he likes yooouuuu," she chants as she plucks a white rose from the vase, slides it in her hair above her ear, sits on top of my desk and perfects a pin-up girl pose, batting her eyelashes at me.

The only time I had received flowers before from a man was when I had to break a dinner date because Pete died.

Ty calls my office phone number and asks if I received the flowers.

"Yes, they're beautiful, thank you."

"Are you available for dinner tonight?"

"Sorry, I can't make tonight, but what about next week?"

"Are you available this weekend?" Ty asks.

"No, I'm going down to see my parents, how about next Tuesday evening?"

"Great! I'll make reservations for nine at L'Escargot, a French restaurant on Union Street. Will that work for you?" Nine o'clock? We are going to start eating at nine o'clock? Holy crap. All my life my mother served dinner at six o'clock sharp. I am showered, in pajamas and in bed by nine on weekdays. Going out that one night at Mums wore me out. I don't want to sound any more farm-girlish than I already am, so I agree to pick him up in my car at eight thirty.

L'Escargot is an expensive, swanky restaurant. The waiters are in tuxes, tables are draped in white linen and the cutlery is real silver. I am glad I wore my little black dress. Ty is impeccably dressed as he was the first night I met him.

Ty pulls my chair out for me. He sits and we study our menus.

"I'll try the *Coq au Vin*," I decide.

"No, you won't like that. Let me order for you," Ty trumped my choice.

Well, that is annoying, but I have no knowledge of French cuisine so it makes sense that Ty orders, which he does in French.

"Pour mademoiselle, le steak béarnaise, avec des frites, et le même pour moi, s'il vous plaît. Pour commencer on prend les escargots tous les deux. Merci beaucoup."

The waiters brings a weird type of instrument that looks like an eye lash curler and an unusually skinny long fork, and lays them on the table, one set for me, one set for Ty. Ty examines the wine menu, makes a selection the waiter enthusiastically approves of and we watch as he flurries off to retrieve the bottle.

"*Grand vin de Bordeaux, Château de Laurée, 1980, d'accord?*" The waiter is back and presents the bottle to Ty. He uncorks the bottle and pours a small amount in the bottom of Ty's wine glass. Ty swirls the wine around, lifts the glass and closely examines the vino.

What is he looking for? I contemplate.

When he seems satisfied he draws the glass back under his nose and inhales, still swirling, before reflectively taking a drink.

"*Très bien.*" Ty nods his approval, the waiter smiles and pours me a glass before going back and pouring more wine into Ty's glass.

Wow, what a ritual. I feel as if I have landed on another planet.

Two waiters, one next to me and one next to Ty, stealthily arrive to place silver domes in front of us and with the precision of synchronized swimmers, lift the domes to reveal snails. Ugh.

"Do you like *escargots?*" Ty asks.

"I think I ate one when I was two years old, on the back patio."

"Here, let me show you how to eat them."

Ty picks up the foreign instruments and elegantly demonstrates the art of eating *les escargots*. I clumsily clench one in the tongs and follow Ty's lead. I politely down a couple, saturated in garlic butter. Not a huge fan. Ty seems overly excited about them.

Ty orders raspberry sorbet.

"Are we having dessert already?" I ask, thinking the French eat their meals in a strange order.

"No, but we must cleanse our palates before the main course."

Cleanse our palates? What the hell is a palate? Did he mean plate?

Ty reads the confusion on my face.

"The *escargot* has a strong taste so we must eat something refreshing before the main course to cleanse the palate." He twirls his hand in the air as if he is turning a lightbulb halfway when he says 'cleanse the palate'.

"This is a very nice restaurant. Thank you for bringing me here." I express my appreciation.

"I enjoy the ambiance here. They also have the most authentic French food in the city."

"Where are you from?" I ask Ty.

"I was born in Jordan and attended college in France. I started doing photography when I was very young."

"How many languages do you speak?"

"Arabic is my mother tongue, I also speak English and French."

"How many countries have you been to?"

"Oh, many... I don't remember exactly, but mostly in Europe and the Middle East.

Ty asks me about myself and I fill him in on my comparatively boring California Catholic farm girl upbringing. Canada is the only foreign country I have been to, and my two years of high school Spanish escape me. I don't know anyone famous.

Ty is both odd and fascinating to me. He gives me his undivided attention and for some reason I seem very interesting to him. I find this unusual because his life is ten times more exciting than mine.

By the time dinner is over it is eleven o'clock. I drop Ty off at his penthouse and drive home. Flowers arrive again at my desk with a card that says '*Let's do it again!*'

"He sent flowers two weeks in a row?" Emma questions. "Does Ty have a brother?"

"Yes, but they're all older and married. He has a sister who's single," I offer Emma as a substitute.

"Okay by me. Does she look like Cleopatra? Are they Egyptian?" Emma walks around my desk emulating how she thinks an Egyptian princess might walk.

Over the next month Ty invites me out almost every night. We go out once during the week and once on the weekends. I make sure I leave an evening or two for Emma and a couple for myself. I am also seeing my friend Nick, casually, a couple of times a month.

Nick is the opposite of Ty – a poor, starving artist, who wears jeans, tattered sneakers and t-shirts. His long brown hair always

looks like he just got out of bed, falling down in front of his dreamy brown eyes. Our dates consist of going to the grocery store to buy brie, baguettes, grapes and cheap *chianti*, which I usually pay for. We walk back to my garden apartment to indulge in our purchases and fulfill our carnal needs. Nick is light and easy to be around. We see other people, no questions asked.

As Ty doesn't have a car, I pick him up from the penthouse and we go out to dinner at Pregos, Tuba Garden, Cadillac Bar or other well-known San Francisco dining establishments, and then head down to Buena Vista for Irish coffee or to one of the hoity-toity nightclubs for drinks and dancing.

Ty is an impressive man who is very accomplished. Although he is two years younger than me, he has the mannerisms and the looks of someone older. He could easily pass for thirty. It is the first time I am dating a foreigner, so different than dating an American. He sends cards and flowers for no reason, opens my car door and always makes an extra effort to make sure I am comfortable and have everything I need.

We spend sunny Sunday afternoons lounging around his penthouse balcony drinking champagne, eating strawberries and talking about our lives.

"Americans don't know how lucky they are. There are so many opportunities here."

"Yes," I agree. "We do take things for granted. We have so much."

"In Jordan, it's difficult to make a living, especially as a poor Palestinian refugee. We're considered second-class citizens. My parents are very poor. My father has been in prison just for being Palestinian. My brothers are successful, working in the Arabian Gulf. We all support my parents."

Hearing that Ty and his brothers support his poor, refugee parents moves me to tears. What a wonderful man. His family has suffered so much.

Ty must have made a lot of money as a photographer because he doesn't work in San Francisco, goes out on the town every night, lives in a penthouse and pours Dom Pérignon champagne

in abundance. Most of us twenty-somethings can barely support ourselves.

He recommends I change my hair and my clothes because people are snubbing me – if I want to be taken seriously at work I need to have a better image. I think my clothes are fine. They aren't designer clothes, but I have a few decent business suits I had to put on layaway in order to afford. The office secretary, Kelly, snubs me but she is a snob to everyone.

On several occasions Ty takes me shopping, buys me new clothes and shoes from Neiman Marcus, Sak's 5th Avenue and Macy's.

"I like these boots," I point to a pair of gorgeous buckskin suede knee-length boots with two inch heels.

Ty puts his right hand on his chin below his mouth, thumb on the right, and index finger on the left, slightly squeezes and scrutinizes me.

"You can't possibly like those boots. Here try these flats. Remember the higher the heel, the lower the class."

I had no idea there is a correlation between heel height and social class. Someone like Ty would know that. I am in trouble. All of my shoes, except for my cowboy boots and sneakers, are high heels. I capitulate and take the black leather flats, which are cute and practical. Maybe I will come back later without Ty and put the boots on layaway, embrace my trashy side.

On one of our outings Ty takes me to get my hair cut at an expensive salon.

"Your hair's still too long, shorter is more stylish," his scrutinizing posture re-emerges.

"I really don't think short hair suits me. I like it the way it is," I get out of the chair signaling to Ty that I am not going to get it cut.

Sometimes dealing with Ty is a battle of wills. Ty's reminders that I am a sheltered California farm girl with no life experience, and he is a famous, world traveled, multi-cultural, multi-lingual, wealthy photographer – so he knows what is best for me – are convincing and uncompromising. My signature cowboy boots are replaced by designer shoes and held in reserve for my monthly trips back down to the central California coast.

We go out to eat and he almost always dismisses my first choice and orders for me.

"No, I know you won't like (fill in the blank), I'll order for you."

For me this teeters between charming and annoying. My culinary knowledge has expanded exponentially since Ty and I started dating, so I go with the flow.

On one of our dates I arrive at Ty's penthouse. As he opens the door I notice he has replaced his usual double-breasted blazer with a more casual choice.

"Nice plastic jacket!" I complement him as I cross over the threshold.

"It's suede, not plastic, and very expensive," he objects indignantly.

"Okay, looks plastic to me."

I kick off the Salvatore Ferragamo Italian leather flats Ty bought me at Neiman Marcus, drop the matching handbag to the floor, plop down and sit cross legged in jeans and a t-shirt then gaze up at him. Ty begins to raise his right hand to his chin. He is probably going to say something about ladies not dropping their handbags on the floor, and then plopping down on the floor like a rag doll, but he seems to change his mind and also changes the subject.

Ty presents me with a book on proper etiquette, *Miss Manners Guide to Excruciatingly Correct Behavior*, at his penthouse soon after the plastic jacket incident.

"I was raised on a farm, but not in the barn!" I am slightly offended, but also amused as he hands me the book.

"This is a good book." Ty offers sincerely, his face confused.

"Okay, I'll read it. Why not?' I think I am going through Ty's version of finishing school.

Ty offers to cook me dinner at his penthouse and invites me to bring my laundry over, rather than going to the Laundromat by my apartment. He totally spoils me, cooks fabulous Italian sausage pasta in a red wine sauce, gives me a full body massage and does my laundry. This is too good to be true. Ty is pampering me and I oblige. He invites me to spend the night, but I have work

early the next morning and decline. My laundry isn't finished. I tell him I will get it the next day.

At five in the morning the doorbell on the street level rings. I get up, unlock my door and walk down the corridor, groggy and cranky.

"Who is it?" I inquire from behind the door.

"It's Ty. I have your laundry."

I open the door to find Ty standing with my laundry, washed, dried and folded neatly in his arms. He is grinning from ear to ear.

"It's five o'clock, Ty!" Half asleep my appreciation is second to my annoyance that he is waking me an hour before I have to get up. We aren't in an exclusive relationship. He has declared he is not seeing anyone else, but I have not made the same declaration. What if Nick had slept over? This would have been a very awkward moment.

"Come in. Come in." I open the door wider to allow him entrance. "How did you get here?" I yawn the question.

"By taxi."

"You took a taxi at five to bring me laundry?" It is an endearing gesture and he was so wonderful the night before. I decide to try to be less irritated.

Ty waits while I shower and dress for work. We grab coffee and a pastry at the café by the MUNI stop and he takes the MUNI with me to the financial district. I go to work and he wanders off to do whatever it is he does all day.

When I get home I check my answering machine to see if I have any messages. There is one from Nick.

"Hey, it's Nick. Just thought I'd see if you want to get together this weekend. Call me back. Who is the dude on your answering machine?" What's Nick talking about?

I listen to my outgoing message.

"Hello. You have reached Paula's residence. She is not available to take your call. Please leave a message."

It's Ty's voice. *What the hell?* He changed my outgoing message to his voice. He must have done it while I was in the shower this morning. I call him.

"Ty, why did you change the phone message on my answering machine?"

"You live alone in the city. It's much safer for you to have a man's voice on the machine than yours. You've seen the Golden Gate barrel murders in the paper haven't you?"

"Yes, everyone's talking about the murders, but you can't just walk into my apartment and change my voice mail message."

"I'm sorry. I only want you to be safe."

"I understand. If you think there's something you want me to do to be safe, then talk to me about it, okay?"

"Yes, okay. I will."

I hang up the phone and change the message back to my voice. I know Ty cares for me. Changing my voice message without asking must be another of his idiosyncrasies.

I am home on one of my monthly trips so my girlfriends and I get together to play Ms. Packman in the bar at Spy Glass Inn. We are fiercely competitive Ms. Packman players. We play two at a time and each of us has two rolls of quarters, which should last a few hours. We start with me and Sara. Rachel will challenge whoever wins, two out of three games. The topic rolls around to sex.

"C'mon, how is Ty in bed?" Sara probes, her eyebrows raise in anticipation, her eyes glued to the Ms. Packman console.

"Ah. The sex. Ty has this little phrase he says all the time, 'sex is overrated'. At first I thought he was using it as sort of a reverse psychology to get women in bed to prove him wrong. When we moved from the 'just friends' stage to 'more than just friends' stage I realized he wasn't kidding. Sex with Ty is rather boring. "Prince Charming is not Casanova," I lament.

"Like boring how?" Sara's brow is furrowed still concentrating on the game.

"Like, he is so quiet."

"Maybe he belongs to a religious order that preaches silent sex? Like silent births in Scientology," Rachel teases me, flirtatiously swinging her beautiful waist length brown hair as a cute waiter brings us another round of drinks. "Is that why you keep Nick around?"

"Maybe he's a follower of Bhagwan Shree Rajneesh. They're up in San Francisco aren't they?" Sara offers. "Is it like having sex with a mime?" Sara does her best mime impression as she gets up from her chair and Rachel sits. I won the first round.

"I don't think the Rajneeshees practice silent sex. And no, I think a mime would be more interactive," I am barely able to get the words out, gasping with laughter. "And yes, if I could morph Nick and Ty into one person they would make the perfect man!"

White Russians and tears of hilarity flow more abundantly that night between me, Sara and Rachel, than Ty's Kir Royales in his Russian Hill penthouse.

"Sex isn't everything," I spontaneously announce sitting out a round I lost, relaxing in a lounge chair, legs crossed, cowboy boots on the table. Their roars and guffaws of laughter reverberate in my head. They playfully repeat my words over and over into the early hours of the morning over the Ms. Packman console.

But really, I have a dilemma. To my parents and everyone I know, Ty sounds like a catch. I think he is too. I begin to believe I can't have it all. I have a nagging question about why someone so worldly and wealthy is interested in me. When we go out to nightclubs, sophisticated women he knows sashay up to him, eyelashes aflutter. He has his pick of women if he wants. Ty makes me feel special, but he also makes me feel self-conscious. As if I'm not good enough as I am, but with his guidance, there is a new, improved me emerging, like Tide.

In July 1983 I decide to take Ty down to meet my parents. They have heard plenty about him on the phone and are anxious to meet him. We leave on a Saturday morning driving four hours straight south on Hwy 101. It is a pleasant drive. Ty is a charming companion even with his peculiarities. He sings off-key to songs on the radio, making up the words he doesn't know or skips them altogether, tries to be cool by moving clumsily to the beat of the music in his seat. It is out of character for him, but he is attempting to get his California groove on. He is wearing jeans, a short-sleeved shirt and running shoes – an effort to be more

casual that doesn't go unnoticed. Our first stop is the Santa Maria Hospital to see Dad.

I hate everything about hospitals, especially the smell.

"Hi, Dad!" I greet him in my cheeriest voice. I hide my dismay at the difference only one month has made since my last visit. I gently hug him aware of his fragility and kiss his sallow cheek. His skin is as thin as his hospital gown, his arm horribly bruised from the IV needle. I wonder how in the world they will remove the tape from around the IV without ripping his flesh. As age, and a disease progression that stumps his doctor, wreak havoc on his body, he is slowly shrinking.

"Hi, sweetheart," his voice is weak, hoarse and gravelly. He attempts to raise his free arm in a feeble half hug.

"Dad, this is Ty." I make introductions.

"Nice to meet you, sir." Ty carefully shakes Dad's brittle hand.

Sir, wow. That scored points. Dad smiles.

I sit on the edge of Dad's bed and Ty pulls up a chair close to us. Ty is kind and attentive to Dad as he complains about the hospital food.

"I'm thirsty, darling," Dad says in a wearied half-whisper.

Ty springs into action and gets him a cup of water. Then Ty excuses himself and goes downstairs to buy Dad some Lifesavers. It is a lovely gesture and Dad is clearly pleased. We visit for about an hour then we leave to see Mom.

"Let's stop and get your mom some flowers," Ty suggests.

Except for flowers on Mother's Day, poinsettias at Christmas and lilies at Easter, I don't think my mother remembers the last time someone gave her flowers. Ty enchants Mom with his undivided attention and she beams in his spotlight. Ty takes Mom and I out to dinner at The Black Angus, a restaurant usually reserved for special occasions. We spend the rest of the evening at home relaxing and making small talk. I am sleeping downstairs with Mom, Ty is banished to the upstairs guest room.

"I don't understand why we can't sleep in the same bed?" Ty seems agitated standing in front of the upstairs bathroom door, bath towel and toothbrush in hand.

"Mom and Dad are old-fashioned. I don't think it's a good idea to push their values right now." I kiss him goodnight and go back downstairs.

Mom and I lie in bed and giggle about Freddie the pet cricket Paul and I had at the ranch, way before we built the house. We would drive up on weekends and stay in the shack. Sure enough, there would be Freddie twittering at us from a hole in the wall. It went on for years, which would have meant he was the oldest living cricket in history. They didn't tell us we had probably gone through fifty Freddies as each one died and its hiding place was taken over by a new Freddie.

"You totally set me up for an exasperating argument with my third grade teacher, Sister Mary Margarita, about the longevity of crickets," I tease her.

I think Mom was happy back then. The days when Paul and I were toddlers and we would spend weekends at the shack – no electricity, bathing in the rubber blow-up swimming pool and lazing under the three fruitless mulberry trees. In the winter Dad would heat up water on the Coleman stove so we could bathe in a big metal tub inside the shack. Freddie the cricket was always chirping close by.

The next morning Ty gets up early, walks to the grocery store, shops and has a spread of French toast, real maple syrup, (sorry Mrs. Butterworth), scrambled eggs and sausage ready when Mom and I get up. There is nothing not to adore about this man, other than my irritation at being reminded of my deficiency of worldliness in contrast to his. I understand that it is technically true, but can we give it a break?

The phone rings during breakfast. The doctor says Dad can come home. We go with Mom to the hospital and get Dad checked out. Ty takes charge of getting him settled back into his room before we head north to San Francisco. I can tell my parents are smitten by Ty.

We stop in San Luis Obispo and I jump out to pump gas. Ty doesn't have a driver's license so I always drive, and he does not know how

to pump gas. Another odd, but not so odd, quirk when you put it in context. The gas station attendant is friendly and chatty.

"Do you go to school here?" I ask.

"Yes ma'am, Cal Poly."

"Ah, my Alma Mater. Where's that accent from?"

"From Oklahoma, born and raised."

"What are you studying?"

"I'm s'posed to be studyin' Agriculture, but I spend more time studyin' perty California girls!" He laughs and winks at me.

"Well, there are plenty here!" I smile at his southern boyish charm.

When I get back in the car Ty is quiet and sullen, in contrast to his upbeat attitude only minutes before. I drive for a couple miles. His silence is measured, begging to be cracked by a question.

"Are you alright? You seem quiet all of a sudden," I raise my eyebrows and look at him.

"Do you know that guy?" Ty's jaw is tight.

"Which guy?"

"The guy you were talking to at the gas station guy."

"No."

"Then why were you talking and laughing with him?"

"Because I was pumping gas and he was standing there."

"So you like him?"

"What makes you think that?"

"You were laughing."

"Oh, so now you're the laughter police?"

"You seemed to be having fun with him."

The arguing goes on for several miles, getting more heated, more ridiculous. Then silence. What Ty doesn't know is that I am the master of the silent treatment. My parents spent most of my childhood not speaking to each other. Just because I hated it didn't mean I didn't learn the art.

After an hour or so of ignoring each other Ty apologizes, becoming cheerful and animated again, like he flipped a light switch – our first argument.

I drop him off at his penthouse. He invites me up, but I am tired

and want to retreat to my little garden studio and see Kiesja. He opens the door, gets out, closes the door then hesitates. Standing on the curb he motions for me to roll down the window, grinning from ear to ear, he says he has a present for me. He reaches into his pocket and hands me a brass keychain engraved *I'm Taken.* Speechless, I take the key chain, thank him, say goodnight and drive home. When I get home Mom has already left a message on my answering machine. I call her back. She is gushing about Ty. She and Dad totally approve. Heavens to Betsy, it is probably the first time ever they agree on something.

I hang up the phone and look down at the key chain. I am not making the commitment to be in the exclusive relationship with Ty that he is pushing for. Committing exclusivity to Ty means giving up my passionate rendezvous with Nick. The way things are now I have the best of both worlds.

Kiesja jumps through the window I left open for her, leaps onto the bed loudly protesting my two-day absence, but quickly forgives me, purrs and zealously kneads my legs before curling comfortably in my lap.

I absently pet Kiesja. I am completely on the fence. I like Ty, but there are times when I am around him I feel as if I am suffocating. I should be more understanding, I argue with myself. *His family is half way around the world, English is not his first language and he is a foreigner. He had a difficult life as a poor Palestinian refugee in Jordan before he established himself as a photographer. He has been nothing but kind, taking me out to eat to restaurants I could never afford, buying me clothes and shoes I would have had to go into debt to buy. Ty is introducing me to a different way of living. Am I rejecting it for old habits and familiarity? Am I too fearful to venture into unknown territory holding onto my unworldly upbringing like a bat hanging onto a rafter in a storm? I left the California central coast and came to San Francisco for something better. Now, when a better option presents itself, I fight it. But he is just so pushy sometimes.*

Ty and I have little in common. I like going to the beach, hiking, camping, swimming, backpacking and horseback riding. He likes eating in fancy restaurants, shopping, traveling and photography.

I would love to travel if I could afford it. A city boy and a country girl – can it work? Ty is financially stable, mature and worldly. He treats me better than anyone I have ever known. He is everything I could ask for. At twenty-four maybe I should be getting my priorities straight instead of rolling in the sheets with Nick.

I glance over at the *Miss Manners* book on the floor that I have thumbed through several times. True, I do put my elbows on the table, hands flailing around when I talk like I am swatting flies. I do hold my fork in my right hand and knife in my left instead of the other way around. I had no idea what all those extra forks and spoons were for in fancy restaurants, and who knew they had to be used in a specific order? Why do you need a special knife to eat fish anyway? I put the keychain in a drawer.

Later that week I pick up Ty. He has *Every Breath You Take* by The Police playing on his sound system.

"Where's the key chain I gave you?" Ty asks when we get in the car, glancing at my keys dangling from the ignition.

"It's under consideration," I declare. Ty looks straight ahead, impatience scribbled on his face, but he doesn't say anything.

I am spending so much time with Ty this summer I barely have time for Emma or Nick. It seems every time I walk into Ty's apartment *Every Breath You Take* is playing. More dinners, more clothes, more shoes, more visits to see Mom and Dad. I relinquish my former fashion sense much to his liking and in return try to bring him into my world.

I take Ty horseback riding on the beach in Oceano. After ten minutes he gets off his horse.

"I don't like riding this horse, I'm going to take it back. I'll meet you at the stable," Ty announces.

"Alright, I'll see you soon." I shrug and keep going, happy to feel the cleansing ocean breeze on my face and enjoy the meditative silence of riding alone in the shallow ebb and flow of the sea. Another day I pack a picnic and we drive to Half Moon Bay for a day at the beach. Ty spends most of his time brushing sand off the blanket and complaining how much he hates sand. We pack up early and leave.

A couple of weekends I go alone to visit my girlfriend Shelly from college, to get some space. Her daughter Abby and her grandmother, who I adopted as my grandma, live up in Grass Valley. They live in the country in an old cabin in the woods. It is gloriously quiet and peaceful. A creek runs close by. We crisscross it by jumping from one boulder to the next, always falling in at some point, laughing hysterically. Shelly teasingly scolds me for convincing her five-year-old daughter, Abby, that there are whales and dolphins in the creek. At night we lay in the bed of Shelly's truck with Abby, cozy and warm in pillows and blankets.

"Abby, do you see those stars?"

Abby nods yes, delightfully squished in between Shelly and I like a little sardine.

"Each of those twinkling stars is the eye of an angel winking at you," I offer up as the absolute truth.

We sing *Twinkle, Twinkle Little Star* and tickle Abby until Grandma calls us to come in for warm cocoa with a little bit of something special she adds for Shelly and me. I would prefer to do this every night instead of drinking Kir Royales at Ty's penthouse.

In the morning Grandma gets up early and starts the wood-burning stove to heat the cabin, and has coffee ready for us when we wake. We spend a few hours riding Shelly's ATV along a forest trail breathing in the fresh mountain air. I head back to San Francisco feeling refreshed and rejuvenated.

I have begun flying down to Diablo Canyon for work meetings every couple of weeks, leaving early in the morning and returning late in the evening. After one of those days I arrive home and Ty has left a message on my answering machine to call him back as soon as possible. I call back, he answers. "Did you hear about Korean Air Lines Flight 007 being shot down by a Soviet rocket? All 269 passengers and crew have been killed." He is quite alarmed.

"No, I didn't," I respond. "I've been on either a company plane or at a nuclear power plant site all day."

"All you care about is your job and that damned cat!" Ty shouts, then hangs up on me.

What the hell? I call my mother crying and tell her what happened.

"Well, honey, you know, Ty is worldlier than you," she says gently.

"Great, thanks, Mom. Like that isn't a mantra playing in my head already."

"Don't worry, *kudka*. Ty's just having a bad day. We all have bad days, right?"

For a woman that spent my entire childhood lamenting about how bad her marriage is I find this an odd defense of Ty's behavior.

"Yes, Mom, we all have bad days, but I don't scream at people because they aren't up to the minute on current events. It's terrible that all those people died, though."

What I needed to hear from Mom was that Ty was being an asshole and had no right to speak to me like that then hang up on me. I call Sara.

"What an asshole!" is the first thing that comes out of Sara's mouth. She makes me feel much better. I shower and go to bed, happy the next day is Friday, and then Sara and Rachel are coming up for the long Labor Day weekend.

Ty is getting ready for a two-day photo exhibit in New York of over sixty of his photographs he has taken around the world. I know he will be busy getting ready for that, giving me time to hang out with my friends.

My phone rings at work.

"It's Ty. I'm really sorry for getting upset with you last night and hanging up. I'm under a lot of pressure with the exhibit in New York. I could really use your help getting the displays ready."

"Okay, apology accepted. I can help you on Monday after Sara and Rachel leave." When someone apologizes I am usually quick to forgive and forget.

"I can take you all out for dinner Saturday night if you want."

"That would be great! I'll check in with you tomorrow afternoon."

Sara and Rachel arrive mid Saturday afternoon. We chat and hang out in the back garden for a few hours until Ty takes us out to dinner at an Indian restaurant in Ghirardelli Square. He is happy and animated during dinner and invites us back to his penthouse for Kir Royales on the balcony. Sara and Rachel love the penthouse and declare they never want to leave. Around midnight I peel them off Ty's bed and pry their hands from their Kir Royale glasses. I know the whole Kir Royales in the penthouse is Ty's signature social affair but it gets old, he's hogging my friend space and I feel cranky. I want to go back to my garden studio with my friends and sleep.

We are going to Golden Gate Park the next morning for roller-skating, after making breakfast burritos in the apartment. It is a glorious Sunday, alive with other skaters, joggers, parents with kids and couples sunbathing.

After roller skating we hang out on 24th street in Noe Valley, window shopping, drinking fruity cocktails with little umbrellas and being silly. We spend the evening back in my studio, continuing our frivolity and fruity libations in the back garden until it gets late, the neighbors shush us and we move inside.

"So, what's up with you and Ty?" Sara asks flopping down on my bed next to me.

"What do you mean?"

"He seems like a great guy, so sophisticated. Do you love him?"

"I think I do. Not in a sparks are flying everywhere kind of way, but in a comfortable couple kind of way."

"Like you've been married forever already kind of way?" Rachel chimes in perusing the books in my bookshelf.

"I've never had a relationship like this before. The guys I date where there's a strong physical attraction are either jerks, or sweet and not really going anywhere – like Nick. The guys where there isn't a strong physical attraction have just been friends. Ty is like that, but we are intimate."

"So, sex hasn't improved?" Sara adjusts a pillow under her head and looks at me with her face scrunched up as if she is in pain.

"Well, it's like, 'Can I buy a vowel?' "

"You're kidding right?" Rachel turns away from the bookshelf and looks at me like I just proclaimed I am a space alien love child at my *Wheel of Fortune* reference.

"No, I'm not kidding. One day I teasingly said something like, 'Wow, if someone were listening they would think I was in here by myself,' and Ty said, 'Only women make noise in bed'. "

"Do you think it's like a cultural thing?" Sara yawns.

"I don't know. It's different, but not creepy or anything, just so damn quiet."

"Wow. I guess you can, like, put Barry White on or something?" Rachel suggests quite seriously.

"Barry White?" Sara and I burst out in harmony and start giggling. It's late and we have drunk too much, so we call it a night and go to sleep.

The next morning we roll our slightly hung-over selves out of bed and meander down to the corner café in hoodies, sweat pants and flip flops, no makeup, hair a mess. We get coffee and pastries, and walk across the street to sit and eat on the church steps in the crisp morning air.

We look homeless. Ty would be aghast. Afterwards we wander inside St. Paul's and bask in the breathtaking English gothic style structure, and vibrant prisms of colored light casting through the magnificent stained glass windows. We light candles, each of us lost in our own thoughts. I love having such a beautiful sanctuary right across the street, especially the awe-inspiring solitude when the 1400 seats are empty.

Sara and Rachel pack while lamenting the trip was too short. They leave and I head over to spend the rest of the day with Ty, bent over a light table organizing slides for enlargements and writing captions. Ty is a gifted photographer with the ability to capture raw human emotion.

"What do you want this one to say?" I point to a black and white slide of an impoverished young girl, eyes wide, dirty and barefoot, standing next to railroad tracks with an old American flag hanging on a pole way in the background.

Ty considers the photo for a moment.

"What do you think?"

"She looks like all hope is lost. How about, *A Child's Lost Hope In America's Heartland?*"

"Good."

I click the words out on the typewriter.

It is the first time I realize how bad Ty's English is. He has decent grasp of spoken English, but he can't spell. I am happy to help him and we stay up half the night working so Ty can get the order to the photo lab to be enlarged, printed and mounted in time for him to take them to New York.

The following day Ty surprises me with an airline ticket to New York to come and see the exhibition. I hug him and jump up and down. I have never been to New York before.

I get a few days off work and fly to New York, meeting with Ty who had flown the previous weekend. The exhibition is a success for him, thousands of visitors attend. Afterwards he is worn out from two days of non-stop talking and standing, but he is determined to show me around the city.

We spend the weekend visiting his friends, take a romantic horse drawn carriage ride through Central Park and experience the culinary combination of oysters and vodka at Tavern on the Green. My experience with the oysters is that I don't like them. I don't understand Ty's enthusiasm over eating slimy food. After a wonderful weekend I fly back to San Francisco and Ty stays behind for business.

When he gets back from the trip I begin teaching him how to drive so he can get his driver's license. I assumed he knew how to drive a car, but needed help with the rules of the road. Not so much.

"Your right foot goes on the pedal on the far right when you want to go. When you want to stop, you take your right foot off the gas pedal and push on the brake pedal."

We practice that for a while with the engine off.

"Now, the last pedal on the left is the clutch. You need to push on the clutch when you change gears. To start the car your left foot needs to hold the clutch down, and your right foot needs to be on the brake."

"I don't understand why your car has to have a cluck." Ty is baffled.

"It's not 'cluck' it's a clutch. A cluck is the sound a chicken makes." I start laughing. Ty looks at me incredulously, but starts laughing too.

People in a relationship should not try to teach each other how to drive. After one month, one clutch, one set of brakes, and an almost nervous breakdown (mine), he gets his license.

Ty and I are at my apartment. I take the key chain he gave me months before and put my keys on it, signaling I am ready to commit to an exclusive relationship with him. He is really happy, hugs me, we exchange I love yous and apartment keys.

We drive to Mom and Dad's for Christmas. My half-brother Norm and his wife Dot come up with their daughter Ellen, and Karen brings her boyfriend Randal, who no one really likes, but we are all polite to him for Karen's sake. Paul joins us on Christmas Eve and Christmas Day. We help Mom cook. Dad spends most of Christmas in bed or in his recliner, the painfully slow deterioration continues. Then it is back to San Francisco.

On New Year's Eve Ty surprises me with a stunning black fur coat. I should have known that once I compromised my values by working for a company producing nuclear power I was on the slippery slope to fur ownership. I am against torturing monkeys in lab experiments, but morally flexible on the wearing of fur. What's a girl to do? Ty knows I hate being cold. How thoughtful he is to buy me such a snuggly warm coat.

We go out to dinner with Tommy, and his date Cynthia, at Top of The Mark on the 19th floor of the Intercontinental Mark Hopkins Hotel for an exquisite meal and up to Ty's penthouse, once again toasting Kir Royales to ring in the New Year – 1984.

HARVESTING STONES

CHAPTER 5
Holy Moly

My birthday is coming up and Ty proposes he host my 25th birthday party at his penthouse. It is the perfect party venue. I invite Emma for the Saturday night before my birthday.

"What should I wear?" Emma muses out loud, as she merrily twirls in her office chair.

"Something chic and sexy," I advise in my deepest trying-to-be-sexy voice.

"Like John Travolta?"

"Sure. He'll do."

"You need to invite Salvador and Tina," Emma scoots her chair over to me and whispers with an impish smile. "But not Kelly!"

Salvador and Tina are our bosses. Reading Emma's face I know she wants to up our office ante. Not inviting Kelly, the department secretary and office snob extraordinaire, is strategic politics. She knows everyone will be talking about the party on Monday and Kelly will feel left out. Payback for numerous wrongs Kelly has done to Emma no doubt.

I decide to wear my black fur coat, the little black dress I wore to L'Escargot and black stiletto heels – my birthday, my way.

Dom Pérignon champagne flows, helium filled black and pink balloons with silver streamers fill the room, catered hors d'oeuvres are served on silver trays and a chocolate mousse cake from Shubert's bakery tops off the festivities. Ty is the perfect engaging host to my friends, work colleagues and bosses who 'ooh' and 'ahhh' and tell me how lucky I am, shouting so I can hear over the music and laughter.

It is a fabulous party. Ty attends to every little detail and is drained by the time it ends at three in the morning.

As anticipated, the party is the office buzz on Monday morning – our bosses are our new best friends. Kelly is beside herself with envy. Emma is smug. Mission accomplished.

A couple of weeks later when I walk into Ty's apartment he is packing, cardboard boxes everywhere and two suitcases open, partially filled, on the floor.

"Are you moving?" I ask him, completely surprised.

"Yes, I'm going to New York then to Dubai for work."

"Was it a sudden decision?" I don't know what else to say.

"No, I've known for a while, but I didn't know how to tell you."

"Okay. Well. I don't know what to say." I feel tears welling up in my eyes.

Ty walks over and hugs me.

"We'll see each other again. Let's see how it goes." Ty is reassuring, but I think he does not want to tell me it is over so he is leaving things open-ended.

Ty is gone within days. I miss him and I feel sad. I finally make the decision to be in an exclusive relationship with Ty then he leaves. Along with the sense of loss there is also a sense of liberation for me – being in a relationship with Ty is all consuming. Now I have some breathing room. I no longer need his endorsement for what I am going to wear. I can go to the store without makeup if I want. Where did I put those cowboy boots?

Even though Ty is gone, he calls multiple times a day from New York leaving messages at work and home if I don't answer the phone.

Emma and I resume our sweatshirt and jeans weekly outings in the neighborhood. I can't afford to patronize the restaurants and nightclubs where Ty took me.

"So, are you going to start seeing other guys again?" Emma inquires over a burger and a beer. "Are you going to call Nick?"

"I haven't seen Nick since last summer. Relationships take a lot of time and energy... I think I'll fly solo for a while."

"I know Steve would still be interested," Emma reminds me of a good friend of hers I met when I first came to the city.

"No, I'm good. I'm going to go up and see Shelly, Abby and Grandma in Grass Valley this weekend. Clear my head." I sip my beer.

"Well, I have a new beau," Emma singsongs.

"Tell me more! Who is he and where did you meet him? I want all the details!"

The rest of the evening I listen to Emma gush about her new boyfriend.

A few weeks go by. I am getting into the rhythm of being single and find I enjoy having more time for myself. I decide to put my time and energy into finishing my senior project and get my bachelor's degree. I still speak to Ty almost every day down from a few times a day – the natural waning away of a relationship.

I am working on a Saturday to finish an urgent project. By the time I get off work, grab some groceries and get home it is late afternoon. I swear I can smell Christian Dior's *Eau Savage*, the cologne Ty wears, as I walk down the long corridor leading to my garden studio.

Wow, talk about an intense olfactory flashback.

When I enter my studio, Ty does a 'ta da' body motion, jumping out from behind the door, scaring the bejesus out of me.

"I can't stand to be away from you!" he announces through his tears, and embraces me in a big bear hug.

My bed is gone, replaced by his. I am stunned. Ty releases me and I sit down on his bed.

"Where's my bed?" I ask.

"It's in storage."

"Oh. Storage. You have had a busy day." I am trying to process what just happened.

"What's wrong? On the phone you said you loved me and missed me! Why aren't you happy to see me?"

"It's not that I'm not happy to see you. I think I'm in shock. You scared the hell out of me!"

"I want us to live together. I gave up everything to be with you!"

"Live together? We never talked about that, Ty."

"I know! I wanted it to be a surprise!" Ty is exuberant, almost jumping for joy.

"Well, it certainly is a surprise," I exclaim, not knowing what else to say

He has arranged a picnic on the floor with champagne, my favorite brie with baguettes, grapes and strawberries. Candles are lit and strategically arranged for optimal romantic impact. I feel my garden studio, my only private, personal space in the whole world, has been ambushed. I smile and excuse myself to use the bathroom. I go inside, close the door and stare into the mirror hoping my reflection is going to tell me what I should do next.

I HAD told him over the phone that I loved him and missed him, but in that 'you're in New York then Dubai and I'm living in San Francisco, opposite shores, opposite ends of the world' kind of way, not an 'I can't live without you, come back and let's live together' kind of way. I flush the toilet to buy time. Holy moly. I splash my face with water. I look back at my reflection.

"Some help you are!" Get a grip Paula. Breathe. Breathe. Breathe.

I come out of the bathroom with the most cheery smile I can conjure after Ty's unexpected occupation of my studio. Maybe this is how they do things in the Middle East, but in the USA we don't walk in and occupy someone else's space. I must have done or said something to make him think this takeover is okay. He is smiling from ear to ear, offering presents he has bought for me in New York.

After a glass of champagne my attention is fading in and out of his excited chitchat of living together.

"What are you going to do all day when I'm at work?" I ask.

"I'm going to start doing some photography jobs."

"Great idea! You'll get bored sitting around here all day." What a relief. I am hoping he has a plan.

I have never asked Ty about his finances. Except for the exhibit

in New York I don't think he has worked since I met him. Mom had told me, after our visit to see my parents, that Ty told Dad he was independently wealthy and was going to retire by the time he was forty. He always carries large amounts of cash with him and the way he spends money, this could be true.

"I'll take the MUNI to work and you can use my car," I offer.

I don't mind. Yes, that will be fine. Everything will be fine – or not. Truthfully, I feel living together should have been something we discussed and decided together, a mutual decision.

"Guess who surprised me by moving himself into my apartment Saturday, saying he can't live without me?" I quiz Emma.

"Ty? Really? Oh my goodness. How romantic!" She places her hands on her heart and gazes up dreamily.

"Romantic? I feel like Palestine."

"Oh, come on. You know he's totally in love with you. You love him too, right?"

"Yes, I do."

"Then what's the problem?"

"I don't know Emma. He made a decision which has a huge impact on my life and I wasn't part of it. Something like that."

"But doesn't love conquer all?" Emma is in la-la land.

"Yes, in fairy tales."

"You're one rebellious young lady, you know that? You either need to tell him to go, because you're upset it wasn't a mutual decision, or be happy he's there and accept it as a deeply romantic move on his part. You can't live with him and then be upset he's there, you'll drive yourself crazy," Emma offers her wisdom.

"Okay grasshopper, so I should ask him to move out? Then we can sit and talk about it, and then he can move back in?" I offer as a solution.

"Will that make you happier?"

"Yes, it would." I am defiant.

"But it would be the same result!" Emma is talking with her hands waving around in the air, irritated with me.

"The same result but a different process. My father made decisions for my mother all her life and she had no say in

anything. I saw what it did to her. I feel like Ty's done the same thing to me." I am nearly in tears.

"But you're *not* your mother, and Ty is not your father. Ty did this out of love, right? Did your father control your mother out of love?"

"Who the hell knows, Emma? I just don't want to be controlled!" I realize I am raising my voice and Kelly is pretending not to hear our conversation.

"Ah, so now we get to the real reason you're upset!" Emma declares as if she's solved an important cold case murder. "Look, childhood stuff affects us all. But try not to let it interfere with the present."

When I get home from work Ty has dinner ready for me. The studio is cleaned, laundry is done. *Okay, I could get used to this.* Maybe Emma is right. I make an effort to believe Ty's behavior is deeply romantic and not an intentional violation of my personal right to determine my own destiny.

Ty turns my dining area into an office for us to share. He helps me finish my senior project and I get my bachelor's degree. He is getting photography jobs, keeps busy and gives me money for rent and utilities. He is attentive and sweet. He doesn't play the 'I'm a worldly photographer and you're just a California farm girl' card which had been a major point of annoyance for me. I keep my hair the way he likes, wear the clothes he bought me and eat with my fork in my left hand, knife in my right. Even the cat seems to be warming to him. Two months pass in harmony. Life with Ty is great.

In April, over another enjoyable dinner Ty makes for me, he mentions, as he has a few times before, that he came into the USA on a special visa given to people with exceptional qualifications, which allowed him to work in the USA. This time though, there is an additional bit of information – the visa is expiring.

"What does that mean?" I ask.

"It means I'm going to have to leave if I don't find another way to stay here."

"So you need another sponsor?"

"I tried but it didn't work. The only way for me to stay is for us to get married."

"Is that a proposal?" I joke.

"Well, no, it will just be on paper so I can stay here. We carry on being together and see if we want it to work out. We won't tell anyone."

"So we'll be married on paper, but we won't tell anyone we're married?"

"Yes. Think of it as a way for us to see if we want to stay together and get married."

"And what happens if we don't get married?"

"Then I have to leave."

"Where will you go?"

"To Dubai."

"Back to your original plan?"

"I'd have no choice. I have nowhere else to go."

"I'd feel guilty getting married and not telling Mom and Dad."

"Don't think of it like that. If we *do* decide to get married for real then we'll have a wedding, and everyone will know. For now it will just be a way for us to stay together. You know I love you and I love living in San Francisco. I want us to build our lives together here in the States."

It is easy to consider such a proposal with the version of Ty I have been living with since his return from New York. We have reached a comfortable equilibrium. What he proposes is an all or nothing deal. If I say no, he will leave and I will probably never see him again. If I say yes, we can see whether our relationship will evolve or not. I wish there was something in between. His fate is in my hands. I don't want to be the bad guy, which is how I will feel if I say no.

I concede. Ty is elated.

And that was that. We have a secret civil marriage at the city hall in San Francisco in April, 1984.

Spring rolls into summer and summer rolls into fall. Ty taking pictures, me working my corporate job. Dad is getting worse and we spend more weekends driving down to Santa Maria. I see glimpses of moodiness in Ty sometimes, but the worst is on his birthday in October. I am leaving for work in the morning and Ty is still sleeping. I leave a note saying I will take him out to dinner that night. When I get home from work, the studio is dark, blinds closed, Ty is still in bed.

"Are you okay?" I ask

"I'm fine," a muffled voice comes from under the covers.

"Well, you don't seem fine. Have you been in bed all day?"

No answer. This is different. I walk over, open the blinds, then the windows and feel the cool air rush in.

"Okay. Rise and shine birthday boy!" I pull back the bed covers. Ty pulls the bed covers back up and covers his face.

"Have you been crying? Did something happen? What's wrong?" I sit on the edge of the bed stroking his head.

Ty has been crying. He has spoken to his mother and his sister. He misses them, poor thing. That is understandable. It must be hard to be so far away from family. He hasn't seen them for a long time. I finally convince him to get up, shower and dress so we can go out for his birthday. I am sure that will make him feel better.

Ty is clean but still forlorn as we head to the restaurant, barely speaking and looking like someone has died. I try to joke and change the mood but it isn't working. He doesn't even crack a smile.

He isn't wearing a dinner jacket and, unbeknownst to me, the restaurant where I made reservations requires a dinner jacket. The maître d' has a spare one for such occasions, but it is green and Ty refuses to wear it.

"Please wear the jacket Ty. I know this is one of your favorite restaurants."

"It doesn't match my pants."

"I don't think anyone will notice."

"You don't know who might see me in it."

"We can ask for a paper bag to put over your head and people will think you're the unknown comic."

"I don't think you're funny, and what is the 'unknown comic'?" Ty is super grumpy.

"Never mind. Seriously, nobody gives a shit what color your jacket is Ty." I am getting impatient.

Ty puts on the jacket making a face like he was asked to eat a can of worms. I try my best to be jovial, but overall it is a miserable night. He whines through dinner and dessert like a moody teenager. It is exhausting.

The next week is much the same. He stays in bed all day keeping the blinds down. My efforts to cheer him up are futile. He seems to prefer being cloaked in gloom. I make a deal with him that he can sleep all day if he wants, but he has to take a daily shower.

Mom is on the phone with me every evening giving me the latest updates on Dad. Mom can no longer take care of Dad by herself, and a nurse comes in a few days a week to give him a bath. The nurse told Mom that Dad knew he was not long for this world. His time is coming. I drive down by myself for the weekend, relieved to get away from Ty's brooding.

By the time I get back Ty has emerged from his slump. A few weeks later I take some time off work and drive down to Santa Maria to spend time with Dad. The day after Reagan wins the 1984 election on November 7th, I am hanging out with Dad in his room watching *The Flintstones*. We chat about what a great man Ronny is. Dad motions for me to sit on the bed next to him. He is weak and small. His thinning head of white hair matches his white bathrobe.

"Darling, I think Ty is a good man. I think you should marry him. We can have the ceremony and reception here at the condo community center. I know he loves you and can take care of you financially. I also know he's going to try to change you – you're strong willed and that's going to cause problems. But every relationship has problems, darling."

He has tears in his eyes, a father's heartfelt appeal to his youngest daughter to marry a suitable beau. I kiss Dad on the forehead and tell him I will talk to Ty about it. He closes his eyes and nods off back to sleep. I get up and sit back in the chair in the

corner of the room. Ty is a good man. He has certainly been great since we moved in together, except for the unusual doom and gloom on his birthday and the days following.

Dad seems to rally for the better and Mom says I can go back up to San Francisco. After a few days of being back I decide to broach the topic of the wedding.

"Dad wants us to get married at the condo community center," I reveal to Ty over breakfast one cold, rainy morning.

"My older sister, Mia, isn't married yet. I can't get married before her."

"Is that a cultural thing?"

"Mia is twenty-five. That's very old in our culture. She'll feel bad if I marry first."

"It would make Dad really happy. We don't have to tell your family. We could have a simple ceremony for Dad's sake. We *are* technically married already, so it doesn't matter."

"Okay, let's plan it with your mom and dad the next time we go down."

"Thank you!" I jump up from my chair and give Ty a celebratory hug.

Mom calls me at work three days later and says I need to come home – Dad is back in the hospital. I drive down after work without Ty. For several days I stay vigil by my father's side. I help him eat jello and soup. I change the television channels for him. Every once in a while he asks what time it is. He can't wear his watch because the strap will bruise his fragile skin. I fasten the brown leather strap around the cold metal arm of the hospital bed, so he can see what the time is if I am not there. On the morning of November 19th he takes a turn for the worse. He fades in and out of consciousness, his alertness controlled by the strength of the morphine drip. The doctor calls us into the hall in the afternoon and tells Mom, Paul and me it is only a matter of a few hours. I don't believe him. I have heard of doctors saying people only have a short time to live, and they live for years or months after.

I go back in and sit, protectively holding my father's emaciated hand. Ty is flying down and will be in around seven that evening.

Just after five o'clock, Dad opens his eyes, asks me what time it is, sits up in bed and says he wants to go for a walk. See. The nurse rushes in and tells Dad he needs to stay in bed. He tells the nurse he is fine, strengthening my resolve that the doctor doesn't know what he is talking about.

Dad doses off, waking half an hour later. He opens his eyes and smiles at me. I smile back. Suddenly his eyes roll back into his head and he goes into a full body seizure, his brittle frame shaking violently. I am scared and don't know what to do. A nurse runs in and restrains him. I am sobbing uncontrollably. Paul is hugging me, my face buried in his chest. Mom watches as if she has detached herself from the whole heart-wrenching scene.

When the seizure stops another nurse brings in leather hospital restraints.

"We need to keep him from hurting himself if he has another seizure." Her voice is gentle and kind. In response to the look of horror I must have had on my face she says, "They have soft cotton on the inside, they won't hurt him."

I compose myself and drive to the airport to pick up Ty. Dad is still sleeping when we get back. I sit next to him and hold his hand. He is snoring, but it is a strange gurgling sound. I guess he is getting some good, deep sleep. When he wakes up I am hoping we can take that walk he wants. The snoring stops and there is silence. I wait.

Mom gently puts her hand on top of my hand.

"Honey, it's over."

"No, no, no, no, no... he's sleeping. See, he's still breathing." Tears are streaming down my face, I stroke his hand. "I think he's still breathing, Mom look..."

Mom takes her hand off mine and starts to remove Dad's watch from the hospital bed rail.

"No, Mom, please Mom, no, he'll want to know what time it is when he wakes up," I beg, weeping, on the verge of hysteria.

Mom takes her hand off the watch, sighs and asks me to look at her.

"Sweetheart, he waited for you to get back from the airport,

but now he's gone." Mom is doing her best to help me understand.

I weep, still holding Dad's hand in mine, my other hand stokes his lifeless face. Whispering to him through my tears and denial, "Please, please, please wake up please. I'm not ready for you to go."

Ty and Paul stay by my side, patiently waiting, watching the agony of my inability to accept Dad has passed.

The emotional pain searing through me is unbearable. I am devastated. Dad's snoring was a death rattle and I can't get the awful sound out of my head. No matter how hard I try I cannot stop crying. I can't eat. I feel physically sick. I overhear Mom telling Karen she is worried about me. She has lost her husband. I am sure she is also mourning in her own way. Paul is holding it together. I can't seem to do the same. Ty hovers around me like a mother hen. I know he wants to ease my pain, but there is really nothing he can do.

The viewing of Dad's body is the night before his funeral. I am mercifully exhausted and dazed. The mortician has parted Dad's hair down the middle as if he has an upcoming gig with a Barbershop quartet. I am mortified.

"Mom, we need to ask the mortician to change Dad's hair and make the parting on the side like he wore it."

"It doesn't matter. It's fine the way it is – Dad won't care."

"But I do, Mom. He doesn't look like Dad."

"It's okay the way it is, *kudka*." Mom doesn't want to deal with anything more than she has to.

I don't think she understands that I need his hair to be the way he wore it. I'm too depleted to argue. No one else seems to care so I don't push any further.

Mom is letting Ty and me sleep in the master bedroom at the condo.

"I can't believe Dad's hair is like that, Ty. I don't know why Mom won't ask them to change it." I am lying in bed curled up crying. Ty climbs in behind me, hugs me and strokes my hair until I fall asleep.

The next morning, I wake up and can't find Paul or Ty.

"Morning, Mom." Mom is sitting in the living room on the sofa in her bathrobe and slippers, sipping Nescafé. I kiss her on the cheek. "How did you sleep?"

"Okay. You?"

"Okay. Do you know where Paul and Ty went?"

"No, I just got up too and they were gone."

I am in the kitchen making real coffee. Paul and Ty walk into the condo through the garage door carrying a blow-dryer. Weird.

"Good morning. What's the blow-dryer for?" I quiz them as Ty comes up behind me and gives me a big hug.

"We went to the funeral home with a comb and a blow-dryer and Ty fixed Dad's hair." Paul offers in explanation.

"That's the nicest thing anyone has ever done for me, Ty!" Tears fill my eyes. I wonder for a second why he didn't ask the mortician to do it, but it is done. That was all that matters.

The funeral is mostly a blur except for a dozen old men in red hats I have never seen before and my mother's choice of widow wear.

"Who are those old men in red hats, Mom?"

"Freemasons."

"Like brick layers?"

"No, your father was a Freemason?"

"What the hell is a Freemason?"

"Don't swear at your father's funeral dear."

Mom, for some reason, thinks it is the modern thing to do to for a widow to wear a flowery red, yellow and orange pantsuit to her husband's funeral. I tell her that everyone else is probably going to wear something a little darker on the color spectrum. She dismisses me. Another time and another place I would have suggested she borrow one of the Freemasons' red hats to complete her ensemble.

Back at home an abundance of casseroles, which seem to appear out of nowhere, flood the dining room table. Ty takes over as host making sure everyone is served. Word spreads about Ty redoing Dad's hair for me and he is the star of the show. Everyone tells me what a lovely gesture that was, what a wonderful man,

what a catch Ty is – Prince Charming himself, like a fairy tale. Except for Sara who whispers to me, "Wow. Isn't that kind of creepy? Why didn't he have the mortician do it?" I can always count on Sara to say exactly what she thinks.

Ty and I drive back up to San Francisco on the Saturday after the funeral. He tries to convince me to stay in Carmel for a night. I feel so weak all I want to do is get back to my little garden studio and hibernate until I have to go back to work on Monday. He tries to change my mind but I lose it, screaming and crying that I want to go home. The rest of the car ride home we are both silent.

I go back to work and my boss tells me to take it easy and if I need to take more time off, or work shorter days, he understands. I don't. I keep working normal hours, but I don't have energy for anything else.

A few weeks later Ty takes me to see a one-bedroom apartment his friend Tommy has for rent in Russian Hill on Vallejo. Because it is for sale Tommy is willing to rent it to us cheap, month to month, until it is sold. The bedroom alone is bigger than my studio. The kitchen is much better and it has a huge living and dining area. It has its own parking and beautiful hardwood floors. It is upstairs. There is no yard so Kiesja has to become an indoor cat. I give my notice at the studio.

We spend our first Christmas without Dad. Only Ty, me, Mom, Paul and Karen. It is quiet but pleasant, Ty ever attentive to my mother's needs.

Just after the New Year, at the beginning of 1985, we move into the new apartment. It is nice to have my own parking spot, but I miss my garden space. I miss Dad.

Ty and I cook a lot together now we have a larger kitchen. We sit down to eat after making a big pan of chicken parmesan.

"I'm not getting enough work in San Francisco to make a living," Ty is leading to something I can tell.

"We seem to be doing fine financially."

"I don't want 'fine' for us. I want to be able to make some real money. For that I need to go to Dubai. I can make more in a week

there than we both make in a month here. If I go for six months, I can come back and we can buy a house."

"That's a big incentive."

"If I leave next month, March, then I can meet you in Europe in June. We can spend some time in London and Paris. Then I'll go back to Dubai for another few months. I'll be back to San Francisco by the fall."

We agree it is a great plan. I'm happy we are making decisions together.

Ty leaves to live with his brother, Victor, and his British wife, Marie, in Lincoln, England, until his work visa comes through for the UAE.

I am still struggling with the loss of my father. Now Ty has left, I feel very alone. My relationships with most of my friends have drifted away since I have been living with Ty.

Mom and her cousin Gertie come up to stay with me for a couple of weeks. I see Mom in a way I have never seen her before. She and Gertie revert back to the mischievous teenage schoolgirls they must have been, forgetting they are sixty-six-year-old women.

One afternoon after work I come home and make dinner. I wait for Mom and Gertie to get home from shopping. They are over an hour late. They don't know how to drive a manual car so I gave them directions for the bus. I am pacing, getting more worried by the minute. Watching the street from the living room window, a blue, late model, four-door sedan pulls up in front of the apartment building, the doors open, and out slide Mom and Gertie. They stand on the sidewalk and wave goodbye before gleefully coming up the stairs into the apartment, loaded with shopping bags from Macy's.

"Who was that in the car?" I demand.

"We got lost and this nice man gave us a ride," Mom acts as if it's no big deal.

"OH. MY. GOD! You got in a car with a strange man? What are you two thinking? He could have killed you and dumped your bodies in Golden Gate Park!" I am shouting at them.

"He was nice. Anyway we're here aren't we?" Gertie dismisses me.

"What am I going to do with you two?" I sigh heavily, leaning against the kitchen wall, left hand melodramatically on my forehead, right hand grasping a kitchen towel against my heart, feigning exasperation. "What have I done to deserve this?"

We laugh out loud at my imitation of Mom during my 'rebellious teenage years'.

"Seriously though, don't take rides from strangers anymore," I scold.

As I watch Mom lying on the floor after dinner, her feet up on the sofa, bare toes with red painted toe nails wiggling, laughing and playful, I wish I had known this version of her growing up. Carefree, happy, full of life – in front of my eyes time has rolled back to the years before her life became complicated, full of the responsibilities of husbands, children and lost dreams. My father's death has set her free.

I can see her in my mind's eye in 1945, at twenty-six years old, my age, wearing one of her stylish suits, a hat, high-heeled shoes and stockings, a gloved hand holding that foot-long cigarette holder, painted red lips and smoky brown eye liner, a whirl of cigarette smoke and Lavin's *Arpège* wafting through the air. WWII had ended and she is heading to Hollywood, California, filled with hope and wonder. At that moment I realize we are the same – each of us searching, in our own way, for something more.

CHAPTER 6
Makin' Mama Proud

I ARRANGE TWO WEEKS OFF FROM WORK IN JUNE TO MEET TY AND his sister, Mia, in London. Then we will head to Paris. It is my first trip outside the USA besides Canada. I am so excited.

"Emma, I'm going to Europe!" I do a little happy dance at lunch. I switched jobs in the department so I don't work next to Emma anymore, but we are down the hall from each other and always have lunch.

"Can you tuck me in your suitcase please?" she purrs.

"We're going to Paris! *C'est une ville très jolie!*" I repeat Ty's words from our first date at Caffé Sport.

"Can you bring me back a French guy? Or a baguette? I don't care, anything French."

I splurge on a new suitcase. I take a shuttle to the San Francisco airport and board the red-eye to Heathrow. Ty meets me and we take a Hackney cab to the Kensington Close Hotel where Mia is waiting for us. Mia is gorgeous with olive skin, smooth, shoulder length brown hair, exotic deep brown eyes, flawless makeup, cultured mannerisms and superb etiquette. Despite having also flown in that morning, her clothes are impeccable. I am disheveled, all traces of makeup gone, my hair in disarray. I am wearing jeans, boots and a t-shirt with big lips on the front. A lightbulb goes off over my head. I am not the sophisticated creature his sister is. Is this what Ty is trying to mold me into?

The day I arrive London is unseasonably warm and sunny. Deprived of sun for so long, Londoners shed their shirts revealing

skin so white they glow with brightness – a funny sight for a California girl. We stroll through Kensington Gardens then down Kensington High Street to do some shopping. Ty says he has to buy me 'suitable' clothing in London before introducing me to his friends in Paris, the Habibi family. Ty's 'I'm worldly, you're not' aggravating-as-hell vibe resurfaces after a long hiatus.

"I don't like it when you pick out clothes for me that *I* don't like."

"We're seeing some very important people in Paris. You *must* have the right image."

"Your attitude makes me feel as if you're putting pearls on a pig!"

"You're a beautiful woman. You just don't know what clothes will give you the best image."

"You're dressing me like I'm forty years old!" I can feel the uprising inside me.

"You're impossible sometimes. This is how the world works. It's all about image. How about I choose an outfit for you and you choose something you like. Okay?"

Ah, a compromise. I pick out a long sleeve, chunky-knit, scoop back sweater, tight black leather pants and tall black leather boots with a one inch heel. He chooses a matronly knee length sawtooth skirt, long sleeve pink cashmere sweater with dainty little pearl buttons. As his arrogance melts away so does my annoyance.

Afterwards we drop our shopping bags off at the hotel and head by cab to Covent Garden. We discover Gordon's Wine Bar, a small, charming subterranean wine cellar that smells brilliantly of old oak barrels and wine, and feels like a medieval dungeon. We huddle together at a small round wooden table bathed in candlelight, and feast on pâté and brie and sip Gordon's Old Tawny Port. Sometimes Mia and Ty argue, or what sounds like arguing to me, in Arabic. Then Mia waves her hand at Ty dismissively, turns to me, smiles and chats.

The following day we take a tourist bus to Stonehenge and Bath. I am mesmerized by Stonehenge. Ty can't understand

what the big deal is about a bunch of big rocks. The following day, we leave London and head up to Lincoln by train from Kings Cross Station. We stay with Ty's brother Victor, his wife Marie – a true English beauty – and their son Daniel, at the quaint bed and breakfast they own. Lincoln Cathedral, Lincoln Castle, the Bailgate and Steep Hill are all picture perfect. I feel as if we stepped back in time into a scene from a Charles Dickens novel, except for the cars. I adore Lincoln and Marie. Victor is pleasant but a bit uppity, impeccably dressed at all times – like Ty when I first met him.

After a few days of exploring Lincoln and Nottingham, we head back to London. We go to Harrods, which to me is exceedingly ostentatious, before we fly to Paris. Ty's friends, the Habibis, have a luxurious apartment close to Quai d'Orsay which runs along the River Seine. Their son, Basil, is a good friend of Ty's so we have our own personal tourist guide. We stay in a small bed and breakfast close to Basil's flat and spend a week shopping at Galeries Lafayette and Printemps. We sit outside Le Fouquet drinking coffee or wine, depending on the time of day, and in the evenings dine on *steak béarnaise* and *pommes frites*. I am eating, drinking and shopping my way through Paris. I make a note to improve my French beyond asking the time and finding the women's bathroom.

Basil drives us to the Palais de Versailles. Afterwards we gorge on more brie, pâté and baguettes with yet more wine, sitting outside under an arbor of grapevines at a French farmhouse restaurant in the countryside. The entire trip is brilliant except for Basil and Ty smoking Cuban cigars everywhere we go, including inside the car. Mia and I are nauseous in the back seat.

In my private thoughts I romanticize about living alone in a small studio in Montmartre, overlooking the rooftops of Paris, barely surviving as a poor American writer, forced to learn French to eke out a living. All this money stuff is enjoyable no doubt, but in my opinion it hardly builds character or nurtures creativity.

Two days before I am due to fly back to San Francisco we are still in Paris.

"Why don't you stay longer?" Ty asks.

"I can't. I have to go back to work."

"Don't worry about your work. Call in and quit. I'm working in Dubai doing photography and making good money. I know you're bored with your corporate job and want to do something different, now's your chance. Call them and tell them you're not coming back. We'll spend another week in Paris and London, than Mia and I'll fly back with you to San Francisco. Let's go down and visit your mom. Take some time off. Decide what you really want to do. I know how hard it's been for you with your dad dying. Take some time for yourself. I want to do that for you."

My sense of responsibility collides with the allure of Ty's proposition.

"But my boss James will be so let down. I have six people who work for me and I'll be letting them down too. Maybe I should call and tell them I need more time off?"

"Why would you do that? Now's your chance to change your life. I told you before, if you have a business idea, the money will be there to support it. Answer one question for me. If money wasn't an issue, would you still be working there?"

"No, I wouldn't. I don't want to be a corporate android."

We talk late into the night. The phone call to James the next morning is the hardest phone call I ever make. He asks me not to quit. Just take as much time as I want. I tell him no, I have made my decision. I hang up the phone feeling both free and terrified.

Ty is in a great mood for the rest of the trip in a 'cat that caught the canary' kind of way. *What's he so self-satisfied about?* Maybe I am mistaking his smugness for his happiness for the new chapter in my life. We all fly back together to San Francisco. I go to my old office to pick up my stuff.

"I'm sorry to lose you, Paula," James says, calling me into his office. "But to tell you the truth, I wish I could do the same thing sometimes," he confesses.

Emma wants all the nitty-gritty details. One of the young women who work for me, Magda, is crying. My good gay friend, Robert, is beside himself. I brought the men silk ties and the

women French toiletries from Paris, redeeming myself from traitor status.

Ty and I spend a week showing Mia around San Francisco then drive down to Santa Maria to see Mom. When Mom and I have some time alone, she expresses concern about me quitting my job.

"What are you going to do now, sweetheart?"

"Take some time off and decide what I want to do next. I have a bachelor's degree, four years of managing commercial real estate and three years as a supervisor with a corporation. I want to find something else to do, something more creative."

"Well, you know you can always come home and live with me."

"You know you love visiting me in San Francisco, Mom. You and Gertie can come up and have more adventures." The last place I wanted to live was back on the central coast of California.

There's something she isn't saying.

"Okay, Mom, what is it you're not saying?"

"I don't want you to lose your independence and be dependent on Ty."

"Really? You and Dad have always thought Ty's the cat's pajamas. In the two years since you met him all you've said is how wonderful he is."

"I know. He seems to be. But sometimes I feel there's something not quite right. Are you ever afraid of him?"

"Afraid? No. Annoyed? Yes. He gets moody sometimes. Like, look at me, I'm all dark and broody and mysterious." I wiggle my fingers in the air and make my voice low. Mom laughs. "But he snaps out of it pretty quick. His 'I know better than you' scenario gets old. But most of the time he's good. Most of the time. After two years I'm sure I've seen the worst."

"Good. If you've seen the worst in someone and can still accept and love them, then that's good."

The next evening we go out to dinner with Mia, Mom, Paul and Karen to the Santa Maria Inn. Just before dessert, Ty gets down on one knee, pulls a beautiful diamond engagement ring out of his pocket, and asks me to marry him. I am completely surprised. He takes my hand and slides the ring on my finger before I have

a chance to say anything. I am sure I would have said yes, but it would have been nice to have said it first. But I guess it doesn't matter. We are technically already married.

Dessert turns into a mini engagement party. The ring is beautiful. A diamond Ty says he personally selected while on an assignment in Antwerp, then had it set in Dubai.

The next day we drive back up to San Francisco via Carmel. Ty and Mia continue to argue a lot in Arabic. At first I think it is my cultural misinterpretation, but they scream at each other, hands thrashing, and faces heated and red. I ask Ty about it and he acts as if he has no idea what I am talking about.

Ty and Mia fly back to Dubai a couple of weeks later. Ty again tells me to take my time, not to worry about working, and think about what I want to do. Because of the delay in getting a work visa for the UAE and our trip to Europe, he says he will be back by Christmas now instead of the fall. After three days on my own I am bored to tears.

I look in the *San Francisco Chronicle* and see a job opening for an Administrative Manager at an art gallery on Beach Street, between Ghirardelli Square and Pier 39. That looks fun. I call and speak to a woman named Jackie. She says she can interview me the next day, Thursday. Jackie is the director of the art gallery, a stunning woman of around forty, an Elizabeth Taylor look-alike, but with reddish brown hair. She is so beautiful I keep staring at her hoping I look that good when I am forty.

We have an immediate connection.

"I'm looking for someone to run the administrative side of the gallery and to stand in as director when I travel, about half of my time."

"I believe I can be that person for you, Jackie," I am confident in my abilities.

It isn't as much money as I had been making at the corporate job but I love the gallery, the paintings and sculptures.

"Although you wouldn't be a sales person, sometimes you might be called to the floor for sales if we're busy, so you'd need to learn the artists' profiles. You'll get commission on any sales

you make, too. But you might want to split your commission on a rotating basis with the sales staff to keep the peace. The sales people can get very territorial!" Jackie playfully rolls her eyes.

Jackie says she will check my references and get back to me. She calls and offers me the job the same afternoon and asks if I can start Monday. I am ecstatic. I am like Jenny Summers in *Beverley Hills Cop*. My wardrobe acquired via Ty is about to be put to good use. I call Mom and tell her. She is excited for me, relieved I have regained my financial independence and wants to know all the details.

When Ty calls me the next morning I tell him the good news. The phone goes quiet on the other end.

"I thought you were going to take some time off?"

"I did. I haven't worked in six weeks. You left and I was bored after three days. Aren't you happy for me?"

"American women are too damn independent." I can hear the irritation in his voice.

"Damn straight we're independent!" My American farm girl pride is glowing, makin' Mama proud.

"We agreed you wouldn't work." Ty is cross.

"No, we did not agree I wouldn't work. You told me to take some time off to think about what I want to do. I thought about it for three days, saw a job at the art gallery, interviewed for it, and got the job. And that is what I want to do now, work at the art gallery."

He makes some excuse about having to go to a meeting and hangs up.

I begin my new adventure and love, love, love it. Most of the employees are charming gay men. They bring me up to speed on all the gossip, who to trust, who not to trust. It is fabulous.

Ty doesn't say another negative word. He asks how I like my new job, all cheerful and whatnot.

About a week after I start working at the gallery Tommy knocks on my door and says he has sold the apartment and I will need to move out as soon as possible. Well, that's sudden.

I find a studio up the hill from the gallery, which means I can

walk to work. I have some savings for move-in costs, but not enough. Ty says he is waiting to be paid for several photography shoots and is short on cash. I call Mom and she gives me some money out of the trust Dad left.

"Remember I mentioned Ty told your father he was independently wealthy and would retire by forty? It seems strange he doesn't have money to help you move."

"Do you think Dad misunderstood?"

"No... I think that was one of the reasons your father wanted you to marry Ty. He wanted to make sure you were taken care of financially."

"Well, Ty says he's waiting on payments for photography shoots right now."

The new studio is half a block down the street from Ty's old penthouse. It is bigger than my studio in Noe Valley, but without the back garden. Kiesja and I move in with the help of my new friends from the gallery.

I settle into my new abode and my new job, enjoying the August weather. This autumn in San Francisco is the best time I have had living in the city. My friends at the art gallery are a fun loving group. We go out on Friday and Saturday nights to gay bars and dance – Ty would be horrified. We roller skate in Golden Gate Park on Sunday afternoons, or take day trips to the beach or the wine country. I am taking on more and more responsibility at the gallery. Jackie is asked to be director of the New Orleans gallery. I know she is going to recommend me to be the director of the San Francisco gallery to the owners in New York.

Ty and I speak on the phone every few days. He loves the affluent Dubai society. I feel I have to play down how happy I am in San Francisco. I send him cards and letters telling him how much I miss him, and I do, but I keep him at arm's length from my San Francisco life. I don't have anything to hide, I am not doing anything wrong or immoral. My new friends, Jackie, a gay couple Bill and Santana, a straight couple, Leslie and Dan, the guys in shipping, and a couple of ladies on the sales floor, probably would not pass Ty's scrutiny.

My little studio gets broken into after Halloween. The thieves take Ty's stereo and scare Kiesja – she runs way up a tree across the street. I call the police and the fire department. They come out and use their tall ladder to retrieve her and bring her down to me. My heroes. When I tell Ty he is upset, saying the city is not safe for me on my own.

"Why don't you move to England?" Ty suggests.

Yes, of course I want to move to England. Yes, of course I want to stay in San Francisco and be director of the art gallery.

"What will I be doing in England while you're in Dubai?"

"I've been doing photography jobs and now I'm producing brochures for companies. Everything's being printed and produced in London. I need you in London to liaise with the printers and photo labs."

"Well, that sounds interesting."

"I can rent us a flat in Lincoln around the corner from Victor and Marie. You would live in Lincoln, but could take the train down to Kings Cross in London to work a couple of days a week. I'd be coming to England at least once a month, so we would see each other more often."

"I love Lincoln, but you said Dubai is a temporary situation for you to make money and that you'll be back here by the end of the year."

"I know. The business is growing, but it's taking longer than I thought. The money's good, but I have to spend a lot of money taking clients out to dinner to secure the jobs. I only need to work in Dubai for another year, and then we'll go back and live in San Francisco. Meantime I think it would be nice for us to live closer together. Having experience working overseas will make you more valuable when we go back to the States too."

"I think Jackie is going to make me director of the art gallery and she's going to move to New Orleans. This is a big opportunity for me here."

"Look at what just happened at the apartment!" Ty is irritated. "What if you had been home? You could have been hurt or raped. I don't want you living alone there. Besides, we can make a lot

more money working together with you in England and me in Dubai. Then save enough to go back to San Francisco and buy a house."

"I really need to think about this. I'll call you tomorrow."

I call Sara and ask her what she would do.

"I would definitely move to England if I had the chance! Why not? If you don't like it, come home."

"I love my job at the gallery and I would love to live in England! I want to do both!"

She starts singing *West End Girls* by the Pet Shop Boys.

"You can acquire a sexy British accent, Robin Hood and *tally ho* and all that. You should go!"

I put down the phone. I love Lincoln. I could sit in a little English cottage and write on the days I am not working with Ty. It is somewhere between my living as a poor American writer fantasy in Paris and living the opulent Dubai lifestyle Ty values so much. The more I think about living in England for a year, the more San Francisco fades into the background. I can take the train and the ferry to Paris.

The next morning I call Mom and tell her about Ty's offer. She isn't happy.

"That's so far away! When will I see you?"

"Mom, you can come stay with us anytime. Let us get settled and come in the spring when the weather's better. You and Gertie can both come. Can you take Kiesja?"

"Yes, of course I can take Kiesja."

I give notice to Jackie and she is not happy because she has to start over and find someone else to run the gallery, but she understands what an exciting opportunity moving to England is for me. I sell all of my stuff, my car, futon, everything. Mom and Karen come up and get Kiesja.

Like a whirlwind I move to Jolly Old England the first week of December 1985.

CHAPTER 7
Autopilot

TY RENTED A FLAT WITH A SMALL LIVING ROOM AND A 'CAN'T SWING a cat in it' kitchen downstairs, a steep stairway leading upstairs to two small bedrooms and one bathroom with a claw foot bathtub. It is furnished with the basic necessities. A door from the kitchen leads into a small antique shop on the Bailgate, which the sherry-soaked mother of our landlady owns. The landlady – also sherry-soaked – and her young daughter live in the flat next door. We share a quaint English country garden backyard. To get to our flat we enter through a door off the Bailgate and walk down a narrow brick-arching passageway leading into the back garden.

Down the picturesque Bailgate are a wine shop, gourmet food shop, butcher, baker, post office and a variety of other cafés and bars, leading down to a cobblestone square and Steep Hill, also lined with quaint shops, restaurants and bars. Lincoln Castle and Lincoln Cathedral are a stone's throw away. Victor and Marie live around the corner.

My first Christmas in Lincoln is excellent. Like stepping back to the 19th century with snow and the smell of roasted chestnuts wafting through the Bailgate, it is lovely. Ty is relaxed and happy.

Life in Lincoln is easy. I speak to Mom every Sunday morning. Ty spends about half of his time in Dubai and half in England. I am the only American living along the Bailgate, so am known by the locals. On snowy, winter Sunday afternoons, Ty and I watch old black and white movies, eat Stilton and drink port. When Ty is gone I feel a little like Rapunzel. I have very little social

interaction except with Victor and Marie. The British people I work with, for the color separation and printing, are outside of Lincoln. Every Saturday the Bailgate is full of people, but it is so quiet. If that many Americans were on one street at the same time it would be a noisy block party.

We have a driver, William, an older, heavyset, balding man with a thick British accent and a comb-over, who loves his beer and betting on the horses. He drives me to the places I need to go if I can't get there by train, or if I am in a hurry.

I buy a book on French at WH Smith. I put the French word stickers, included in the book, on everything in the flat and walk around repeating the words out loud in French. I find a gym and work out a couple of days a week. I am starting to write but somehow, knowing the language and not depending upon my writing for sustenance, it has lost its romanticism.

Ty calls from London one April afternoon and says he is on his way up to Lincoln on the train. He walks into the flat, happy and chatty. He asks if we have anything to eat and goes to the kitchen.

"Why isn't there any bread?"

"I didn't buy any."

"I called and told you I was coming up. Why didn't you go shopping?"

"Let's go shopping now." *Wow, cranky are we?*

Ty's temperament shifts like a tectonic plate.

"You can't even fucking buy bread for me. What the fuck is wrong with you?" He is screaming. I have seen Ty irritated and annoyed before, but he has never screamed or sworn at me like this.

I grab my handbag, take out my little phone book and credit card, and start dialing.

"Who the fuck are you calling?" he demands.

"British Airways, then my mother. If you think I'm going to stand here and listen to you scream at me and hurl insults you're wrong!'

"British Airways. How can I help you?"

"Reservations please." Ty is still standing in the kitchen staring

at me. My blood is boiling. How dare he speak to me like that! "Yes, I'd like to book a ticket from London to San Francisco please."

In my head I am thinking, *What's wrong asshole, cat got your tongue?*

Ty suddenly becomes calm, collected and polite.

"Can we talk for a minute? Please put down the phone." He is looking at me like a puppy with his tail between his legs.

I stare back at him for a moment with daggers in my eyes, making good and sure he gets my drift, before I tell the reservations lady I will call back.

I hang up the phone. Ty walks over to the couch, sits down and starts sobbing.

"I'm so sorry. I'm just so tired and jetlagged and hungry. Can we forget the whole thing?"

I can barely make out what he is saying, he is crying so hard. Jetlagged with only a three-hour time difference? I am taken aback. I have never seen a grown man cry like this before. He gets up, hugs me and takes his suitcase upstairs. I hear his footsteps walk into the bathroom and I hear the shower turn on.

I sit back on the couch and stare through the window into the English garden. The flowers are struggling to bloom in the sporadic spring sunshine. Is this what Mom felt when she said there was something not quite right? When she asked if I had ever been afraid of Ty? I don't know if I was afraid or startled, but I know I am not going to put up with anything like this. I guess I hadn't seen the worst because this is the worst. The question in my head – *Is this the worst? Or is this the worst so far?*

Ty stays ten days. He is back to normal, no mood swings, no angry outbursts, just loving and kind and attentive. We spend several days in London. Then William takes us up north to meet with color separators and printers.

Our routine from spring and into summer is Ty working in Dubai and me in England. Ty lets me know once again, that we will have to extend our time overseas for another six months to a year. I don't mind. Marie has a beautiful daughter in July, Mara.

I enjoy being a new aunt. I can sense Mom's loneliness in her voice. Paul and Kiesja are living with her and she sees Karen once a week or so and has a couple of friends she goes shopping with. She announces she wants a facelift instead of coming to England, but promises she will visit me in England the following spring.

I fly home in August to visit and to take Mom to get a facelift. One of the women I had befriended at the art gallery is a nurse, whose husband is a renowned plastic surgeon in Marin. We drive up for her initial appointment.

"I went to see a psychic," Mom declares randomly.

"What did they say?

"It was a woman psychic. She said I'll be going on a long trip."

"Well, I guess that means you're going to come visit me in England."

"I don't know. I don't think I'm going to live much longer, darling."

"Really? Then why are you getting a facelift?"

She laughs.

"She also told me that one of my children is a genius."

"That must be Karen."

"No, I think it's you."

"Are you telling each of us that?"

She laughs again. I like to make Mom laugh.

We go to see Dr. Lawrence, the plastic surgeon, first. He speaks with Mom and she explains what she wants and he explains the procedure. He says Mom will need a full physical and release from a medical doctor before he can proceed. He refers us to Dr. Spiro in San Francisco, who can see Mom the next day.

We get a hotel in San Francisco for the night and go to Roses for prime rib.

"I wish you hadn't moved to England."

"Well, once you get done with this facelift business, you can come stay with me for a few months."

"I just miss you."

"I miss you too, Mom. We can go up to Scotland like Dad talked about. Or anywhere else you want to go."

Mom seems happier to have something to look forward to. The next day I take her to see Dr. Spiro.

After Mom's examination, Dr. Spiro asks if he can speak to me privately.

"Your Mom has a small heart and the facelift is going to put a strain on her body. I've told her that, and she still wants to go through with it. I just want to let you know. I'm sure she'll be fine, but she'll need a longer recovery period than most sixty-seven-year-olds that have this procedure done."

Back in the car I question Mom's determination to get the facelift, but she is adamant.

We drive back to Santa Maria. Dr. Lawrence books Mom's facelift for the following week. I think to give her time to make sure she wants to go through with it.

The next week we are back at the hospital in Marin. A young, good-looking doctor walks by.

"He's good-looking. You could marry a good-looking doctor like him."

"I'm engaged to Ty. Maybe he would be good for Karen. A little young for her though."

"I was thinking for me if he were a bit older!" Mom smiles with a twinkle in her eyes.

"Mom, how much younger do you think this facelift is going to make you look?"

Mom goes into surgery. I wait several hours. I am shocked when I go into the recovery room. She looks like someone in one of those late night 'ambulance chaser' insurance commercials, wrapped up like a mummy.

"Hey, Mom, love the new look!"

Regret and tears fill her eyes.

"Sorry, Mom. Not funny."

I take her to the hotel. Karen comes up to stay with Mom and drive her back home because I am flying back to London.

Mom and I resume our Sunday chats and review her plans to come to England in the spring, once her face is completely healed. She tells me she would have never gone through the surgery if

she had known how painful it was going to be. But she is happy with the results.

Paul calls me the first week of December and says Gertie had come downstairs the day before and found Mom on the couch, unconscious and blue. She called the ambulance. Mom is fine, but it seems her heart slowly stopped beating.

I call the hospital and speak to Mom. She sounds weak.

"I don't know why Gertie woke me up. I was feeling so peaceful."

"Mom, you were dying!"

"We all die, darling."

"Not before you come to England in the spring. How are you feeling now?"

"I feel fine. They're letting me go home today."

I wasn't planning on going home for Christmas as Mom is coming to spend the spring with me in England. On December 9th Rebecca calls and says Mom had a stroke, is in the hospital, and I better come home.

I hang up the phone and call Ty. I tell him I have to go home, Mom had a stroke. We have been using my credit card for Ty's tickets back and forth from Dubai to London, and there's not enough credit on it to buy a ticket home. I need him to make a reservation for me to go home.

"You know we're in the middle of producing a brochure?"

"Rebecca said I need to go home urgently."

"You can't leave right now."

"MOM HAD A STROKE!" I am screaming at him thinking maybe he didn't understand.

"I'll deliver the brochures on Saturday, fly to London on Sunday, and we'll fly to see Mom, together, on Monday. Okay?"

"That's almost a week from today Ty! Rebecca said to come home as soon as possible."

I hang up the phone. Mom has money in the trust for me, but I can hardly ask her for it now. Call Paul? He is in Hawaii thinking everything is fine. He won't be back until Thursday. I have no way to call him. I know Rebecca doesn't have money.

On the morning of Friday, December 12th Rebecca calls and says Mom is worse. I ask her how bad. She says Mom may not make it through the day.

I am infuriated at Ty for not letting me go earlier in the week. I am angry at myself for allowing Ty to control such a major decision in my life. I am angry at God, screaming that he has taken my father away from me and now he is taking my mother only two years later. My entire being aches. I spend the day in bed sobbing until I feel as if I can't breathe.

By nightfall I am shattered. I sit on the bed by the phone. Waiting for it to ring but praying it won't. Begging and pleading with God to buy some time.

In the midst of my anguish, a sensation of warmth and peace flows through my body as soft as a gentle ocean wave. My tears stop. A mother's last hug, a tender goodbye and I know she is passing, she is passing through me – the eternal connection between mother and child.

"Goodbye, Mom," I whisper. "I love you." When the phone rings ten minutes later I already know. I cry all night and all day Saturday.

Ty arrives the morning of Sunday, December 14th, with tickets in his hand for early morning Monday. I have already packed my bag and arranged for William to take us to Heathrow the following morning. I keep sobbing, telling Ty, "You should have let me go!"

I should have ignored Ty and asked Rebecca for money and paid her back. Ty says he is sorry, that he was wrong, he should have let me go. His apology doesn't matter to me. He wants to hug me, to console me, but I don't want his comfort. I pull away. He is hurt and I don't care.

William picks us up at four in the morning and drives us down to London Heathrow. I usually don't mind the long transcontinental flight, but this time it feels like days. We arrive in Los Angeles and a friend of my sister, Eva, picks us up. We arrive at the funeral home in Santa Maria in the evening. The walk towards my dead mother is torture. My knees buckle.

I collapse in tears against the casket, sobbing, caressing her face-lifted face. I am wailing, "Mom, why didn't you wait for me? Why didn't you wait?"

The room starts spinning and caving in at the same time. I feel I am in one of those bad dreams where I am falling and desperately trying to wake up before I hit the ground. But I just keep falling. I grasp onto the side of the coffin to support my weight. When I finally turn around, more relatives and friends have silently gathered, watching, their eyes filled with tears. I had been oblivious to their presence.

Another funeral means another chance for Ty to step up and take over and be the perfect host at the post funeral gathering. More casseroles appear from nowhere. I don't care about anything anymore. I am on autopilot. Mom and Dad are dead – part of me feels dead, another part of me wishes I were dead. I am not sure which parts of me are still alive. I am not mad at Ty anymore. I am not anything.

Ty leaves the day after the funeral to go back to London. I spend a few numb days with Paul, Karen and Rebecca.

"I can't believe she's gone." Paul and I are sitting on the floor in front of the fire at Mom and Dad's condo.

"I know. Want to see something weird?" Paul asks me, as he pulls his watch out of his jeans pocket and shows it to me. The watch is stopped. "I left the hospital to run some errands. When I got back to the hospital Mom had died. I asked what time she passed and it was the same exact time my watch stopped."

I told Paul I had felt her passing. She had said goodbye to each of us in her own way.

Paul takes me to the airport on the morning of December 21st to a puddle jumper from Santa Maria to Los Angeles. I wave goodbye to Paul from the plane window and feel his aching solitude. Maybe I should have stayed longer.

I meet Ty in London for a day then we take the train up to Lincoln. Depressed, Christmas passes in a daze for me. We spend it quietly with Victor and Marie and their children. New Year's Eve 1986,

I drink so much all I remember is Ty giving me a ruby and diamond bracelet and some British bloke commenting that I am a typical American drunk on New Year's Eve. I have a mind to tell him to fuck off, but then decide I will only reinforce the stereotype.

Ty decides we should get married and have the wedding at Lincoln Cathedral, then he will get me a visa to join him in Dubai for a while. I don't care. Whatever he wants is fine. I hand him the reins to my life.

Ty's family springs into action making the wedding arrangements at Lincoln Cathedral and the reception at Victor's bed and breakfast. Mia and Ty's mother, Mama Wafa, fly over to help.

Mama Wafa is a robust, sturdy woman with grey hair which she dyes a soft brown. Ty looks a lot like her. I can tell she has had to work hard in her life. She speaks only a few words of English. She embraces me as if she has loved me all her life and I sink into the warmth of her bosom like a child.

I am Catholic and Ty is Greek Orthodox. In order to be married by a Greek Orthodox priest, I have to be baptized Greek Orthodox. One afternoon I find myself dressed in a knee length white night dress, commando, standing in the basement of a stone, and stone cold, Greek Orthodox Church in London in a metal tub of cold water. It is snowing outside and the church basement has no heat. The bearded old priest has run an extension cord to a small space heater. It crackles and sputters on and off next to an ancient marble column, but it is like trying to heat a football field with a match. Ty and Mama Wafa stand stoically close by. The old priest repeatedly pours cold water over me, mumbling in Greek. I am shaking uncontrollably, teeth chattering louder than the priest's invocation. When I start passing into the third stage of hypothermia, I consider this may really be a human sacrifice.

Fortunately, or not, the ritual ends before I lose consciousness. The priest offers me warm tea, but I can't lift my arms or open my hands. Ty holds the cup to my pale lips so I can sip the tea, while Mama Wafa peels the soaking wet dress off my body and briskly

rubs my frozen limbs with a towel to bring back some circulation in an attempt to avoid amputation. I doubt if we can save my baby toes. I am so miserable I don't care that I am butt naked in front of a bearded old priest and my future mother-in-law. Ty takes his coat off and puts it over me. Once I am thawed out he helps me get dressed.

Time for wedding dress shopping. Trying on wedding dresses with Ty and Mama Wafa is enjoyable, much more so than freezing my butt off in the church basement. Ty sits back and does not push his opinion on me. When I find the dress I want, he and Mama Wafa agree it is the best too. I feel a spark of emotion for the first time since my mom's death.

We take a late train back up to Lincoln and I am beat. The next few days are a flurry of activity. Paul, Karen and Ty's older brother, Ziad, arrive for the wedding.

The night before the wedding we have dinner together at the bed and breakfast. It is so nice to have Paul and Karen in Lincoln with me. Walking back to the apartment, Ty and I have a disagreement about something unimportant. Ty pushes me and I fall in the snow. He says he didn't mean to, apologizes and helps me up. I am suspicious it is not an accident – I don't feel he is being sincere, but it doesn't make sense. I meet his mother, his oldest brother and reunite with his sister, Mia. Why would he risk being a jerk the night before the wedding? I decide I am being over-sensitive. Maybe it is a coincidence that he tripped and one hand pushed me forward into the snow the exact moment I disagreed with him. Maybe.

With barely a month passing since my mom's death I am still depressed. Everything is happening so fast. The morning of the wedding Mia and I gulp small bottles of brandy from the mini-fridge, while she does my hair and makeup. I am not going to freeze in another cold church. The whole ceremony is in Greek and I have no idea what is going on. I am told to stand, walk around in a circle three times and it is over. Lincoln Cathedral could hold hundreds of people but there are only a dozen of us. The priest's chanting echoes eerily through the medieval walls.

Everything had been arranged for the reception. I start drinking champagne before I start eating, which is a mistake. I don't remember most of the night except for snippets here and there. Ty gives me a gorgeous eternity diamond ring. The next morning I have the worst hangover ever. Everyone gathers for brunch and I feel awful. It is the second time in a month I have been drunk, drowning my sorrows.

The following day Karen and I take the train down to London. We walk through Kensington Gardens and see Princess Diana in the back of a car. We give her the 'look there's Princess Diana' spastic American hand gesticulation. Di gives us a 'look there's Paula and Karen' royal wave. It is a magical moment. We go to see *Phantom of the Opera*, my first London musical.

After Paul and Karen leave England and return home, Ty and I go to Guernsey in the Channel Islands for a honeymoon, which isn't much of a honeymoon. Ty chooses Guernsey so he can set up offshore companies for business. He spends most of the two days we are there in meetings and I hang out at the hotel, bored, until Ty gets back. On the way back to London we are fogged in and Ty has a fit at the airport. He is complaining and moaning about the weather. I get so fed up of listening to him I go and sit a few chairs away. He gets snappy because I am not sitting with him.

"There's nothing we can do about the weather, we just have to wait."

"You're insulting me by not sitting next to me, I am your husband."

"Stop complaining and I will sit next to you."

"Sit next to me and I'll stop complaining."

Ty can argue to the point you wished you were a deaf mute. I go back and sit down next to him. He mutters something under his breath. I ask him to repeat it, but he refuses. He doesn't speak for the rest of the waiting time or during the flight. He slowly defrosts when we get back to London.

Ty goes back to Dubai and I stay in Lincoln, going back and forth to London for work. I take a weekend trip to Paris, alone, to get away. My French has improved a little and I feel more confident navigating my way around the city. When my visa is ready, I fly to Dubai on March 5th 1987.

Walking through immigration I am escorted into a small interrogation room with two metal folding chairs, one metal desk, and one bare lightbulb hanging from the middle of the ceiling, by two UAE Immigration agents speaking rapidly in Arabic, while they go through papers written in Arabic. My one semester of Colloquial Arabic class I had taken at Berkeley University doesn't help me understand anything they are saying. There is nothing on the beige walls except photos of two sheikh-looking fellows in plain black frames, and a variety of smudges and scrapes. No blood splatter or electrodes anywhere. That's reassuring. I wait about twenty minutes until one of the agents says "*Yella*," which I know means 'come on' or 'let's go' or something like that.

He hands me the papers and gestures towards customs, but it is more like going through security to enter the country. Instead of a wall leading out to the meeting area, Dubai has massive floor to ceiling windows. Hundreds of people watch arriving passengers go through customs. I feel like a zoo animal.

I finally make my way out of the enclosure and Ty, Mia and Mama Wafa all exuberantly hug me. I notice that Ty is animated and cheerful, but Mama Wafa and Mia are subdued. They are happy to see me, but not one word is exchanged between them and Ty all the way to the apartment. I arrive late at night so I do not see much of Dubai other than high-rises and lights.

The apartment Ty has rented is large. He gives me a tour. A nice entryway into an open living and dining area, already furnished with a couch and two matching armchairs, and a dining table that can seat eight. A picture window and sliding glass door runs the length of the two rooms, opening on to a large balcony overlooking an extensive parking lot and more high-rises, but with a partial view of the Deira Corniche and the water. The small kitchen seems out of proportion to the size of

the apartment. There is a laundry room, but no washer or dryer yet. Three bedrooms and two bathrooms – the master for us, one bedroom for Ty's office and the third bedroom already shared by Mia and Mama Wafa.

I keep the question in my head, *We're going to be living with your sister and mother?*

The thought has never occurred to me. I wasn't necessarily against it, I just had no idea. Ty could have mentioned it in passing, 'Oh, by the way, my sister and mother will be living with us when you come to Dubai'. Something like that would have been nice. I get the feeling they had not just moved into the apartment, but have all been living together for a while.

We sleep in the office in a foldout couch because the master bedroom only has a dresser. The bed and bedding are coming the following day.

At five in the morning a tone-deaf man singing '*allah ho akbar*' over a speaker jars me out of a deep sleep. I jump out of bed and look out the window – right below is a mosque. Ty laughs at my state of shock.

"Does that happen every morning this early?"

"Yes, and four more times during the day."

"It's so loud!"

"You'll get used to it."

"I need coffee."

Mama Wafa begins teaching me Arabic from the first moment I see her in the hallway.

"*Sabaah el kheer habibti.*" (Good morning my dear.)

"*Hada beejama.*" (This is a pajama.) Pointing to her pajamas.

"*Hada rasi.*" (This is my head.) Pointing to her head.

Mama Wafa is adorable and my instant surrogate mother, filling the heartrending void left by my own mother's unexpected death less than three months before.

Our first morning is spent discussing what we are going to cook and serve that evening. Ty's brothers and their families will be coming for dinner to meet me.

Ty spends the day with Mama Wafa, Mia and me in the kitchen.

It is barely big enough for the four of us at the same time, and we relocate the prep work to the dining room table. Mama Wafa continues her Arabic lessons, having me repeat every word for kitchen items – spoon, fork, bowl, cup, and so on, and food items – onion, garlic, tomato, meat and lentils. It is the best possible language immersion I can ask for.

A California girl through and through, I longingly gaze at the azure blue seawater of the Corniche. The sun shines down on our balcony and, after spending the spring in cloud covered England, I am dying to feel the heat of the sun on my skin and get a little color. I ask if I can put on my swimsuit and tan a little. Ty looks at me as if I have two heads.

"You can't sit on the balcony in a bikini here!"

"Why not?"

"It wouldn't be appropriate. You have to go to one of the hotel resorts to sit in the sun."

Clearly I had a lot to learn about living in Dubai. The day is pleasant. The chill the previous night between Ty and Mia and Mama Wafa has warmed. In the afternoon, while Ty and Mama Wafa nap, Mia and I sit on her bed and talk. Mama Wafa does not understand English and we speak freely while her mother snores only a few feet away.

Mia is a few months older than me. But at twenty-eight, in their culture, she is old for a woman – an old maid. Mia shares that she wants to have her own apartment, but the family will not allow it because only bad girls live alone. She feels suffocated having to live with her mother and hates that her brothers control her life. Mia pours her heart out, and we bond over the sorrows we have experienced in our relatively young lives.

Before I have been in Dubai twenty-four hours I am happy that Mia and Mama Wafa live with us – Mia needs me, I need Mama Wafa. Mama Wafa needs Mia. It is a triangle of need.

A feast is laid out that evening on the dining room table. *Mjedera*, *hummus*, *tabouli*, *mutubbal*, roasted lamb, *kitbee*, *fatayer*, and more. Ty's brothers, Ziad and Sameer, their wives, Madeline and Nadia, and children arrive. It is a joyous occasion and

everyone embraces me immediately as part of the family. The conversations around the table with Ty and his family are lively and good-humored.

For dessert, Ty goes down to a sweet shop and brings back *kanafe*, an Arabic sweet presented on the largest round pizza-sized plate I have ever seen. It is heaven. I have been to Lebanese restaurants in London, but this was like nothing I have ever tasted before.

After dessert Ty goes to his office, leaving me with the family who are only speaking in Arabic. I understand because Mama Wafa only speaks Arabic, and the eldest gets priority. I leave the room and wander back to the office and tell Ty I do not understand what anyone is saying. I am not complaining, only making a statement.

"If you don't like it here then you can leave," Ty looks up at me and says from his desk.

Just like that. No emotion. No support. No, *Oh honey it'll be okay, just give it time. Or, Don't worry, I can help you.*

I don't respond, just turn and walk back to the living room. Ty has thrown down the gauntlet. I will learn Arabic from Mia and Mama Wafa.

CHAPTER 8
Madeline's Tea Towel

Two days after arriving in Dubai I am walking back to the apartment after picking up a few things at a local grocery store. I walk slowly, relishing the heat of the sun on my face and arms. A small boy, maybe seven years old, runs up to me. He is wearing the traditional male dress in the UAE, a *dishdasha*.

"I fuck you, one dollar."

"Excuse me?" I think I must have misunderstood.

"I fuck you. One dollar."

"Do you even know what that means?"

He repeats himself, again. Each of us stand statue-still staring at each other, and then he runs off. Unbelievable. I take the elevator upstairs and tell Ty. He is sitting with Mama Wafa at the dining room table.

"A little boy just said to me, 'I fuck you, one dollar'."

"Blond women come to the UAE from Europe and the UK for vacations and have sex with the UAE national men, so now that's how blonde women are viewed."

"Lovely. Should I be worried?"

"No. But that's why you can't sit out on the balcony in your swimsuit. You don't want someone seeing you and following you."

That is a nice little tidbit of information to be aware of.

"I know I've only been here a couple of days, but I don't see any signs of crime in the newspaper."

"That's because of the Ministry of Information here. Nothing gets in the media without going through the Ministry. They

don't want to scare off tourists, so the newspapers usually aren't allowed to publish anything about crime."

"No freedom of the press?" I am puzzled.

"No."

"Toto, I've a feeling we're not in Kansas anymore."

"Who's Toto?"

"From *The Wizard of Oz*." I forget my American movie and television culture references are often lost on Ty.

My first month in Dubai I find myself gently emerging from the depression after my mother's death, thanks to Mama Wafa. I spend my days with her absorbing Arabic cooking techniques in the Arabic language. Ty works out of the home office and always seems to be doing something very, very important. He often leaves for meetings without saying anything and returns to the apartment without saying anything. As if we aren't there. Then other times he kisses me goodbye, and kisses me hello, also greeting Mama Wafa and Mia. I find this particularly strange, but observe that neither Mama Wafa nor Mia comment on it.

The other person I adore is Madeline, the wife of Ziad. She is a beautiful, full-figured woman with a sharp mind and quick wit. She speaks multiple languages and has a heart of gold. One afternoon Madeline and I are sitting in her kitchen alone. She grabs a brand new tea towel from a drawer.

"You see this tea towel, all bright and colorful and new?"

"Yes," I respond, wondering why she is showing me a new tea towel.

"Being married to a member of this family is like this," she is scrunching up her face and twisting the tea towel, as if it is full of water and her life depends on wringing it out. "He will twist you and twist you and twist you like this until there is nothing left. He will take everything from you and you'll have nothing, everything you are now, bright, happy, beautiful, will be gone. He will squeeze the life out of you and you will end up like this!" She grabs an old washed-out and threadbare tea towel from the kitchen counter and waves it in the air at me, her eyes wide. My jaw drops.

"He will suck the life out of you. You will see, *habipti*."

We hear the front door open. It is Ziad coming home. We resume our cheerful banter on other subjects, but her 'tea towel monologue' is seared in my synapses.

A few days later I am chatting with Ty as he is getting ready for a morning meeting.

"Nadia is having a coffee morning at her house tomorrow. You should go, meet some new people." Ty is standing in front of the mirror holding up different ties against his shirt.

"I like the red one," I comment, still sitting in bed. "Okay, I'll go. I'll call Nadia today and let her know."

"I have meetings all day. I won't be home for lunch." Ty walks over and kisses me on the forehead before he heads out the door. He is wearing the red tie.

For the coffee morning I decide to wear a simple top, a silk peach colored matching jacket and skirt, some taupe flats and gold earrings. It is ten in the morning and I feel overdressed. I didn't need to worry. The women arrive in full makeup and designer clothes – cocktail rings with emeralds the size of olives, cascading diamond necklaces on plunging necklines revealing ample cleavage, chandelier ruby earrings dangling under beautifully coiffed hair. It is the Academy Awards of coffee mornings. The coffee mornings I remember my mom having before we moved to the ranch, the women came over in hair curlers and sweatpants so they could exercise watching Jack Lalanne on the black and white television set.

One of the social stigmas here, I learn quickly, is that it is shameful for a wife to work. *What, he is not man enough to support his family?* And the wives are success barometers – the designer clothes and diamonds they wear reflect just how successful. Here image is everything.

At one point three women arrive covered in *burkas*, but instead of joining the group, they walk down the hall to one of the bedrooms. I am intrigued. Other women join and every so often I glance over towards the hall wondering what happened to the three women in *burkas*.

Were they having their own separate party?

After about twenty minutes I am about to burst with curiosity.

"Nadia, what happened to the three women in *burkas* who went down the hall?"

"They're sitting next to you, *habipti*. They wear the *burka* to come here, but they take it off in the bedroom. Then they come out with what they are wearing underneath," Nadia whispers to me, amused. She is a small, fragile woman with dark hair and eyes, very sweet and quieter than Madeline.

"Oh. Oh. Okay." It takes me a minute to process this new information.

I am in a room with about twenty wealthy women who don't work. They gossip about their husbands and the women who did not come to the coffee morning. In an Alcoholics Anonymous meeting format, one by one the women talk about how her husband leaves clothes on the floor, or how the housemaid has to clean up after him like a two-year-old, and one woman goes into detail about how her husband had diarrhea the night before. It is horrifying. Then they start on the women who aren't there.

"Can you believe what she was wearing by the pool at the club last week?"

"What was she thinking, and at her age?"

Then they get all giggly and self-satisfied, sip their tea or coffee, and daintily hold a cookie, biting into it without smudging their lipstick.

Someone shoot me now, please. I've got to get out of here.

"Nadia, thank you for inviting me, it was lovely. I wish I could stay longer, but I have some things to do for Ty." I turn to the gaggle of gossipers, "It was nice meeting you all."

They barely notice me leave, enmeshed in their scandalous chitchat. Nadia walks me to the door.

"The coffee mornings are weekly. If you join you'll have to be put into the rotation and host at your home too."

I walk home, straight to the doorway of Ty's home office.

"How was it?" Ty asks, without even looking up from his desk.

"Don't ever ask me to go to one of those again, please."

That got his attention. He looks up at me over the top of his reading glasses questioningly.

"Unless you want the wives of Dubai business men knowing your personal hygiene habits or whether you fart in bed, I don't have anything to talk to them about."

"That bad? Sorry. I thought you could make some new friends."

"You have no idea." And that was that, I was relieved from coffee morning obligations. One thing about Ty, he did not want anyone knowing his personal business.

The weather in Dubai in spring is beautiful, hot without the searing heat and humidity of the summer months. I go to one of the beach clubs with Mia a few times. Most of the women at the beach, including Mia, don't go into the water past their knees. They wear makeup, their hair is done and they change swimsuits several times throughout the day. They relax on chaise lounges under umbrellas and have the cabana boys bring drinks with smaller umbrellas, and chain smoke. My idea of going to the beach is *sans* makeup, one swimsuit, dive into the sea, swim for a good half hour for exercise, then flop down on the sand and let the sun bake through my body. Maybe do some abalone hunting, crabbing or fishing and knock down a cold Dos Equis beer with lime.

I adore Mia, but I don't fit in with her group of prissy friends.

The summer heat in Dubai, 110°F with a hundred percent humidity, melts the mascara off my eyelashes into my eyeballs. Foundation oozes down my face like night of the living dead. Wearing makeup is pointless. During the day, people dart between air-conditioned houses, air-conditioned cars and air-conditioned offices. I spend my first summer inside with Mama Wafa. Summer turns into fall as we settle into a daily routine. Mama Wafa and I shopping and cooking, while Mia and Ty work. Every Friday is a family gathering at one of the brother's houses, reminding me of the fun gatherings when I grew up.

I meet Ty's father for the first time when he comes for the holidays. I do not know why, but I don't feel the same immediate affection for him I felt for Mama Wafa. He is polite

but distant. In his defense, so am I. He is not going to become my surrogate father.

No one can cook a turkey like an American farm girl. It is my chance to show off what I learned from my mother for Christmas dinner. I prepare a feast – turkey with stuffing, gravy, candied yams, brussel sprouts with bacon, mashed potatoes, carrots with rosemary, and cranberry sauce. For dessert – chocolate fudge, apple pie and cheesecake. Ty's family has never had the American Christmas feast experience. They decide I should be the official Christmas dinner chef for eternity.

New Year's Eve I am sitting with Mia in her room. She is dressing up to go out with her friends.

"Where do you think you're going?" Ty's father's voice booming in Arabic startles us.

"It's New Year's Eve, I'm going out with my friends," Mia is surprised.

"No, you will stay home with your family," Ty's father announces.

Mia objects, and I object in solidarity, but it is useless. Her father will not budge. Mia sits on her bed and sobs for the next hour. I hand her tissues one by one until the box is empty. She swears to me she will marry the next man she meets just to get away from her father and brothers. She says she will never accept a man who treats her the way her father treated her mother.

"What do you mean? How did he treat her?"

"It doesn't matter. Forget I said anything."

"No, tell me please, I want to know."

"I can't."

Mia spends New Year's Eve locked in her room. I split my time between comforting her and participating in the New Year's Eve feast. The family has a tradition of playing games and giving away silly wrapped prizes, like a potato or bar of soap, to the winners. We laugh so hard we are all in tears. Except for Mia, and I feel bad for her.

In the spring of 1988 Ty comes to me with a request.

"The business is going well, but we're having some cash flow problems. Do you think you can call Norm and ask for some money from your trust?"

"The money Mom and Dad left me is supposed to be kept for me in savings. I don't know if Norm will agree."

"I'll pay it back. We only need it temporarily. Many clients owe us money."

I call my brother Norm and he agrees to wire me $10,000.

Shortly afterwards Ty has to go on a business trip to Europe. His travel to Europe is limited because he has to travel on the Jordanian Travel Document for Palestinian Refugees. He has to apply for visas to travel months in advance and all I have to do is walk in with my American passport. Ty wants an American passport to solve his travel problems. We need to move to the States for that, but it seems the date for moving back home keeps getting pushed further and further into the future.

We fly to Geneva, Switzerland. Ty surprises me with a diamond and ruby necklace, earrings, bracelet and ring at the Noga Hotel in Geneva, before an important dinner meeting with two clients and their wives.

It is hard to accept such an expensive gift when Ty has borrowed a large amount of money from me.

"These are beautiful, but how can you afford something like this?"

"You know how it works. We're meeting some very important people tonight and you have to have the right image." He is gently pushing back my hair and putting the earrings in my ears. *I know he needs me to wear expensive jewelry to demonstrate his success, but did I just buy my own jewels?*

The two couples we meet for dinner are multi-millionaires judging from the quantity of diamonds and precious gems adorning the ears, necks, wrists and fingers of the wives.

Since moving to Dubai Ty has become more of an enigma. He is kind and affectionate, sitting down and being chatty and engaged. An hour later a simple conversation is a battle of wills.

He acts like a spoiled child at times.

One afternoon he goes into the kitchen and opens the refrigerator door.

"Mama!" he shouts.

Mama Wafa gets up from her chair in the living room and makes a beeline for the kitchen. In Arabic Ty starts screaming at his mother because she has covered food with aluminum foil and he cannot see what it is. He is throwing containers from the refrigerator onto the floor of the kitchen. Mama Wafa gets down on her hands and knees and starts picking up the containers and food that has splattered everywhere, tears streaming down her face, saying in Arabic,

"It's okay, Ty. It's okay."

I stand in the doorway in disbelief.

"How can you treat your mother like this?" I shriek at Ty in English. In Arabic I ask Mama Wafa to get up off the floor and I help her to her feet. Mia comes in, sees what is happening and starts screaming at Ty in Arabic. Mama Wafa is crying. Mia and I are screaming at Ty. It is a mess. Ten minutes later, Mia, Ty and Mama Wafa are all sitting in the dining room laughing and chatting as if nothing happened. *What the hell?*

The dynamics of this family are most unusual. They are able to conjure up drama from thin air.

I wake up in agonizing pain one morning and go to see my French gynecologist, Dr. Cerise. She diagnoses me with salpingitis, an infection in the fallopian tubes. She prescribes antibiotics and painkillers.

"Dees will knock you out for about one week, zen you will be fine, no?"

I go home, take the meds and indeed they knock me out. I wake up one afternoon. Ty and Mama Wafa are standing at the foot of the bed staring at me, both are crying. I mean really crying, tears running down their face.

"*Sho? Am tahcky ma knoury? Enna mish am mout.*" (What? Did you call a priest? I'm not dying.)

The most ridiculous and juvenile performances are from Ty

- Mia gets a short, sassy haircut that looks great on her, but Ty doesn't like it. He goes around the house clucking and flapping his arms like a chicken for days until Mia is in tears with frustration.

Another time Ty gets into an argument with the doorman because the doorman refuses to pick up our garbage from the front of the apartment. He tells Ty we have to take it down ourselves. Ty accumulates a week's worth of garbage in bags, piles them into the elevator then presses all the buttons sending the rotting rubbish on a trip to all floors of the building.

Then there is the Arabic bread incident, which I think deserves its own special place in history. Mama Wafa put a few loaves of Arabic bread in the freezer. Ty pulls them out of the freezer, throws them in the trash and shouts that he doesn't like bread that has been frozen. Mama Wafa starts crying, extracts the frozen bread from the trash, puts them in a plastic bag, and walks over to Ziad's apartment. An emergency family summit immediately convenes in our living room. Everyone is screaming at each other in Arabic much too fast for me to understand. Mama Wafa stops putting Arabic bread in the freezer and walks down to the store every morning to get fresh bread.

I find out I am pregnant and we tell Mama Wafa and Mia, but ask them not to tell anyone, which translates as 'tell everyone' it seems. When I tell Mama Wafa a few weeks later that I miscarried she cries and hugs me, telling me in Arabic it's okay, it happens.

Mia, as vowed on the previous New Year's Eve, removes herself from the family and the drama by indeed marrying the next man she meets. She is engaged in November 1988 and the wedding is January 1989. Mia moves out and Mama Wafa goes back to Amman within weeks. I feel a big loss with Mama Wafa gone, even though living with her and Mia can be overwhelming sometimes.

I am pregnant with twins. I don't say anything to Mama Wafa, waiting to see if I get through the first trimester. I don't. When I miscarry the twins in the spring I am shocked by Ty's reaction.

"Face it – you'll never be able to have children."

"I don't think that's the case. I can get pregnant, only I can't seem to get through the first trimester."

"No, forget it. You can't have children. Now what am I supposed to do?"

"Are you asking me what *you* are supposed to do?"

"What did Dr. Cerise say?"

"She asked me whether I'm stressed."

"You don't have anything to be stressed about!" He is shouting now. "What the fuck is wrong with you? I know what the fuck is wrong – you have a weak body. You can't have children."

Thinking I might get a little empathy from Ty hours after miscarrying twins is an illusion, obviously.

"I don't have a weak body and there's nothing wrong with me. You know, you're being a jerk right now!" I am used to Ty's unusual behavior, but this is too much.

I try to get out of my chair, but Ty stands right in front of it, blocking me from getting up.

"I will tell you when you can get up!" Ty shouts in my face. He rants for several more minutes, and then he goes to his office and slams the door.

I feel an aloneness in the depths of my soul I have never felt before. I sit on the floor in the corner of the bedroom in the dark, crying. I want to go home, back to California. Live with Paul for a while and get my bearings, decide what I want to do. It is hard to believe I have been in Dubai for two years. The time has gone so fast. Have I stayed so long because of my attachment to Mama Wafa? With her gone I feel so lonely. The arguing and intermittent drama with Ty is exhausting. In between he is wonderful. I want the nice equilibrium we had in San Francisco, not '*yom asal, yom basal*'. ('One day honey, one day onion.')

I climb into bed. During the night I have a dream or a vision or a visitation – I am not sure which. A light radiating from the hallway wakes me. I quietly slide out of bed and follow the light as it moves towards the front entrance and then curves into the living room, where sitting in an armchair is my mother in a lovely white gown. She looks younger than when she died, maybe forty,

and glowing with health. I get down on my knees in front of the chair, place my head in her lap and wrap my arms around her. I can feel her body, her warmth.

"*Kudka*, I can't stay long. This isn't usually allowed. Your father and I talked and we want to know if you want to come with us."

"Mom, I miss you and Dad so much. I love you."

"You have to decide now. Do you want to come with us or do you want to stay."

Suddenly I am filled with the knowledge of what she is asking. I am miserable and heartbroken and she is giving me a way out. Mama Wafa leaving, Ty's roller coaster behavior, the miscarriages, I am overwhelmed. She is telling me without words that my spirit can leave my body now and go with her.

"It's not my time, Mom. I'm so happy to see you. Please stay with me Mom, don't go."

"That's not allowed, darling, I'm sorry. I came to see if you wanted to come with me. I love you. I have to go now."

And like that she is gone. Once again I feel the warm gentle wave of peace and love pass through me as I had the night of her death. Only now I cry tears of happiness instead of tears of sadness.

Going back to bed, I sleep more soundly than I have in a long time. I wake up late, feeling calm and strong, like a glove of tranquility is protecting me. Ty is not in bed. I get coffee from the kitchen. A beautiful bouquet of red roses with a card from Ty, apologizing and saying how much he loves me, greets me in the dining room.

I have heard that before. I have heard it from Mama Wafa too, "*Whoa saab, lakin whoa behebic aktheer.*" (He is difficult, but he loves you so much.)

Sitting by the window I stare at the beautiful blue water off the Corniche and the wooden *dhows* gradually sailing away. I think of Madeline's tea towel monologue. This is the twisting she warned me about. Are my colors starting to fade?

Ty has an office outside of home and I figure that is where he went after going to the store for the flowers. When he comes

home at lunchtime he is a changed man, so sweet sugar wouldn't melt in his mouth. Gone is the dramatic, unpredictable Ty and back is the engaging, attentive Ty.

"I've been under so much stress lately. I'm so sorry. Things will be much better now. We finally have the apartment to ourselves. We've not had the chance to live in Dubai alone before. This is going to be really nice, just the two of us," he takes my hand and leads me to the dining room to gaze once again at the beautiful roses.

"I think I'd like to go home for a while and see my family. I haven't been home in over two years."

"Why would you go home now, when we finally have a chance to be alone?" He has tears in his eyes. He is hugging me, making me believe every word he is saying, convincing me he is genuine. I want to believe him.

I cannot think what to say. I am so confused.

CHAPTER 9
Bundle of Joy

Ty, true to his word, keeps his drama under wraps for the most part. His behavior is enough to convince me that trying to be consistent is his new normal. He buys a new car and gives me the old one. I have much more freedom now. I go to one of the local beach resorts to swim, relax and sunbathe. I start taking French classes at the Alliance Français. I am working more at home for him, writing proposals for brochures and annual reports, and doing some copywriting. I don't get paid, but I don't mind. He has several employees, including one girl from England who I am becoming friends with. There are many fancy dinner parties with wealthy business associates, Government ministers and clients. I have acquired the wardrobe and jewels necessary for the image expected of a successful businessman husband.

"So, Paula, what do you do all day while Ty is working?" the wife of one of the ministers asks over a charity dinner.

"I'm working with Ty copywriting and writing proposals."

"Oh my dear, you truly are American aren't you?" Everyone at the table nods and chuckles in approval. Because I am an American wife, working is seen as 'charming' and not shameful.

"Is there a reason why you and Ty don't have children yet?" she prods. It is unusual in this culture for us not to have had a child yet. I have been in Dubai almost two and a half years and no baby. I am not going to tell them about my miscarriages.

"It's a work in progress!" I smile sweetly and raise my wine glass in a toast, gold bracelets clatter down my wrist, a ruby, diamond

and pearl cocktail ring clinks against the stem. Approving nods all around as everyone raises their glasses in accord.

When I get pregnant in August we decide not to tell anyone. Ty, knowing I am at risk for miscarrying in my first trimester, treats me like a queen. He overdoes it at times and I have to remind him I am pregnant, not dying. Dr. Cerise says not to overdo anything and no sex.

Ty hires someone to do the shopping and cleaning. He brings home food from outside so I don't have to cook. I am totally spoiled.

When we tell Ty's family in November we discover Madeline is also pregnant, and so is Mia. We have three babies on the way at the same time, bonding us three women together. Christmas 1989 is especially joyful with our extended bellies the center of attention. I am having a boy, Mia and Madeline girls. I am due in May, Mia in July and Madeline in June.

Ty and I are turning Mama Wafa and Mia's old room into the nursery. We choose a nice light green for the walls and a white crib that can be converted into a small bed. My waters break early in the morning on April 3rd, one month before my due date. I had carried two heavy bags of groceries into the apartment the night before and I think I may have strained too much. I had to carry the bags because the doorman figured it was Ty who sent the rotting garbage bags on a trip up and down the elevators, and stopped helping me with the groceries even though I am pregnant. Collateral damage. We rush to the women's hospital. Ty is nervous.

"I'm not sure if I want to be in the room," Ty is backpedaling on me.

"You were there when he went in, you're going to be there when he comes out!" I don't give him a choice. Don't mess with a woman in labor.

The birth is difficult. I have to be induced, they give me drugs and I am as high as a kite. Ty keeps touching my arm trying to comfort me and I am like Linda Blair in *The Exorcist*, a guttural voice from somewhere in the back of my throat spewing,

"DON'T TOUCH ME!" but without the green vomit. I am in sensory overload and cannot distinguish a gentle touch from searing pain. He is trying to remind me how to breathe like we learned in Lamaze class, but I forget everything. The baby is in distress, the umbilical cord wrapped around his neck. The doctor and the midwife argue whether or not they should do a C-section. They do an episiotomy instead, and it feels as if they are cutting me down to my knees. In the process they slice through a major blood vessel or an artery – blood spurts everywhere, all color drains from Ty's face and he starts to faint, falling into a chair keeps him from slamming on the floor.

After eight hours in labor, Faris is born. The midwife brings him to me. He is the most beautiful being I have ever seen. I thank God for giving Faris to me. Okay, now I understand. At this moment I forgive God for taking my parents away from me and for giving me a difficult husband. All that matters is that I have given birth to a healthy, beautiful baby boy, my new bundle of joy.

I am plum worn out. The midwife thinks Faris is slightly jaundiced and she takes him away to wash him and put him in an incubator. The midwife and Ty help me shower and get checked into my room so I can rest.

They bring Faris to me in the evening and I clumsily try to breast feed him with the guidance of the nurse. He seems to know what he is doing. I don't have a lot of experience fondling my own breasts, but we make it work. Faris is so lovely. Life is a miracle.

We go home two days later and Madeline helps me settle back in. The biggest bouquet of flowers I have ever seen is delivered – huge white stargazer and casablanca lilies, roses and ferns, at least four feet tall. The card is addressed to Ty. The inside of the card reads, '*Ty, congratulations on the birth of your son!*' It is from one of the ministers.

I turn the card over a couple of times, examining it carefully. Surely there is some mention of me?

"Why are the flowers for Ty? Why didn't they say for Ty and Paula, you know the one who's been pregnant for eight months,

in labor for eight hours and feels like she's been split in half by a log cutter?"

"Because the children come through the woman, but they are for the man."

"Are you shitting me?" I don't swear much, but that statement called for an expletive.

"No, that is how it is here, *habipti*. Lucky you had a boy and not a girl."

"Why?"

"*If you had a girl the card would say, 'It's okay, maybe you will have a boy next time'.*"

A few days later Dr. Cerise comes to the apartment to examine me. She takes one look at me spread-eagled on the bed and says, "You are a mess."

"Thanks."

She sighs, and then explains.

"When zay did ze episiotomy zay cut very long and deepa. When zay stitched you up zay only stitched ze top. Ze top stitches did not hold. At zome point in time, when you are done aving ze children, you can get it feexed."

"Well, that's good news. For the next baby I can squat and it'll fall out."

"I'm going to give you a prescription for zome crème. Ask Ty to put it on tree times a day. At least that vill stop any infection. No sex for at least tree month, no. Get a round blow-up tube to seet on. And come zee me in dwo weeks."

"Can't you re-stitch it now?"

"No. It iz already 'ealing. We need to recut zen sew ze sides togeter."

I call the office and ask Ty's office boy, Krishna, to go to the pharmacy for the crème and asked him to find a round blow-up tube. Later that night I ask Ty to put on the crème. I lay down on the bed, back in my spread-eagle position.

"Where do you want me to put it?"

"At the entrance of my vagina."

"Where is it?"

"What do you mean, where is it? Where it's always been."

Ty looks at my face then looks back at my vagina, bewildered.

"Oh for heaven's sake. Can you get me the hand mirror from the bathroom please, so I can see?"

Ty dutifully goes to the bathroom returning with the hand mirror. I position the mirror to get a clear view of the situation and burst into tears. Where my perineum once was is a gaping hole. The entrance to my vagina is indeed undistinguishable. I can now give birth to a bowling ball.

Mama Wafa has come from Amman to help. I ask Ty if she can stay with one of his brothers and come round and help out during the day. I didn't want to return to the silly drama dynamic he has with his mother, especially the early morning scenario. I hear Mama Wafa is upset she isn't going to be staying with us, but I have to preserve my own sanity. Mama Wafa arrives at our apartment by six every day anyway, opens the front door with her key and begins making coffee.

Ty gets up, showers and gets dressed. He is fine, but the second he opens the bedroom door and sees his mother, the drama begins.

"Why do you do that?" I ask in bewilderment.

"Do what?"

"Be fine and then act like you're at death's door when you see your mother in the mornings."

"It makes her happy."

"Seeing her son acting like he is half-dead makes your mother happy?"

"You wouldn't understand."

"S'plain it to me, Lucy." I say in my best Ricky Ricardo voice.

"Who's Lucy?"

"Never mind."

As I am breast-feeding Faris I have him sleep next to me. Ty's family thinks this is wrong. I explain humans are the only animals that give birth then make their babies sleep separately.

"Look at every other animal and show me one that doesn't sleep with their babies," I challenge them. I know there are

still murmurs of disapproval about the California hippie but, whatever man.

Faris is with me twenty-four seven as I am working for Ty from home. Ty is working outside most of the time. Faris is the love of my life. Ty adores Faris and showers him with attention.

Mia and Madeline have beautiful, healthy baby girls. We get together with all three babies. Life is all about poop, breast-feeding, formula and diapers. It is a wonderful time. Mama Wafa returns to Amman after all the babies are born.

When Saddam Hussein invades Kuwait on August 2nd 1990, there are rumors of threats of chemical weapons being used against the UAE. People rush to the stores as if there is a blue light special on bread, duct tape and diapers. Ty decides it is best to leave for a while. We fly to Cyprus on August 17th. His parents meet us there along with other long lost Palestinian relatives living in Israel.

At four and a half months Faris is the star of the show, passed around from elder to wrinkly elder, bounced on knee after arthritic knee. When we walk past a row of young topless beauties sunbathing by the pool, Faris looks at the girls, his eyes wide, arms flapping like a dodo bird, excitedly uttering, "Ooh, ooh, ooh." Which I think means 'buffet?' in baby talk.

This week in Cyprus is enjoyable with Ty and Faris. Most of our time is spent with the elder relatives because we will probably never see many of them again. We manage to get to the pool just one time the afternoon before we fly back to Dubai. Ty is relaxed and back to his congenial self.

The invasion of Kuwait sparks a strange paranoia in Ty back in Dubai.

"I'm a Palestinian from Jordan, so I know we are being watched."

"Who is watching you?" I question.

"The authorities. Our phones are being tapped too."

"Why?"

"Because the Palestinians support Saddam Hussain."

"There are hundreds, if not thousands, of Palestinians working

in the UAE. Are they all being watched?"

"I don't know." Ty is peeking out to the parking lot from behind the living room curtains. He points to a black car parked under a tree occupied by a driver.

"See. That car has been there for hours watching our apartment." It may or may not be true, but he is acting so peculiar.

There is a huge loss of revenue in the business. In war everyone stops advertising or producing brochures, waiting to see what is going to happen. Ty is on edge. In November Faris is in his crib crying. I am on my way into the room. Ty doesn't see me, but I see Ty pick him up and throw him against the side of the crib. Faris hits his head on the rail of the crib and starts screaming.

"What the hell are you doing?" I go into full-blown mama bear mode.

"He won't stop crying!" Ty screams.

"So you throw him! How does that make him stop crying?"

I pick Faris up and take him to our bedroom to settle him down. Ty follows.

"I barely moved him. He's fine. You're spoiling him. That's the fucking problem."

"You can't spoil a seven-month-old baby! And I saw you throw him. Don't lie. What is wrong with you?"

"Nothing is wrong with me. Fucking fucked up American!" Ty slams the bedroom door and leaves. Wow, a new insult. The last time he insulted me, when I miscarried the twins, I got flowers.

I comfort Faris. He stops crying and I tuck him in close next to me to sleep.

I felt pure hatred for Ty at the moment I saw him throw Faris. For the next few days Ty only comes home to shower and sleep. That is fine with me. Slowly he comes home earlier and plays with Faris and tries to engage me in conversation. For me, Ty has crossed another line. I am hesitant to leave Faris alone with him. Has he done something like that before when I wasn't home? I don't trust him.

My sister Karen is getting married in January in California. I want to take Faris with me, which means being at Ty's mercy for Faris' passport. Ty is practically doing handstands to get back on my good side.

"Look, I was tired and he wouldn't stop crying. I'm sorry. It won't happen again." Ty assures me. I am breast-feeding Faris and Ty is standing at the foot of the bed in tears. That must be the crying spot.

"I don't care how tired you are – if his crying is bothering you walk away, leave the house."

"Yes, you're right. I promise it won't happen again."

By Christmas and New Year things are back to normal and I try to believe that throwing Faris was an isolated incident. I leave for my sister's wedding, with Faris, on January 10th 1991. We fly from Dubai to London, then to Los Angeles. We spend the night at Eva's house and she drives us up to Arroyo Grande the next day. Faris is very easy to travel with, but the trip is exhausting for both of us.

Faris ends up getting sick from an ear infection and I spend most of the wedding reception at Urgent Care with him. After the wedding Karen and Robert leave on their honeymoon and we stay with Paul. I am content away from Ty, relieved to be in a 'drama free' zone, back in my own country. The California central coast, the place I could not wait to get away from, is now a place I have much more appreciation for after having lived overseas for almost four years. Paul has a two-bedroom duplex. The second bedroom where Faris and I sleep is small but cozy. I think it would be nice to stay with Paul for a while and delay going back to Dubai. I don't think Paul will mind.

I have been at Paul's for about a week when there is a knock on the door. I open it and there stands Ty. He steps in, hugs me, then goes to Faris who is excited to see him. I feel like he is invading my personal space, the same feeling I had when he moved himself into my apartment years before.

"I wanted to surprise you!" Ty is joyful. "I think we need a nice

vacation after all the stress in Dubai, with the invasion of Kuwait and everything."

The Gulf War started a week after I left. Ty said business in Dubai is worse than ever.

"I have airline tickets for us to go to San Francisco. I already spoke with Tommy and we can stay with him. Then I thought we could rent a car and go to Lake Tahoe for a couple of days. What do you think?"

I don't have a chance to answer before Ty continues, "Let's look for a place to live in San Francisco. I think we should start a photo lab business while Dubai is so unstable."

That got my attention.

"What about the apartment in Dubai?" I ask.

"I moved everything into a small one-bedroom. I gave most of the furniture to my brothers. With the loss of business we can't afford the big apartment anymore. I thought we'd get the photo lab business established in San Francisco. When the war's over I'll go back to Dubai to see what can be done. You can stay and run the lab. I need us to live here so I can get the American passport.

"Yes, of course. I think that'll be a good idea. What about our clothes and things?"

"I packed them so they can be shipped back once we have an apartment in San Francisco."

I am elated. I have been dreading telling him I want to stay with Paul longer and the guaranteed argument that will spur. We stay with Paul for another day then head to San Francisco. I am hoping Ty will get back to a nice equilibrium again in the States.

We stay with Tommy for a few days then drive up to Lake Tahoe. Faris gets really sick. I call the hotel nurse in the middle of the night and she says he has the flu. Meanwhile Ty stays up all night gambling. He comes in early in the morning happy with his $6,000 winnings. We drive back down to San Francisco. Faris gets worse and we end up in the emergency room at the Children's Hospital in San Francisco. The doctor puts him on strong antibiotics and he bounces back in a week.

We take a trip down to San Diego to check it out and see if we want to live there and decide to take a one-day cruise to Mexico. I get so seasick I don't want to take the ship back to San Diego. Ty gets us a cabin for the return trip, but I am still sick as a dog.

Back up in San Francisco we find a site for the photo lab on Polk Street and we negotiate a lease. Weeks have passed and Ty hasn't been moody. Maybe the stress of Dubai and the Gulf War was causing Ty's mood swings. A committed bachelor, I am concerned Tommy would be fed-up having a baby in the house, but he seems to enjoy our company.

My period is late, but it's okay. I am still breast-feeding Faris and Dr. Cerise told me that it's a good form of contraception. When I am ten days late I take a pregnancy test. Positive. That is probably why I got so sick on the cruise ship. The first week of March, while we are still staying with Tommy, I tell Ty I am pregnant. He is elated once again. I tell him we should probably get our own apartment soon.

"Well, the war is over, we can go back to Dubai."

"I thought you were going to go back to Dubai and I would stay here."

"You can't stay here pregnant, taking care of Faris by yourself!"

"You said Dubai is too stressful. That's why we're going to live in San Francisco and open the photo lab."

"We will. We are. But I still have to go back and see what we can do to salvage the company. We can't afford two apartments right now *and* the lease on the photo lab."

"Let's see if Faris and I can stay with Tommy while you go back. I'm worried the long plane ride may cause me to miscarry."

"I don't want you being alone and pregnant. In Dubai you won't have to worry about anything. Just take it easy through the first trimester. Besides, we don't have medical insurance in the USA. Everything in the UAE is free for you and the baby, even the hospital."

"Maybe, but you're changing plans on me. At Paul's you said you would go back to Dubai and Faris and I would stay here. You said our clothes and things were ready to ship to us when we got

an apartment in San Francisco. Now you want us to go back with you to Dubai."

"The plan changed because you're pregnant, *habipti*. Anyway, we signed a lease on the space for the photo lab and started renovation. That should prove we'll come back after you have the baby in Dubai."

I feel like Tevia from *Fiddler on the Roof*. On one hand, the commitment to the photo lab did demonstrate we would be coming back to San Francisco, on the other hand I am nervous with Ty's unpredictable temperament in Dubai and his control of our passports.

Logically and financially it makes sense to go back to Dubai to have the baby. I can't give a logical reason to stay and, after two and a half months in the States, Faris and I fly back to Dubai with Ty on March 24th, 1991.

The new apartment in Dubai is very small. About the same size as the flat we had in Lincoln, but on one level and the one bedroom is larger. It fits our bed and Faris' crib. Luckily it is in a corner and we have windows on two sides and the rooms are bright, except for the kitchen.

Victor, Marie, Daniel and Mara are on vacation in Bahrain. Ty gives me our American passports again so Faris and I can fly to Bahrain on April 2nd and celebrate Faris' first birthday with them. Faris has his maiden sensory beach experience, including putting sand in his mouth and examining seashells and rocks. I videotape him for a moment for memories' sake, before I stop him from eating the whole beach.

The Bahrain trip gives me some comfort. Even though Marie is my sister-in-law, she is a good friend and confidante. It is nice to have someone I can be honest with. It is too dangerous to confide my concerns about Ty's behavior to my two sisters-in-law in Dubai.

With the baby due in November it means making it though the hot summer in Dubai pregnant. There is a nice park right across the street where I take Faris in the evenings when it has

cooled down a little. Ty spends the summer trying to salvage the advertising business and travels back and forth to San Francisco getting the photo lab up and running. I work from the small apartment writing proposals and copywriting.

Ty recruits Victor to come and work in Dubai in August 1991. Victor moves into the small apartment next to ours, so I will have someone to help me if I need anything while Ty is traveling.

It is a blessing having him so close. On more than one occasion I do need his help.

I go into labor on November 16th. Ty is in a meeting. Victor goes through most of my labor with me at home, calling Ty every ten minutes telling him to leave the meeting and come home.

"Hurry up!" Victor scolds Ty before he barely steps in the doorway. "Do you want her to have the baby on the couch?" Victor is furious at Ty.

Ty takes his time and showers. My contractions are getting closer. I go to see what is taking Ty so long. Ty is standing in front of the mirror slowly combing his hair.

"Are you going on a date?" I ask sarcastically. "Do you think you might have time to drop me off at the hospital on your way so I can have this BABY!" I shout, doubled over as another contraction hits.

"Paula, *yella*, I will take you myself!" Victor grabs his car keys.

"I'm coming," Ty acts as if we are interrupting him. Victor stays with Faris and Ty takes me to the hospital. I stand up to get out of the car and my waters break in the parking lot. The nurse rushes me up to the delivery room and the midwife admonishes me for waiting so long to get to the hospital.

Within twenty minutes Samer is born. There is no time for painkillers, the birth is *au naturel*. After Samer is born Ty looks at me and asks, "Why were you screaming so loud?"

"Really Ty? Why was I screaming? That's the first thing you say to me after I give birth to our son?"

The midwife hands Samer to me. He is so beautiful. I marvel at the miracle of birth. And once again my whole world disappears except for the wonderful baby in my arms.

With Samer there aren't any complications like there were with Faris, and we go home the next day. Faris loves his new baby brother. At nineteen months he can't say Samer so he calls him Hammer. Marie, Daniel and Mara join Victor in Dubai. Ty spends Christmas with us but heads back to San Francisco for the New Year. Victor and Marie help me as much as they can, but it is draining taking care of two children under the age of two, alone.

I have them both sleep with me, which makes it easier, one on each side. One night neither one of them will stop crying so I lie in bed and cry too, three of us wailing away like stranded baby seals.

Ty focuses on running the photo lab in San Francisco and Victor is running the advertising business in Dubai. Finances are improving.

With Ty gone so much the small apartment is fine for the boys and me. I find a daytime nanny and begin to work more in the advertising company with Victor. The British gal I like so much quits and goes back to England. The European employees don't last long working under Ty. The employees from India and Sri Lanka last a long time, but the vibe in the office tells me no one really likes working for my husband. Victor is easier to work with and I am warming to him – we bonded while I was in labor with Samer,

One of Ty's Sri Lankan employees, Bala, tells Ty he has to go home because his wife is dying. Ty refuses. She dies. Been there, done that. He finally agrees to let Bala go home. As revenge, one of the other Sri Lankan employees, Rajo, a friend of Bala, breaks into Ty's desk, gets his own passport, forges a check for the equivalent of $10,000, cashes it at the bank and flees to Sri Lanka. Ty is furious. I think Ty got what he deserved. Not that money would have brought Bala's wife back, but that much money in Sri Lanka will make him and Rajo wealthy men. Ty tries to get Interpol involved but $10,000 isn't enough for them to be bothered.

CHAPTER 10
The Scaffolding comes Crashing Down

THE NEXT YEAR PASSES QUICKLY BETWEEN WORKING AND TAKING care of the boys. Ty and Victor argue incessantly. He is often irritable and combative, and I learn to gauge his moods. Ty hires an Australian girl, Michelle. I like her and we become friends. Her mother dies suddenly while on vacation in Paris and Michelle leaves for a couple of weeks. When she returns in late January 1993, she really isn't ready to come back to work. She starts crying at her desk and Ty yells at her. She quits and runs out of the office. Another one bites the dust.

"Michelle's still upset over her mother's death. I think you could have been more sensitive," I mention casually as I am doing the dishes.

"What the fuck did you just say to me?" Ty's voice roars like thunder. I look up startled. His face is ablaze with rage as he attacks. He grabs my arms, throws me against the wall then drags me out of the kitchen, forces me out the door and down the hallway. I am hitting, kicking and scratching to break away from him, screaming for help. No one opens their apartment door to take a look. In the elevator I continue to fight him, but it is no use. He is double my size and as strong as an ox. Once outside I cry for help to people in the parking lot, but they quickly walk in the other direction as Ty throws me into the car.

"Stay there. Don't move if you want to see your kids again!" he

bellows. His eyes are wild, deranged. He stomps around the car and gets in the driver's seat.

"What are you doing Ty? You can't leave Faris and Samer alone! They're babies!" I am somewhere between hysterical and in shock.

"Shut the fuck up!" Ty drives around mumbling to himself like a crazy homeless person. He launches into a diabolical monologue about dying and killing me, and about how fucked up I am for daring to criticize him. I commence survival mode.

"I'm so sorry Ty, I'm sorry for saying anything about Michelle. I didn't mean to upset you!" My words are measured, but my mind is racing. I need to calm him down and get back to my babies.

"Shut up!" he commands. I comply. "You have no fucking right to talk about how I treat my employees. Do you understand, bitch?"

"Yes. I understand. I'm sorry." I will sell my soul to the devil this very second if he can make this nightmare stop.

"And you'll never fight me again, do you understand, bitch?"

"Yes. I promise."

Ty continues to mumble to himself but drives around for another half hour before heading back to the apartment. We get out of the car, go up in the elevator and back into the apartment in silence. Samer and Faris are huddled together in Samer's crib crying. Faris had been so scared he left his bed, climbed in the crib with Samer and vomited all over his brother and the sheets. Ty goes straight to bed, mumbling again as he walks by us giving me the evil eye. I spend the next hour showering the boys, putting them in fresh pajamas and changing the sheets on the crib.

"Why Mama go?" Faris is still upset, his eyes wet with tears.

"Baba and I had to go to the office to get some papers. We didn't want to wake you up. I'm sorry you got scared." I sing 'Hush little baby' to them until they fell asleep.

I am so shell-shocked I fall asleep quickly to escape the riot of emotions I need to deconstruct when it is safe.

The next morning Ty says he is taking the day off work and suggests we go for a drive. I can't read his disposition. He doesn't

seem irritated, but his vibe is dark and calculated. I wear long sleeves to hide the bruises on my arms from the night before. I decide to be cheerful and get the boys settled into their car seats in the back seat. Ty starts driving towards Abu Dhabi without saying a word. The boys fall asleep. Ty starts speeding. The deranged look on his face re-emerges, worse than Jack Nicholson in *The Shining*.

He starts punching me in the face with his right fist, steering wildly with his left. He keeps screaming what a fucked up American bitch I am. It was my fault he is going to drive off a bridge and kill us all.

"How do you fucking like *that*, bitch! You fucking speak to me like that!" he splutters as he hits me again. "You fucking want to die!"

I frantically glance back at the boys, they are still sleeping. *Thank God.*

I try to remain as calm as possible but my heart is racing. I apologize again for what I said to him about Michelle.

"I thought we settled this last night Ty. I told you, I didn't mean to criticize you. I just know how she felt losing her mother and I got over-emotional. I promise you it will never happen again!" I would have promised him anything.

"You are a kind, loving, wonderful man. This isn't like you Ty!" I see his face shift slightly at the compliments and I continue to tell him wonderful things about himself.

"You are a great provider. The boys adore you. I love you. You have two successful businesses. This isn't you Ty!" I am laying it on thick and heavy, manipulating his pliable madness.

Eventually Ty pulls off to the side of the road, turns off the car engine and starts bawling like a baby. I reach over and comfort him, stoking the back of his neck. In my mind's eye I am pushing him out the car door leaving him on the side of the road, driving straight to the airport and getting the boys and me the hell out of here.

"I'm so sorry." He is stammering, tears dripping down his face falling into his lap.

"It's okay, Ty. I understand. We all have bad days. Let's just go home and forget about it."

I keep thanking God the boys slept through the terror. When Faris wakes up he asks me what happened to my lip. I tell him I hit myself by mistake with the car door.

Ty drives home. I cook. We sit, eat, watch television and play with the kids like nothing happened. We go to bed and have sex and it is awful. How can you threaten to kill someone then get an erection and have sex with the person you threatened to kill? I pretend to enjoy sex with the lunatic that endangered our lives. I lay awake in in bed listening to Ty snore.

The realization Ty is dangerous and mentally ill hits me like a thunderbolt. I wondered sometimes with his mood changes, but I thought he was just temperamental and demanding. This time the scaffolding came crashing down and the monster revealed its terrifying wrath. Nothing will ever be the same again.

Now I know why I had the feeling not to leave San Francisco. Did Mom see this coming? Can dead people see the future? Is this what she was trying to save me from when she appeared to me? I feel the twisting. I hate myself for coming back to Dubai when Faris and I were safely home. Realizations flood my mind. Ty never wanted me to stay in California. That is why he showed up at Paul's house unannounced. He was so convincing. I had my chance to escape and I didn't take it. I could have lived with Paul and had Samer there. I could have found a job with insurance for us. I was such an idiot. I will never ignore my instincts again.

I need to get the boys out. Ty has their American passports locked up somewhere. Since Rajo stole the money, Ty changed the hiding place and he may be keeping the passports with one of the brothers.

Ty is sugary sweet again by morning, overnight reconstruction of his scaffolding complete, nail by nail, board by board, stuffing the beast back into its lair. Too late. I have seen the truth and the brutality of the horror that resides underneath.

A couple of weeks later Ty is talking about the photo lab.

"I need to go back to San Francisco."

"Why don't I go this time? Karen can come up and take care of the boys while I work. That way you'll have less stress," I propose, making sure it sounds as if I am doing it because I want to relieve his pressure.

"That's a great idea, but you will go by yourself. The boys stay here with me."

"But you're working all the time, how can you take care of them? The nanny is only part time. Karen can help me in San Francisco." I try to reason with him.

"No fucking way. You are not taking Faris and Samer to San Francisco, ever. The nanny will take care of them here. You can stay with Tommy. You need to find an apartment too, as soon as you get there."

I don't question why he wants me to find an apartment. I might not want to hear the answer.

The thought of leaving the boys with Ty is heart wrenching. I talked myself into a corner. If I back out now he may go into another rage. For the next couple of weeks I pretend everything is wonderful between Ty and me. If I travel to San Francisco and get things sorted out at the photo lab and get an apartment, Ty might surprise me and show up with the boys. It is a long shot, but I don't have a lot of options. I kiss my beautiful boys goodbye on February 25th 1993. I stay with Tommy until I find a studio apartment down the street from the photo lab. One evening during dinner, Tommy and I are talking and he asks me a question.

"I wonder what would have happened if I never gave Ty your number and I'd called you instead. Do you ever wonder if things would have turned out differently?"

"I'm sure they would have." I know what he is hinting at. I change the subject. He is Ty's friend and I am not going to say anything about Ty.

I move into the apartment; a cute studio with a Murphy bed and bay window with a wooden window seat overlooking Polk Street. Separate kitchen and bathroom down the hall. Every night I pull the creaky Murphy bed down from the wall, climb into bed and cry myself to sleep. I miss Faris and Samer so much

my heart feels it is going to break. I am worried what Ty might be doing to them when I am gone.

Karen comes to visit and we make enlargements of her wedding photos at the photo lab. I want to tell her how bad Ty is but I don't want her to worry, so I pretend everything is fine. I don't think she believes me because she asks a lot of questions.

I hire a manager, Greg, a young man with an honest face who has photo lab experience.

One night on the phone I excitedly tell Ty how cute the studio apartment is and how great things are going at the lab with Greg on board. I suggest he comes to San Francisco with the boys and we can have a vacation. Despite my best efforts he doesn't take the bait. It is the longest nine and a half weeks of my life. I miss Faris' third birthday.

I call the American embassy in the UAE anonymously, and inquire what can be done to get an American woman and her two children out of Dubai if they are being abused. I get bounced from person to person. No one can help me except to say my friend needs to find the American passports and leave. I can't stand it anymore and return to the UAE on May 3rd.

Ty picks me up from the airport. Being away from him did not make my heart grow fonder. I know the drill.

"I missed you so much!" I am holding his hand and chatting happily. He looks at me suspiciously. At some level he must doubt my sincerity, but I am confident his ego will succumb to my performance. When we walk in the door the nanny greets us. Faris and Samer start coming towards me, but with one wave of Ty's finger they stop and stand like well-trained dogs. *Bloody hell.*

I stand there, they stand there, Ty stands as if we have been flash frozen. Finally Ty gives permission, "Okay, you can hug your mother now."

They come to me cautiously. I kneel down on the floor and hug them and smell them and start crying. I would rather live as a prisoner with them in Dubai than live without them in the USA until I can get us out.

My new strategy is to be completely compliant with whatever I think Ty wants – shine his shoes, initiate sex, go down and turn his car on and get it nice and cold with the air-conditioner so he doesn't sweat before an important meeting, and prance around as if I am the happiest person on earth, blessed to be orbiting around his narcissistic core. As long as he thinks he is in control, things will be fine. I need to keep the peace for the boys' sake and keep my eyes open for the boys' passports. But Ty is more distant and self-absorbed than ever since I got back. The more I give, the more he demands.

I am happy to see Victor and Marie. Although Victor is Ty's brother, I don't think he is mentally ill, or at least, not as mentally ill as Ty. I have to be careful what I say to Victor, but I feel safe around him. Would Victor protect me if Ty became violent in front of him? Ty is too calculating for that – in front of Victor he will scream and insult me, but he stops short of any physical assault.

Another long, hot summer is passing. Mama Wafa comes to visit and sleeps on the couch as we have such a small apartment. She adores playing with Faris and Samer and I am thankful for the love and attention in which she swathes the boys. Ty's weird behavior around his mother resurfaces.

One morning I am still in bed. I hear Ty in the shower talking to someone. I roll over and the bathroom door is open. Mama Wafa is going to the toilet while Ty is showering. *A full-grown man is in the shower, speaking to his mother while she is using the toilet in the same bathroom. No way.* I blink several times. I turn back over. I hear Mama Wafa flush, wash her hands, and walk to the living room. When Ty gets out of the shower I turn back around.

"Were you and your mother having a conversation while she was using the toilet and you were showering?"

"Yes, so?" he says it like I am annoying him.

"So... that isn't something I've ever seen before," I choose my words carefully.

"You aren't close with your family like I am with mine."

"Yes, I see that," and I left it alone. I know better than to say what I am really thinking.

In November I am shocked when I find out I am pregnant again. "I'm pregnant," I announce over dinner after I have put Faris and Samer to bed.

"Being pregnant is going to affect your work performance."

No emotion. I realize I now exist to support his business and his carnal needs. But I am pregnant with another beautiful baby. This is what God wants for me. I have to begin to believe in something beyond myself.

Business is going well and we move into a very nice three-bedroom apartment with maid's quarters. It is huge compared to where we have been living. Two of the bedrooms and the dining room have closed-in balconies. We hire a live-in housemaid, Alana, whom Mia employed before Ty secretly helped Mia and her daughter escape to another country to flee her husband, and, I believe, her family. Mia told me in secret that she wants to start her life over, from the beginning, without the constant arguing and control of her father and her brothers.

I am working all the time now, sometimes fourteen hours a day, but several times a month we pull all-nighters. There are times I am so sleep deprived I can't feel my legs. I burst into tears at my desk. Ty doesn't care. All that matters are his work deadlines. With the brain fog from pregnancy and exhaustion from working I am making mistakes. Ty storms into my office like an inferno.

"How the hell do you spell Brian Hayes?" He is furious. I quickly calculate that no one else is in the office except me and Ty. I am behind my desk and he is blocking the doorway. I am cornered.

I carefully spell out Brian Hayes for him wondering if this is a trick question.

Ty slams down one of the name cards I had made for a press conference around three o'clock that morning for the launch of a major consumer product in Dubai. I read the name card out loud.

"Brain Haze," the irony of my mistake is too much and I burst out laughing.

Ty's face erupts in anger. He dives forward, grabs the phone off my desk and throws it at my face. I quickly block it with my hands. When I tell him to stop he grabs my arms, pulls me out of my chair and pushes me up against the wall. I am eight months pregnant and terrified he is going to hurt the baby.

He snatches an Exacto knife from my desktop and holds it to my face.

"I should cut your fucking tongue out for laughing at me!"

"I'm sorry Ty! I was laughing at myself, at my mistake, not at you!" I am crying, frantic.

I hear the main office door open. It is one of the employees returning from lunch. Ty releases me, steps back, and puts the knife back on my desk. *Thank God.*

"Just give me the report when it's ready please," Ty says loudly, so polite, pretending we are having a regular conversation as he walks out of my office into the waiting area. I hear him greet Krishna. He starts chatting as if nothing had happened. I pick my phone up off the floor wondering if my baby can feel the fear I felt. I sit back down in my chair for a few minutes waiting for my heart to stop pounding in my head.

I walk on eggshells doing anything not to anger Ty, so scared he may hurt my baby. Within a month of the brain haze incident, in July, I begin having contractions. I leave the office mid-afternoon and go home to rest. This time when I ask Ty to take me to the hospital at five o'clock he does.

The attendant at the hospital tells me I am in false labor and should go home. I refuse.

"Do you want to bet I'm going to have this baby by seven o'clock?"

"*Habipti*, you are in false labor, go home, you are not having this baby tonight."

"I know my body. Now please check me in and get me a room upstairs."

She reluctantly complies, rolling her eyes convinced I am wasting her time. An attendant takes me upstairs.

"Can you please get me a midwife?" I ask as politely as possible under the circumstances.

A woman in a medical robe walks in.

"Are you a midwife?" I am starting to get panic.

"No, I'm a nurse."

"I don't need a nurse, I need a midwife! Get me a midwife!' I yell at the nurse. She gives me a scolding look and shuffles out to find a midwife.

"You're being rude. Why are you yelling?" Ty berates me.

"Because this baby is going to slide out onto the floor if someone doesn't come soon, that's why!"

"You are so dramatic!" Ty sneers at me. If Ty is not the center of attention he has to admonish the person who is.

By now there must be a report running through the hospital that there is an irrational American woman in the house. I am desperate. I know my body. I know the baby is coming, no one is listening to me and Ty is on his cell phone engulfed in self-importance. Thankfully, Lisa, the same midwife who delivered Samer, walks in.

"I remember you. You deliver really fast!" Lisa checks my cervix quickly. "Oh my God! You're fully dilated – we need to get you to the delivery room NOW!"

Lisa leaps into action, calling for help so she can move me to a delivery room. Tariq is born ten minutes later on July 17,1994. I have another beautiful baby boy and another moment of bliss and wonder at the miracle of birth. A hairy little baby this one is too! The other two had some hair on their head, but this little guy is a fuzzy-wuzzy bear.

Ty barely takes the time to acknowledge Tariq's arrival before he says he is going back to the office. He isn't going back to the office though – he will make the announcement to his family that his third son has been born. Everyone will gather at the apartment and celebrate his fatherhood where he will stand tall and proud, absorbing the attention like water into a dry sponge. After having three sons I am certain someone is going to slaughter a lamb in Ty's honor.

When I come home with Tariq the next day I am grateful Mama Wafa has come to live with us and help me.

I'm back working in the office within two days. I answer the phone and people ask when the baby is due. When I tell them I had the baby two days before, they scold me for being at work. I have no choice. All that matters to Ty is what he wants and needs, like a two-year-old, but much more dangerous.

Ty leaves at the end of August and takes Faris with him to San Francisco with plans to fire Greg and run the photo lab himself. I miss Faris so much, but I am hoping this is a move towards relocating back to San Francisco, then I can get us all away from Ty.

CHAPTER 11
American Passport

WITH TY GONE I AM SPENDING MORE TIME WITH TARIQ AND SAMER. I am relieved the first few months of Tariq's life are calm and drama free. Samer is also calm and relaxed. Not seeing Faris is torture. I have support with Mama Wafa and Alana at home. Victor is easy to work with and does not push me – he does the opposite, knowing how much pressure I am under.

I go to see Dr. Cerise for a postpartum checkup. After the examination, we are sitting across from each other at her desk.

"What iz Ty doing to you Paula?" Dr. Cerise questions.

"What do you mean?" I am stunned.

"When you first come to zee me, you were a beautiful young bride, no? Now, you are so tired, worn out. You 'ave had tree children and I 'ave been your doctor for all tree. Ty did not come one time to an appointment with you. Zometing is wrong."

"Everything is fine. I'm just tired between working and the kids. You know how it is."

"Yes, of course, I do know how it eez, that is why I feel there is zometing wrong."

Dr. Cerise is dating a business associate of Ty's. I smile and thank her for her concern, but assure her I am fine.

Ty did not sign the paperwork for Tariq's certificate of birth abroad before he left. The only paper I have for Tariq is a birth certificate in Arabic from the hospital. Even if I find mine and Samer's passports, I can't take Tariq out of the country. Even if I could leave with Samer and Tariq, Ty would fly back from

San Francisco with Faris, and make sure I never see my eldest son again.

I go to the American embassy with Tariq's birth certificate anyway to see what I can do without Ty's permission.

"Here's the paperwork, but we need both you and Ty here with Tariq to submit it, just like you did with Faris and Samer." The consular officer is an Arab man, Khalid. "How is Ty?"

"He's fine, traveling. Can I ask you something? A friend of mine, she is American too, her husband is Jordanian. He has been hitting her. Is there anything she can do?"

"That's very difficult here. If she calls the police the police won't do anything except tell her to obey her husband and stop making him angry. The husband has the right to discipline his wife any way he wants. The police will not interfere." Khalid is being sincere.

"What if he starts hitting the children?"

"A father has the right to discipline his children any way he wants."

"What if there are bruises on the children?"

"Nothing will happen unless the injuries are life threatening. But then the husband will probably tell the police your American friend did it and she will be arrested."

I somehow knew what his answers were going to be. I don't know what I am going to do.

Ty and Faris are gone four months, arriving back shortly before Christmas. I can see that Faris is attached to Ty after the long San Francisco trip. I know I will have to gently ease back into his heart and gain trust. I have no idea if Ty hurt him while they were in San Francisco. Faris' behavior though, indicates the attachment is more out of fear than love. Faris sneaks into our bedroom in the morning, tippy toes to my side of the bed and hugs me, the whole time keeping a watchful eye on Ty. Then he goes to Ty's side of the bed and climbs in next to him.

This happens every morning after they get back from San Francisco and I am suspicious. One morning, after Faris hugs me and tucks in next to Ty, I pretend to be asleep. After a few

minutes I sit up quickly and throw the covers off Ty and Faris. Ty is fondling Faris' penis.

"Faris, honey, can you go back to your room please?" I say calmly, although I am seething.

Faris gets out of the bed and trots off.

"Ty, what the hell do you think you are doing?" I know my explicit confrontation may cause a shit storm, but I don't care. Not when he is a grown man sexually touching my child.

"It comforts him."

"It comforts him? *It comforts him?* No Ty, it doesn't comfort him, but obviously it comforts *you*! What the hell are you doing?" I am furious, screaming at Ty, daring him to respond.

"Answer me!" I demand.

Ty doesn't answer me. He gets out of bed and walks to the bathroom. He has been caught red-handed and I think I shamed him. His perverted secret is exposed. Now I know what was going on in San Francisco.

Ty showers, dresses and leaves the apartment refusing to engage with me or look me in the eye.

"Faris, honey, you don't have to let Baba touch your penis, okay? You can tell him no. If Baba touches you like that again will you tell me?" I speak to Faris as soon as Ty leaves.

"I don't want Baba to be mad at me." Faris casts his eyes downward.

"Sweetheart, I need you to tell me, please."

"Okay, Mama." I give him a big hug.

After that Faris still tiptoes into the bedroom in the morning, hugs and kisses me but goes back to his room and does not get in bed next to Ty.

Christmas is always at our apartment. Christmas 1994 goes surprisingly well until everyone leaves. Four months of being away from Ty didn't change a thing. I can feel Ty's mood shift from across a room, blindfold.

"I don't fucking believe you. My family thinks you are so perfect. But they don't know the shit I have to put up with from

you." He is justifying a reason to attack and I need to de-escalate him somehow.

"I don't understand why you are upset. Everything went fantastic today. Everyone was happy, the food was good," I am trying to be bright and cheerful in an attempt to sway whatever ranting is going on in his psychopathic brain.

"No. They're fucking wrong. They all think I'm the crazy one, but it's you. You are the problem." He is speaking low and quiet, deliberate and calculating.

That is when I see the glimmer of the edge of the knife he is holding in his hand. He is standing in the landing between the boys' bedroom, the guest bedroom, our bedroom hall and the entryway. I slide down on the ground against the wall on the inside of our bedroom hallway. I don't want him to back me into our bedroom.

"Get the fuck off the floor." He is holding the knife in his right hand behind his body, his left hand by his side, fist tightly closed. His parents are sleeping in the guest bedroom to my right. If he lunges at me with the knife I am close enough to grab the door handle, turn it and shove my body against the door. Ty may be bigger and heavier than me, but I am faster.

"Get the fuck off the floor," he repeats.

"Not until you put the knife away." I am speaking in a normal voice.

"Get the fuck off the floor and I will put the knife away." He is lying.

"Put the knife away, Ty, or I will scream right now. I wonder what your mother will think about you threatening me with a knife."

"I'm not threatening you. I'm just standing here, I just happen to have a knife in my hand. You're the one who's paranoid, you're the one who's crazy." He turns and walks away, back to the kitchen. I hear the kitchen drawer open and close. I scoot my body on the floor so I am in front of the bedroom door. My left arm raised up, my left hand on the doorknob of the guest room.

Ty walks back up to me.

"See, you're the crazy one," slowly he walks by me and goes to bed. The knife is gone. It is a large knife and he is wearing shorts. He would have had nowhere to hide it.

I sit on the floor in front of the door until I hear him snoring. I go to the boys' bedroom and kiss each one of them on the forehead. With each kiss making a silent promise I will keep them safe, no matter what it takes, I will keep them safe. I sleep in bed with the boys.

The next day Ty acts as if the knife incident never happened. He acts as if he is the happiest person in the world through New Year's Eve, then the bizarre behavior returns like swallows to Capistrano.

Ty's obsession with obtaining an American passport intensifies. His travel is so limited, especially in Europe and even in some of the Arab countries. It is his holy grail.

"Everything would be perfect if I had an American passport!" he cries and sobs, blubbering like a baby, sitting on the edge of our bed.

"Then let's go back and live in the States until you accumulate enough time to qualify."

"No, we're never going to go live in the States."

Of course not. He wouldn't have any power over me and the boys in the USA. I know not to push the idea too hard or he will get suspicious. I don't want him going back and taking Faris and leaving me in Dubai with Samer and Tariq again with no way out.

Ty fires Alana after she talks back to him and he hit her – punches her right in the face. He sends her packing back to the Philippines the next day. We find a temporary daytime housemaid and go to the maid broker to hire a new live-in housemaid.

"Here, look through these binders." The male maid-broker hands several three ring binders to us. Each page has a colored picture of a housemaid and information about her age, nationality, languages spoken, height, weight, religion and a list of countries she has worked in. *What in the world?*

I guess there is no other way to do this, but I feel like I am 'buying' a girl. Ty tells me to choose. He is setting me up – if

the one I choose turns out to be bad then he can blame me and validate his anger. I look into the blank, detached faces page after page. I find one girl with kind eyes from Indonesia, Sonata. There is something about her that is different from the others.

"I like this one. Her profile says she speaks Arabic." That will make Ty happy as he is always scolding me for speaking English at home. He wants Arabic to be the boys' mother tongue.

Ty pays the broker his fee and gives him the money for the airline ticket and visa. Sonata arrives two weeks later. She barely speaks Arabic or English. She is a simple girl, very sweet and innocent. She has never even seen basic household appliances like a toaster. She is perfect for the boys. I communicate with her by drawing clock faces with different times and then drawing stick pictures of the boys eating, taking baths and so on.

The boys quickly realize Sonata is not going to supervise them. They have a heyday – color the computer purple with a marker, pour water in the corner of their room with a bucket in an attempt to make an indoor swimming pool and create a crayon mural on the carpet in the entranceway. I walk into the apartment wondering what tornado came through.

"What happened here, Faris?"

"Sonata lets us do whatever we want!" he chants happily.

"You and Samer need to clean everything up now, right now!" I am dreading Ty coming home and seeing the disaster.

"Sonata, come please." I show her the damage.

"Playing, madam."

"No, not playing Sonata."

She tries to explain to me in broken Arabic and English that at her last job in Saudi Arabia she was not allowed to discipline the children. She was locked in a house with the children during the day and had to make sure they were fed and had baths, but they could do whatever they wanted. Then at night when everyone slept, she had to go clean everything up.

"Sonata, here, when I am gone, you are the boss. Do you understand what boss means?"

"Yes, madam."

"Faris, honey. I think you and Samer know what is right and what is wrong. Please don't do this again. Do you understand?"

"Yes, Mama."

With round-the-clock support at home again, I am working sixteen hours a day and Ty is pushing for more. I finally convince him he needs to hire someone to help me. Ty hires Anna, a young nineteen-year-old Palestinian girl who was born on the wrong side of the world. She wants nothing more than to live a western lifestyle, but comes from a conservative Muslim family. I train her to answer phones, file and help with basic office support. Anna is happy to be working, anything to be away from her parents. When she arrives at work she has to call them to tell them she arrived. When she leaves for home she has to call them and tell them she is leaving. This girl has to account for every minute of her time.

One day Anna tells me she is afraid to get married.

"Why would you be afraid to get married?" I find this a strange declaration.

"A friend of mine in our village in Palestine got married. On the wedding night she had sex with her husband, but she didn't bleed. You have to bleed so the bed sheet can be hung on the balcony and everyone in the village can see that you were a virgin on your wedding night, otherwise it is a shame to the family and the bride will be killed."

"You've got to be joking. Are you serious, Anna?"

"Yes. My friend didn't bleed. She was a virgin, Paula, but she didn't bleed. Her husband and her father dragged her out of bed and asphyxiated her using a can of Raid. What if I don't bleed on my wedding night? They will kill me too."

Anna starts crying.

"Look, Anna, I don't know what to say except don't get married in your village, and marry a western man."

"My family will never accept that."

"Then marry a liberal Muslim. Find someone who does not believe in all that honor killing nonsense." *Damn barbarians.*

What kind of craziness are women locked into in this world?

Ty spends so much time with Anna in the boardroom with the door closed that Victor is getting irritated.

"You spend more time with that girl than you spend with your wife and kids!" I overhear Victor scolding Ty.

"Anna has a lot of problems. She needs someone to talk to for advice!" Ty barks back.

I tell Victor not to worry about it. Ty spending time with Anna is not a problem for me. Anna is the one I worry about. Ty is not the right person to be her confidante.

Anna's parents are going to Jordan on vacation and Anna does not want to go. Ty tells them we need her in the office. My guess is Anna wants to enjoy her freedom in Dubai with her parents away.

A couple of days later we get a call from Anna's uncle, Hassan, a friend of Ty, saying Anna was supposed to come over to their house for dinner the night before but never showed up. Hassan went to Anna's house, she wasn't there. The safe where Anna's parents kept her passport had been broken into and Anna's passport was gone. So it seems, was Anna.

Anna's father is already on his way back to Dubai from Amman. Late that night Hassan, Anna's father, Basil, and Ty meet. I am not sure how the details are discovered, but Anna had met a lesbian Filipino limo driver who works for one of the royal families. They took off together to the Philippines.

Hassan, Basil and Ty form a posse, fly to Manila and hire people to find her. When they find Anna she sets her conditions for coming back to Dubai. She doesn't have to cover her head, she can wear makeup and western clothes and she doesn't have to report to her father every second of every day.

Her father agrees. He has to get her back to Dubai as soon as possible to save face. When Anna walks back into the office the first day after her adventure I don't recognize her, all made up, her beautiful long brown hair cascading down her back. She is a beauty, a butterfly that had emerged from its cocoon.

About a month later, after one of Anna and Ty's private

meetings in the boardroom, Anna comes out in tears. She gives me a big hug and says she has to go. Shortly afterwards Ty announces he is closing the office and everyone can go home early. When we get home that evening Ty is acting strangely.

"Anna is not your friend," Ty announces out of the blue.

"Oh really, why isn't Anna my friend?"

"Because today she hugged me and told me she loved me."

I am sitting on the floor trying to clean something sticky off the VCR that the kids have spilled. I scoot around enough to face him.

"And you are surprised Ty? She's a young impressionable girl. You spend all of your time with her listening to her problems, probably telling her how wonderful she is, right? You take off to the Philippines on the whole 'Anna ran away with the lesbian driver' fiasco. You give her more attention than you give your own kids. And then you're surprised when she thinks she loves you? You're the one that's not my friend, Ty!"

I am not sure what Ty's reaction will be. I say it calmly, but I have said things calmly before and it triggered hells fire. Ty says nothing. He turns and walks away into the kitchen. Anna works for us for a few more weeks then quits. I don't know if it is because of embarrassment or because of Ty's unreciprocated love. But I am without an assistant and that means double my work, again.

Later that summer Ty and his brother Ziad come to me and say they found a way to get Ty an American passport, but they need my help. If I am working for an American company in Dubai, then Ty can get an American passport. They arrange for me to get a job with Rayburn through a hiring agency, as a secretary for the director.

I start working for Rayburn in August, from nine till five. The first day I am ecstatic to be working away from Ty. Most of the employees are American and I feel at home. The atmosphere is jovial and the other American secretary and I bond quickly. It is nice to have a friend.

I get off work, call Ty and tell him I am on my way home.

"Why are you on your way home?"

"Because I'm done with work and I'm going to go home and see the kids."

"No, you need to come to the office. You still have to get your work done here."

I should have seen that coming. Ziad does not want me working with Ty. Victor told Ziad about Ty's behavior and Ziad thinks my working with Ty is the problem. It isn't, but Ziad wants me to work only for the American company and told Ty he needs to hire someone to take my place. Ty won't do it – that would expose him too much.

I work days at Rayburn, evenings, nights and weekends, with Ty. I am working two full-time jobs, only sleeping four hours a night at the most. After two weeks I am like a zombie. My boss at Rayburn calls me into his office and asks me if everything is okay. I tell him my kids have been sick with ear infections one after the other, and I wasn't getting enough sleep. He is very understanding, but I am not sure he believes me. I think about telling him about Ty and ask for his help to get the boys and me out of Dubai and back to the States, but I have not been here long enough to build that kind of trust.

I am so excited to get my first paycheck. I haven't earned my own paycheck since working at the art gallery in San Francisco. I excitedly wave it in front of Ty and Victor. Ty looks at it and takes it.

"We need it to pay the employees this week!" Ty announces. Victor rolls his eyes but doesn't say anything. I don't know why I am surprised. I am a machine Ty is using as a means to his own ends, the same as everyone else who is an employee or a client. Ty is an energy vampire, sucking talent, souls or money out of people. Twisting them like Madeline's tea towel, squeezing everything he can out of them.

The next thing Ty needs for his American passport acquisition is a letter from Rayburn confirming my employment. He tells me to ask my boss for a letter, saying I need employment confirmation to buy a house back in the USA.

When I hand the letter to Ty he looks like he won the lottery.

Hugging me, jumping up and down, and saying how things are going to be so much better now. Better for whom I wonder? *Better in that I'm not going to threaten to kill you and the kids again, and I'm going to stop being a psycho kind of way?*

The next morning, when I am getting ready to go to work at Rayburn, Ty starts on me.

"You like working there don't you?"

"Yes, I do."

"Why, are you fucking someone there?"

"No, I'm not fucking anyone there, Ty."

"Then why are you putting on makeup?"

"For heaven's sake, Ty, you spend years scolding me for not wearing enough makeup. Now when I put on makeup you ask me why?" I know I am walking on thin ice, but I am beyond exhaustion, physically, mentally and emotionally dangling on the edge of a breakdown.

"Call in sick!"

"What?"

"Call in sick. You are not going to work today – or tomorrow."

"Don't you need me to keep working at Rayburn so you can get the American passport?"

"Not any more. All I needed was the letter confirming you work there."

"Fine, then I'll just quit."

"You can't quit!"

"What exactly do you want me to do, Ty?" I am exasperated.

"You'll call in sick today and tomorrow. Then go in for a day or two, and then call in sick for a couple of days and keep doing that until they fire you!"

And that is exactly how it played out.

One evening in September Victor asks me to come see him in the boardroom. He asks me to watch a promotional video of a five star hotel in Morocco. When it is over he looks at me, concern fills his eyes.

"You're leaving aren't you?"

"Yes."

"Are you going to be the manager?"

"Yes, but I would wash dishes if it meant not having to work with Ty."

We laugh. But it isn't a happy laugh for me. It is the laugh you laugh through tears in the face of tragedy, to try to convince yourself everything is going to be okay.

I know this means Victor, Marie, Daniel and Mara will be leaving in October. I feel happy for him, to be free of Ty. I also know with Victor gone, someone else will have to take the impact of Ty's daily tirades. That will be me.

I take the opportunity to tell Victor I need help.

"Victor, you know how bad it is for us. Please do something about Ty before you leave."

Victor nods his head yes, but looks down in shame.

After Victor leaves for Morocco I discover Victor told Ziad I went to him for help. Ziad told Ty. The only thing that came from it was Ty slapping me, telling me to never, ever speak to his brothers again about our personal problems.

The approaching acquisition of an American passport does improve Ty's attitude slightly. Ty leaves the first week of December to New York to see his immigration lawyer, take the oath, become a citizen and get his prized American passport.

Two days later Ty calls me in the middle of the night from New York screaming like a wild banshee. According to him, his lawyer asked for the letter I got from Rayburn. He handed the letter to her and she asked if I was still working there. Ty said no. That is when she screamed at him and kicked him out of her office. Apparently, Ty and Ziad did not read the fine print on whatever statute or rule they had found – I had to be working for the American company at the time Ty receives citizenship for their plot to be legal.

He is livid. Screeching out of control like a screaming mimi, one of those WWII rockets.

"You were the one who came up with the 'how to get fired' ploy, not me Ty. I was willing to keep working. You created your

own mess, not me!" It is easier to stand my ground with Ty when he is on the phone halfway around the world and I know his fist can't fly through it.

It is around two in the morning my time, six in the evening his, but Ty orders me to go to the office and says he will call me there. Once I get to the office he directs me towards a file, tells me which papers he wants faxed. I dutifully obey, then go home and go back to sleep.

I am not sure what transpires in the next twenty-four hours, but Ty calls me and says he has the citizenship, he has the American passport. He is so happy I think that maybe, just maybe, this will make things better.

Having the American passport does transform Ty. He becomes more arrogant and boasts to people he is an American. This gives him a status far above the stigma of being a Palestinian refugee and opens up worldwide travel.

It also gives him power, a dangerous thing for a violent, mentally unstable human being, and he doesn't need me anymore.

CHAPTER 12
One Stone at a Time

CHRISTMAS MORNING 1995, ONLY WEEKS AFTER HE HAS BECOME AN American, Ty walks into the boys' room and tells Samer to change the shirt he is wearing and hands him an itchy sweater. Samer is a headstrong four-year-old. He has color coordinated his clothes from the time he was three and I always let him choose what he wanted to wear. Samer tells Ty, "No."

I can feel the tension rising and gently maneuver myself between Samer and Ty. I ask Samer if he can please wear the sweater that Baba has chosen. Samer shakes his head no.

"Slap him, Paula, or I will!" Ty orders. I know if Ty slaps him it will be much harder. I slap Samer lightly on the cheek, mouthing the words and lightly whispering so Ty cannot hear, "Cry or put on the sweater!"

Faris learned early on that crying is a good survival skill. It gives Ty a sense of control and he will back off. I need Samer to cry, but he won't. I slap him again a little harder. It is killing me inside, but I can feel the heaviness of Ty's wrath behind me.

The next thing I know Ty grabs Samer by the waist. Samer is kicking and screaming. Ty marches with him into the guest bathroom, lifts the toilet seat, put his hands around Samer's neck from behind, and starts strangling him and drowning him in the toilet water.

Ty is hunched over, his huge body towering over Samer. I am beating on Ty's back, screaming, crying, telling him to stop, please stop, STOP. He is killing him. The guest bath is small and

narrow and I cannot get around Ty's large body to try to pry his fingers off Samer's neck. I try pulling on Ty's leg to get him off balance, but he is too heavy for me to budge.

"Ty stop! Stop! Ty, please stop you're going to kill him!"

Finally, he pulls Samer's head up, pushes him to the floor, pushes me out of the way and stomps out of the bathroom. Samer is coughing up water, choking and screaming hysterically. I grab him and rock him, holding him tight, stroking his head, kissing his face.

"Okay baby, it's okay, you're okay!" *Oh my God, oh my God, what am I going to do?*

I don't know how long Samer and I huddle together on the bathroom floor, his little body shaking, his little spirit destroyed.

When Samer stops crying I carry him to the bedroom. Faris is on his bed, horror fills his sweet face. Tariq has been in the maid's room with Sonata. I have no idea where Ty went.

"Samer, honey, can you please put on the sweater Baba wants you to wear?" I am trying not to cry, to be strong, but it is difficult.

"Okay, Mama," Samer whispers, his bottom lip quivering and his eyes filling with tears again.

"I am so sorry I slapped you, honey. I am so sorry. I love you and I wanted you to put the sweater on so Baba would not get mad. We must do what Baba says, okay?' I take off his t-shirt to put on the sweater.

"Okay, Mama," a broken little boy whispers back to me.

That is when I see the marks in the shape of Ty's hands on Samer's neck, the bruises already starting to form. Faris sees the bruises and his eyes fill with tears. Faris helps me get the sweater on Samer the whole time repeating, "It's okay, Samer." Faris hugs Samer and holds his hand.

Ty's family members are due to start arriving any minute. Ty walks back into the boys' bedroom and sees Samer is wearing the sweater. He shows no sign of remorse. He arrogantly glowers at Samer and says, "Nice sweater!" and walks away. I want to run up behind Ty with a rope and strangle him.

The doorbell rings. The first to arrive are Madeline and Ziad with their children. Madeline takes one look at Samer and gasps.

"What happened to Samer's neck?"

"Paula did it!" Ty condescendingly announces.

My heart sinks. Madeline looks at me. She knows. She knows Ty did it, but she learned long before me to keep her mouth shut.

I am good at pretending everything is wonderful, but today is the most difficult. Faris does not leave Samer's side for the rest of the day, even when all the cousins are playing together. Faris hovers over Samer like a hen over her chicks. The bruises on Samer's neck are the big elephant in the room everyone is ignoring. His brothers know from the size of the bruises that Ty did it, yet no one says anything. *Why doesn't someone say something? Why don't they tell Ty to cease and desist or they will take matters into their own hands?* Maybe if Victor were here he would say something. But for the rest, blood is thicker than water. I remember Khalid from the American embassy telling me that if the injuries are life threatening then the father will say the mother did it and she will be arrested. I am alone in this madness for the survival of myself and my children.

During the first couple of weeks in 1996 I wait for an opportunity to get to the American embassy again. I speak to Khalid.

"Khalid, if we need to leave the UAE and go home, but I don't have the boys' passports, how can we leave with them?"

"You can't leave without their passports. Did you lose them?"

"No. What's the procedure to get new ones?" There is no way I am going to tell Khalid what is going on. I don't trust anyone. I don't know who Ty knows.

"Is this for your American friend?" Khalid is referencing our previous conversation. I nod yes.

"We can issue new passports if they are lost or stolen, but both parents need to come in."

"Okay, thank you Khalid."

"Paula, is everything okay?"

"Yes, fine. Thank you." I don't know if Khalid suspects I am my American friend.

My day-to-day goal is to try to keep the boys safe, away from

Ty's rage. The good thing with his newfound freedom as an American is that he travels as much as possible, and is gone much of the spring. I take the opportunity to look for the passports, but it is like trying to find a needle in a haystack. He takes Faris with him to Singapore in March, even though it means missing school. I am confident Faris will tell me if Ty starts fondling his penis again. For the most part Ty travels alone. With Ty gone so much the boys and I have some normality to our lives and Sonata is a blessing. They can play outside, and sweat and get dirty without fear. I take them to the beach or to the pool. They don't worry about having to shine their shoes every day or be terrified because Ty found sand in their shoes after school.

By June Ty is having me travel with him again, to Bahrain and Qatar mostly. When I am not traveling with him I work long hours at the advertising company. Ty hires a new lead designer from Ireland, Kian, to head the design studio and supervise the three designers from Sri Lanka. I wonder how long Kian will last.

We have a long-term client, the Asabis, a very wealthy Arab family who have multiple business interests. They are good, down to earth, honest people who work hard. You can tell by their eyes. Self-made millionaires who haven't let their wealth go to their heads, not wanna-be millionaires like Ty.

Ty does make money, lots of it, but he is a compulsive spender. He thrives on projecting his wealthy, international businessman image, dropping $2,000 for dinner to entertain people he wants to impress as if it is nothing. And there I am beside him, laughing, lighthearted, playing along in my diamonds and pearls, the perfect, happy couple. A pathetic lie.

I hate how Ty is charming and polite to the Asabis then turns around and mocks them when they leave. He calls them his victims. They trust him so he increases his prices on their jobs, then goes back and requests more money, always with some excuse which makes perfectly good sense, except it is all fabrication. Ty is a con artist in both his professional and personal life. He was never a millionaire. He had misled my father on purpose, knowing what my father wanted to hear – that his daughter would be well taken

care of. He is a social chameleon with the keen ability to quickly determine what color he should shift to next, depending on the perceived expectations of his victims.

He never knew all those famous people he talked about when we first met in San Francisco. He had made money as a photographer for famous magazines, but when that money ran out his brothers were supporting his extravagant lifestyle in San Francisco. Almost his whole life is a big, ugly web of deceptions.

Big-brand clients in the automobile, fast food and beverage industries, with huge advertising budgets, are getting screwed by Ty too. He only runs half of the television advertisements the client pays for, and then he gets two media certificates. One certifying the real number of advertisements run, and the other certifying the false number. He gives the client the one certifying the false number. Ty pays the television station based on the certificate for the real amount. When the client pays him, Ty pays off the guy at the television or radio station. The only media he cannot fake is newspaper and magazines. The client asks for the tear sheets as proof. But for television and media, the only proof is the certificate – Ty always convinces the client that television and radio are the best. In addition to that he is taking the 17.5% advertising agency fee.

A client will pay $117,500 for a campaign, two-thirds of it going to television and radio advertising and one-third to print. The client gets around $67,000 worth of advertising, pays $17,500 to the agency and $33,000 – God knows where that goes. Several times men come to the office and ask for Ty. I have no idea who they are. I go to Ty's office and let him know the person is in the waiting room. He tells me where he has left an envelope and instructs me to give it to them. I hand the mystery person the envelope, usually very thick, and they leave without seeing Ty. I am their money mule.

Ty and I sit in the fabulously expensive boardrooms of affluent clients. Ty always presents the campaigns I have written and produced with the design team. I am there for window dressing, his personal Vanna White. In one meeting, when Ty gets up to

speak, one of the clients tells Ty, "Why don't you sit down and let Paula speak. We know she's the one who does all the work!" The pressure in Ty's head must feel like an erupting volcano. He is coughing and sweating, his face turns bright red. He adjusts his tie and his collar. I think steam may start shooting out of his ears. He takes a drink of water and tries to compose himself by laughing it off.

I hear Ty come back from a meeting. He storms into my office.

"Why do you use words you know I won't understand? Are you trying to embarrass me?" He is mad as hell. Kian, the design team and Krishna are in the office, I am safe from a physical assault.

"What happened?" I ask scanning the proposal in my mind wondering what word he could be referring to.

"Sages! Goddammit! Sages!"

"I didn't use sages in any proposal."

"No, you used it in our Christmas Newsletter. He shoves it in front of me."

"This is from a couple of years ago. What are you so mad about?"

"I was showing it to the Asabis. Then they asked me what sages meant and I didn't know."

"Why didn't you tell them Paula wrote it and you didn't know. Anyway, it's from a poem by Robert Lewis Stevenson. '*Happy hearts and happy faces, Happy play in grassy places, That was how, in ancient ages, Children grew to kings and sages*'." I recite.

"I don't give a damn. From now on, I don't want to see a single word I don't know!"

Kian, hearing the screaming, walks into my office as Ty walks out.

"Okay, luv?" Kian asks when Ty is out of earshot. He looks concerned.

"Yes, fine. Thank you. Do you have time to go over the design for the Kuwaiti oil company annual report?"

Kian nods yes, and I walk back with him to the design studio. I hear Ty's footsteps close behind. He knows Kian heard him shouting and he wants to make sure Kian does not say anymore to me about it.

I am thinking about having to be careful now what I write. Ty has about a third grade understanding of written English. I can hardly write professional business proposals to ministers and graduate level professionals using crayons and connect the dots.

A wealthy couple, high-end interior designers for the royal families, comes in to pick up the flawless brochures we have made for them. Ty has done all the photography, I have done the copywriting and Kian has done the design.

The wife looks through the brochure thoughtfully, closes it, considers me and gushes, "You're so lucky to be married to such a talented man. It's hard to believe a man has such sensitivity and emotion in his writing. He's truly an inspiration."

"Yes, it is hard to believe isn't it?" I agree. I smile politely. Silently thanking her for the compliment.

Ty doesn't bat an eye. "Well, thank you. But your beautiful work is the inspiration for my writing."

Oh please, gag me.

Most embarrassing for me, other than being the bull's eye for Ty's anger in front of employees, is that he has me use a different name on the phone for different clients. Some clients know me as Ty's secretary Marie, and some know me as Ty's wife, Paula. Having to keep those straight is nearly impossible. I beg him to hire someone to replace Anna but he refuses, saying I need to work harder.

This summer is exceptionally bad. Ty doesn't allow the boys to go out of the apartment. They are bored and pale. They probably have vitamin D deficiencies from the lack of sun.

Ty flies into a rage if they breathe wrong. Samer pokes a hole in the bug screen. Ty slaps Samer repeatedly, ties Samer's hands together, ties Samer's feet together and throws him in the dark storeroom. I am screaming, "Are you out of your fucking mind?" For which I get slapped hard across the face.

Ty screeches, "If you dare get him out of the closet I will fucking kill you!" Ty leaves and goes into our bedroom. Samer is screaming and crying. I sit on the floor and sing, *'Hush little baby, don't say a word, Mama's going to buy you a mockingbird,'*

through my tears, through the door, hoping my voice will soothe his little soul, bound and tied in the darkness.

Ty comes out of the bedroom fifteen minutes later, opens the storage room door, and tells me to be in the office in five minutes. I untie Samer, hug him, and tell him everything is going to be all right. I give Sonata some money and ask her to take the boys and get ice cream.

Today Faris says he isn't hungry at lunch. Ty screams at him and makes him get into a large black garbage bag. Faris is terrified, screaming and crying inside the bag. Ty screams at him, kicking the bag, telling him he is garbage. Samer, Tariq, Sonata and I watch in horror. We have learned intervening means things will only get worse. Ty suddenly stops, opens the bag, and tells Faris to go eat. Faris eats. After that, Ty walks around the house with a black garbage bag shaking it at the boys, telling them they are garbage. He looks at me and utters, "Fear teaches kids discipline!"

We are living with a mad man, a crazed monster

I see Ziad in the office. When Ty goes to the bathroom I tell Ziad I can't take it anymore.

"You should be used to it by now!" Ziad laughs it off. They aren't going to help me.

I decide to buy a tape recorder and try to tape one of Ty's raging episodes. Maybe I can take that to the American embassy and they will find a way to get me out without needing the passports. One afternoon after lunch, I sense Ty's dark wrath descending. I push the button and start recording. As anticipated Ty begins screaming and threatening us. He calls Faris into our bedroom. When Faris walks in he asks, "Mama, what's that light in your handbag?" Ty grabs the tape recorder, pulls the tape out and destroys it.

"If you ever try to fucking tape me again I will kill you, you fucking American cunt."

Each year is getting worse and worse – me fearing Ty more and more, fearing we are living on borrowed time.

In July we finish a big campaign for a major consumer brand. We are going to take Kian out to dinner. Ty calls.

"I'm staying in Bahrain tonight. You take Kian out."

Kian is twenty-five, untidy dark hair, easy on the eyes. With his adorable accent and his carefree manner, he has no problem with the ladies.

We go to Mama Mia's, a small Italian restaurant crowded with westerners. We order a bottle of *chianti* and share a pizza, making small talk mostly. Trading stories of our rural upbringings, pets we had and the latest project we are working on. Then Kian surprises me.

"Y'know, yur a beautiful woman. Smart, fonny."

Compliments? I hadn't heard those in about a decade. Kian gently begins drawing a sensual circle with his finger on top of my left hand, looking me straight in the eyes.

"Ah could take ye home and make luv to ye. Ah promise I'll make ye feel good."

This guy is killing me. He is twelve years younger than I am. I haven't thought of myself as being desirable by anyone in a very long time. I am enjoying the moment.

"Kian, you're very sweet. And I'm flattered. But that's not going to happen."

He leans in closer to me, his hand protectively on top of mine now.

"Ty is a fouck'n asshole. He doesn't treat ye right, luv. Everyone in the office 'ates em. He's fouck'n bollocks."

"The punishment for adultery in this country is being stoned to death, Kian."

"Ah won't be tell'n nobody. We can just enjoy ahselves for a wee bit of time."

"When we're done here I'll drop you off at one of the nightclubs. I'm sure you'll find someone to take to bed tonight."

"I want to spend time with ye, not some dumb girl in a club. Why are ye loyal to him? He doesn't luv ye. Not the way he acts. He treats ye like dirt. Ye deserve betta."

"It's not about him. It's about my children. I would never do anything to risk their safety. Their mother being stoned to death is not in their best interests."

"Ty is the one that's stonin' ye to death luv, he's just doin' it one stone at a time."

The truth of Kian's words burn like fire in my heart. We finish dinner and I drop him off at his apartment.

When I get home, Ty is there.

"I thought you were staying in Bahrain?"

"I decided to catch a flight home. You're home earlier than I thought you would be. How is Kian?"

"He's fine, we had dinner at Mama Mia's then I dropped him off at his apartment."

I can't help but wonder if Ty was setting me up, giving me just enough rope to hang myself, thinking I might stay out late with Kian so he can justify his next episode of violence. Maybe justify killing me. I lie in bed and think about what Kian said. I would never take such a risk in this God forsaken country. Madeline's tea towel, scaffolding, Kian's stones – my life is a becoming a string of metaphors.

The fall of 1996 Ty travels without me again. I search for the passports. He may come back in a day, or a week. I don't know. When Ty gets back Kian quits, telling Ty he is going back to Ireland. Kian calls me a few weeks later and says is back in Dubai working for another design firm. He gives me his number in case I need anything. I won't call him. I will be putting him in danger if I ask for his help.

Ty flies back to the UK to find another lead designer. With him gone I take the boys to the pool at one of the clubs. When Ty calls I rush someplace quiet and answer.

"Where are you? I called the office and the house! You didn't answer!"

I tell him I am doing grocery shopping with Sonata and the boys or taking one of them to the doctor. If the excuse involves food or medical needs he is fine.

"When will you be back? I need something!" That is my cue to get the boys back to the house and my butt back to the office.

One afternoon I tell the design team I am going to run some errands. I get in the car and drive mindlessly along the road that

runs beside the sea and the length of my prison, an endless moat around a pretentious kingdom. I find myself at the gate of the women's beach. I am wracked with guilt. It is a gorgeous fall afternoon and the boys are at home with Sonata. I should have gone home, gotten them and taken them to the pool. But they are safe and they love Sonata, and I need some precious time to think, to plan, to scheme how I will get out of here.

The women's beach is a paradisiacal alcove. The main entrance is guarded by a policeman, who sits in a small hut taking entry fees during opening hours. A police boat guards the sea entrance a polite distance from the opening of the inlet. No men, or boys over seven years old, are allowed. Ty says the women's beach is full of lesbians, which he has accused me of being on several occasions when I fail to fake an orgasm when we have sex.

In front of me young Emirati women pay their two *dirham* entrance fee and run down the dirt roadway, though the oleander hedge and onto the grassy lawns that stretch to the white sand and brilliant blue water. I have seen them so many times. In exuberance they shed their black *abayas* like snakeskins, revealing dark-skinned beauties wearing colorful bikinis, their long, black hair flowing over sun-warmed skin. Freedom. They chat excitedly while rolling out their blankets, set down their boom box and bags laden with food before running, screeching and giggling, into the salty water. Swimming, laughing and splashing with each other in the gentle ebb and flow of the sea, they are truly happy. They run back up to the shore, flop on the ground, open their bags to reveal a culinary Arabic feast.

Rested and fed, they turn up their boom box and dance, in slow, suggestive, swaying, body movements, seeking the approval of their voluptuous forms from their girlfriends. In a suppressed society where young women are not allowed to socialize with young men or reveal any part of their body in public, this beach offers the freedom of fleshly self-expression. Here they are free, projecting their forbidden sensuality through dance, a short reprieve from the ever-watchful eye of their conservative elders.

I am trapped. So very trapped and alone in my search to

escape. So full of love for my children I desperately want to get back home to the safety of the USA, so full of anger at Ty for everything he has done to us. I want to scream and this is the place to do it.

I strip down to bra and panties and glide into the sea. The surface of the water glistens like diamonds. I dive down until I reach the cooler water, scream as loud as I can, and then come back up for air. Each time I dive deeper and scream louder, then came up for air with dolphin-like fluidity, until I collapse on the shore.

I find a trio of large rocks protecting me from view if other ladies decide to encroach on my space. I flop on the soft white beach, the lower half of my body in the water so I can take the heat longer. I remove my bra and press my belly and bare breasts into the welcoming warmth of the sand, resting my head on my hands. The deep penetrating heat of the sun dries my back.

Warm seawater laps gently around my thighs, the ebb and flow of the tide gently lulling me into a light sleep. The sea, earth and sun massage and caress my body in beautiful sensual harmony. I awaken to a momentary tantric connection. I feel alive. Amused, I mindlessly draw designs in the sand for a few minutes until I turn, splash water on my breasts and belly to wash off the sand, and lay on my back. Here, with my eyes closed in solitude, I imagine I am on the beach in California, the boys playing close by. We are free and Ty is no longer in control. Then the call to prayer from the nearby mosque drifts into my consciousness and I am back in my prison.

I put my bra back on, get dressed, get in the car and drive home. With Ty gone I am free to hug and kiss my boys and that is what I want to do. Just hug them and kiss them. When I walk in, I hear them playing in their bedroom.

"Hello, madam!" Sonata greets me in a singsong melody. "We are playing!" Sonata is sitting on the floor leaning against the wall. Her hands are tied together at her wrists and her feet tied together at the ankles.

I sit down and sigh. The boys are re-enacting Ty tying up Samer. At least they didn't lock her in the closet.

"Okay, boys, let's untie Sonata and go get ice cream!" Squeals of joy fill the room as they release the ropes from Sonata's limbs.

We go to the Burger Queen down the road. The boys play in the ball pit and on the slides without fear of getting into trouble for sweating or getting dirty. I explain to Sonata that she should not let the boys tie her up. She answers, "Just playing madam?"

"Yes, I know, but it's not good for them to tie you up. You can play other games."

"Yes, madam."

When we get home I go to my room and sit on my bed. A few moments later my three little angels come into the bedroom. They stand in front of me, all in a row, holding hands, seriousness on their innocent faces. Faris is their spokesperson.

"Mama, we don't want to live with Baba anymore. He is mean. We want to go live in America with you."

This is something they have talked about, have come to a consensus and, like a little committee, have come forward with their request.

"Come sit with me," I pat the bed beside me and they jump on. "I know. I'm trying and I promise as soon as I can get us out, we'll leave and go live back home in California."

I wasn't lying. It is truly how I feel. Their beautiful, pure faces beam at my words. We talk about where we will live. They want a kitten and a puppy. They gleefully bounce up and down on the bed shouting out their heart's desires. Tariq turned two in July. I am not sure he knows what is going on, but the elation in Samer and Faris is contagious.

After Ty's near killing of Samer the previous Christmas, I am dreading the holidays. It doesn't matter what you do, Ty will find some excuse to justify his violence. I can do ninety-nine out of a hundred things correctly. He will ignore the ninety-nine and focus on the one thing he can tear you apart over. Christmas and New Year pass with Ty ranting and raging about the potatoes not being done enough and using the wrong size shrimp, but at least no one has bruises this time.

HARVESTING STONES

CHAPTER 13
A Cry For Help

JUSTIN, A CHARMING YOUNG MAN FROM SCOTLAND WHO IS REPLACING Kian as our lead designer, arrives after the New Year. Justin is very handsome with hair that sweeps above his eyes, a boyish grin and an endearing Scottish accent that is, at times, difficult for me to understand. I wonder if he will last as long as Kian before he can't take Ty anymore.

I know my birthday – January 16, 1997 – and the day after, are going too well. We work all day on a photography shoot for a client in Abu Dhabi even though it is a Friday, the weekend. When we get back in the car Ty starts speeding. I haven't said anything and I have no idea what he is mad about. He starts shouting at me, driving faster. I ask him to slow down. He backhands me with his right hand and screams at me not to tell him what to do.

"Okay, but if you're going to speed at least put your seatbelt on please!" I think by showing I care about him, maybe I can stop whatever this is from escalating.

It is Ramadan during *Iftar* (the evening meal during Ramadan), and the roads are practically empty. I watch the speedometer hit 160kph.

"Are you afraid to die? Are you fucking afraid?" He is spiraling out of control.

I don't know the correct answer. I know from past experience whatever I say will be wrong.

"Answer me!" His voice is booming.

A sandstorm had engulfed the UAE earlier in the week leaving

sand piled on the sides of the road, like snow piled on the side of the road in the mountains. Ty drives onto drifting sand, panics and over corrects. The last visual memory I have of the crash is the headlights on the concrete barrier. The last aural memory I have of the crash is the sound of the car slamming head-on into the concrete barrier and bouncing off two or three times, like a ball in a pinball machine.

When I gain consciousness a man is pulling me from the car shouting, "Get out, get out, get out!" He pulls me a safe distance from the car. I turn around and cannot believe what I see. The car is destroyed. The only thing intact is the passenger compartment. I can hear the ambulance and police sirens. I feel light-headed.

Ty seems fine. He is walking around the car looking at the damage. *Thank God the children weren't with us. Why the hell did I tell him to put his seat belt on? He would have catapulted through the front windshield and the rest would have been in God's hands.*

I tell the man I need to find my glasses. He helps me up, but I get dizzy and sit back down on the asphalt. The gas tank has ruptured and he is concerned the car will explode. The police and ambulance arrive. A policeman takes one look at the car and says, "If you'd been in another car instead of a Volvo, you'd be dead."

The man helps me up and I go back to the car to try to find my glasses and get a few things.

I don't remember much of the ambulance ride to the hospital. I am on a gurney looking down at my toes. *I don't have a toetag on, so I didn't die along the way. I really need a pedicure.*

Ty walks into my hospital room with his left hand bandaged. Seems his hand got caught in the steering wheel and twisted. The doctor addresses Ty.

"Your wife has head injuries. I really need to keep her here overnight for observation."

"She can go home with me. I'll watch her." Ty informs the doctor.

They are speaking about me as if I am not in the room.

"Then you'll have to sign a paper saying the hospital is not responsible for anything that happens to her."

"Hello, hey Doc, what if I want to stay?" I ask. Hospital observation would be a nice vacation away from Ty.

"If your husband signs the paper and says you have to go, you have to go. There's nothing I can do. I'm sorry. Is there anything else?"

Well, isn't that nice, another reason I love this country so much.

We climb into the back of the taxi. My head is throbbing. Ty starts screaming at me without skipping a beat, as if the car accident didn't happen. There is enough light from the half-moon above the Dubai/ Abu Dhabi road to see camels dotting the sand dunes in the distance. I wish I were one of those camels. I would walk over the sand dunes as far away as I could away from Ty. He goes on and on, but I block it out. He isn't going to hit me with the taxi driver present – I close my eyes and pretend to sleep. With head injuries sleeping isn't the best thing to do, but I cannot stand the sound of his voice any longer.

We get home and Ty goes to bed. I go to the boys' room and kiss each of them on the cheek. It is time to get help. I am wrong to think I can do this on my own. I am not going to make it out of this country with my boys alive.

I sleep for around four hours. When I try to get up I cannot move. The shock from the accident has worn off. I can't move my neck or my head. Every muscle in my body screams in pain. I have to roll onto the floor on my knees, then lay my upper body across the bed and straighten my legs to stand. Ty is still deep asleep. There is a question often asked about people who do terrible things, 'How do they sleep at night?' I can tell you, they sleep fine, just fine.

I go to see the boys. I tell them we had a car accident, but we aren't hurt. Everything is going to be alright. I take a hot shower, then some pain killers, and drive the boys to school in Ty's car, go to the office and call Paul collect so the call doesn't show on the phone bill.

I spill my guts, the accident, Ty's violence, the craziness of life day-to-day. I am sobbing. I want out, I want to come home. I am begging in between gasps and sobs. Paul listens until I calm down. He says he has suspected things weren't right for a long time.

Paul mobilizes Karen and Rebecca. Over the next few weeks they call their congress representatives and senators, the State Department and the American embassy. No one will help. How can that be? I am an American citizen with children who are American citizens and I want to go home. That is all. I didn't commit any crime here. I just want to go home.

Now my family knows, in some ways it is harder. They are terrified for me. My sister Karen keeps telling me, "You need to get out!"

I know that. I also know Ty now knows I want out, and he has put everything into place he can think of to prevent me from leaving. Sad really, to be unloved by your wife, your children, your employees, so the only way to keep people around you is to hold them prisoner.

Ty travels to Singapore and takes Faris with him. He calls and tells me where he left Samer's passport and to come with Samer to Singapore. Tariq's passport is not with Samer's passport. Ty has hidden them separately. I have my passport already.

Samer does well on the plane until we stand up and start walking down the aisle to disembark. Samer projectile vomits on the man in front of us. Fortunately, the man is very kind and understanding. I take Samer to the bathroom at the airport and get him cleaned up. Poor baby is miserable.

Ty and Faris meet us and we take a taxi to the five star Shangri-La Hotel. To the untrained eye we look like a happy couple with two adorable children – Faris bright eyed and inquisitive, Samer curious and observant. We watch a Chinese New Year celebration at an outdoor restaurant. The boys love the dragon dances. We take the boys to Sentosa Island for a day and have fun. In earlier years I may have believed this was the new normal. But it is the scaffolding; all neatly hammered securely back into place, no spaces between the boards, for a brief moment in time.

Ty leaves the boys' passports in plain sight on top of the table in the hotel. He is baiting me. If I run with Samer and Faris now I will never see Tariq again. He knows I won't leave Tariq. It is a passive-aggressive reminder of his power.

The night before we leave to return to Dubai, I am lying in bed and ask Ty why he married me. I blurt out the question, as if it was in my head but I said it out loud.

"Because I thought I could mold you into what I wanted you to be."

That answers the question I had all those years ago, *why is someone so worldly and wealthy interested in me?* Ty skillfully manipulated my innocence. Oh, how he must have been frustrated when I resisted, changing the answering machine back to my voice after he changed it to his without telling me, not putting the 'I'm Taken' key chain on my key ring until months after he gave it to me, getting a job at the art gallery after he persuaded me to quit the utility company. I suddenly realize why Ty is silent during sex. Intimacy is an act of letting go and revealing who you are to another person. He is not capable of true love, of allowing his soul to bond with another. Sex is a physical release for him, no different than masturbation. Is that why he fondles Faris' penis? I cannot dismantle the tangled distortion of Ty's existence, I am not a psychologist.

We fly back to Dubai together. The rest of the spring I go with Ty to Bahrain and Qatar on multiple trips, relieved he is away from the boys and I can take the impact of his ranting and raving.

On one trip to Qatar I had forgotten my mascara. To anyone else the simple solution would have been to go to the store and buy mascara. But Ty is not anyone else.

"You can't even fucking remember to bring mascara?"

Here we go.

"Let's go to the store and buy a new one. This is a five star hotel. Don't they have a store in the lobby?" I offer a simple, quick solution.

"That's not the fucking point!" He grabs my arms and pushes me against the wall of the hotel room. No witnesses. I am in trouble.

"You need to be more fucking responsible. You have children to feed! How the fuck are you supposed to go to a meeting without mascara."

"We can go to the store now and buy it. Ty, you're hurting my arms!"

Then comes the slap across the face.

"Don't fucking talk back to me."

I am crying now. He slaps me again – this time for crying.

"Stop fucking crying!"

By the time he is done screaming at me my face is red from being slapped and my eyes are red from crying.

He tells me to sit down, brings me a warm, wet washcloth, sits down next to me on the bed and gently wipes my face.

"Feel better now?" Ty asks nicely.

I don't answer.

"Now, let's go to the store and buy you mascara," he says, as if nothing has happened. As if he is responding to me when I first said I had forgotten my mascara without all the screaming, pushing, slapping and crying in between.

I put on a light sweater to hide the marks emerging on my arms. We take a taxi to Salam Studio and Stores, the local department store. Ty buys me mascara and a beautiful two-piece quilted pink Chanel suit. I am only physically in the store with him. Mentally I am back in the States with the boys, safe and away from Ty. He keeps asking me what is wrong, as if he has no clue, and I tell him I am tired.

Since Singapore, Ty is physically violent almost weekly, targeting Faris, Samer or me. He seems to ignore Tariq who always runs and hides in Sonata's room when his little radar senses trouble. The rest of the time Ty is sullen and moody. His other two channels are strategically hostile and brutally violent.

Anything we do can send him into a rage – baking a cake for Tariq's third birthday, Samer accidently spilling his cereal, Faris sweating – breathe wrong and you are taking your life into your hands.

At lunch at home Faris doesn't want to eat some squishy chicken.

"It's okay, darling, put the squishy parts on the side of your plate. Will that be okay?" I gently ask Faris.

"Ignore what your mother says! Eat it!" Ty unravels.

Faris tries, but can't swallow the squishy parts.

"Look at what the fuck you do to him, you and your fucking American habits!"

He begins slapping Faris across the face screaming at him to eat the chicken. Faris is crying. Ty grabs Faris by the hair, forces his head back and shoves chicken down Faris' throat. Faris is choking and gasping for air, he gags and vomits. Ty is scooping up the vomit in his hand and forcing it back into Faris' mouth. Faris is choking and I jump up from my chair to help him.

"Don't you fucking help him!" Ty screams

"Fuck you, Ty! Fuck you!" I scream back. I am ready to fight. I might lose but I don't care.

Ty runs to the bedroom, grabs the video camera, comes back to the dining room and records Faris's ordeal.

"See what the fuck you caused, this is your fault. I don't want your fucking American bitch influence on my children anymore!' Ty is madder than a rabid dog.

Ty puts down the camera, grabs Faris, holds him and rocks him like a baby in his arms, Ty starts crying, his tears dripping down onto Faris face. Faris looks up at Ty in stunned silence. We all look at Ty in stunned silence. We are frozen with shock and horror at the raging lunatic that terrorizes us in our own home.

CHAPTER 14
Mama has to Die

IN AUGUST TY NEEDS TO GO TO JERUSALEM FOR A PHOTOGRAPHY assignment. He takes me with him because the client's wife will be there and he wants us to socialize. Ty thrives on equating himself with the fabulously rich. We fly first class to Amman, Jordan. Ty stands in the middle of the aisle, glass of champagne in hand as if he is at a *soirée*, speaking loudly so the other first class passengers can hear.

"Remember when we took that trip to Paris? Or was it Rome?"

I am horrified. I sit in my window seat with my nose in the in-flight magazine, pretending I don't know him and hiding my embarrassment. Nobody cares about where Tysir Dasanti traveled, especially not wealthy, first class passengers.

From Amman, Jordan we take a bus across the border into Israel. As we live in the UAE we cannot fly there directly. When we enter Israel they don't stamp our passports, but stamp a paper we have to surrender when we leave.

We stay at the American Colony Hotel in Jerusalem, a historic boutique hotel with a center garden courtyard. The hotel is built of stone and one of the loveliest places I have ever seen. But it is more than the structure reaching out to me. There is something enchanted here. I can feel it. I wish Ty wasn't with me. His dark aura is sucking in the light.

The photography shoot is in Ramallah, a town in the West Bank and the birthplace of the *Intifada*. The residents are mostly Palestinian refugees. Every morning the client sends a bulletproof

Mercedes to pick us up. We pass through Israeli checkpoints – armed guards with machine guns ready to fire check our passports, examining our faces against the passport photos, and then wave us on. We repeat the routine on the way back to the hotel every evening. I don't feel afraid when machine guns are pointing at my head. They pose less of a threat than the man who is sitting beside me. Mercifully Ty is on his best behavior. The client is wealthy and powerful, Ty can't afford to upset me and have me looking as if I have been crying. He certainly can't risk me having any bruises as I socialize with the client's wife.

Ty shows me around both the Palestinian side of Jerusalem and the Jewish side. The tension between the Palestinians and the Israelis is palpable. Palestinian taxi drivers lament the injustices and the oppression of the Israelis. Israeli taxi drivers express loathing and fear of the Palestinians. When we get into a Palestinian taxi, Ty speaks in Arabic with a Palestinian accent, proud of his heritage. When we get into an Israeli taxi, Ty speaks English, emphasizing an American accent, proud of his American citizenship. For once I am grateful for his social chameleon-ism.

We take a taxi one evening to Tel Aviv and spend the night. Ty hates the Israelis and is tense and nervous in Tel Aviv. He perceives a much larger enemy here – anger towards me is off the table temporarily. The following day we take a taxi up to the Palestinian villages south of the Lebanese border, where Ty has relatives. We are treated like royalty. The village holds a party in our honor, and around a hundred and fifty people come. Ty and I are the center of attention, he soaks up their adoration. The villagers only speak Arabic and Hebrew. My Arabic is put to the test and I am beholden to Mama Wafa for being such a good teacher.

The villagers are very poor and very healthy. The children are tanned, strong and peaceful with glowing rosy cheeks. They live off the rich, fertile soil, so red and earthy you can inhale and taste the fullness on your tongue. I think of my boys in Dubai, pale, dark circles under their eyes from lack of fresh air and sun, nervous and tense, living under Ty's tyranny.

"I would love to live in this village. Have a simple healthy life where everyone works in communal gardens, bread is baked at home and eggs are from the chickens in the back yard, milk from a family cow and meat from the butcher."

"Are you out of your mind? There isn't a supermarket or store in sight! Why the hell would you want to live in a poor Palestinian village instead of Dubai?" Ty is aggravated, but controlled. He must be having withdrawal symptoms not being able to smack me in the face at will.

We spend the day visiting different relatives in the village, drinking mint tea and eating meal after meal. Everyone wants to hear stories about Dubai and America. The next morning, while we are having coffee on a balcony of one of the modest stone houses, the radio announces that Princess Diana died. I start crying.

"What the fuck is wrong with you? People die all the time!" Ty snarls.

I ignore him. I don't understand why Princess Diana, someone who is so beautiful and does good in the world dies, and someone like Ty, who destroys everyone he touches, lives.

We spend the morning in the village, say our goodbyes and travel to Haifa. We have lunch at a restaurant on the water with one of his uncles, take a taxi back to Jerusalem and the hotel where we spend one more night before catching the return bus to Amman.

Back in Dubai, a childhood friend of Ty's is in town and we are taking him out to lunch. We meet him at the Mexican restaurant where I had taken Kian. The first thing that strikes me about Sami is his eyes. They are alive. They twinkle with light. He smiles and laughs easily and his eyes smile and laugh with him. I look at Ty. Ty's eyes are cold and dead. A friend of mine once told me that Ty has taken the light out of my eyes. Maybe that's what Ty is good at, extinguishing the light in other people's eyes. Sami is charismatic, energetic and looking for a job. Ty hires him to work as the marketing manager. I wonder how long he will last.

Sami comes into the office later that week to sign paperwork and meet the staff. Ty asks for Sami's passport to make copies for his work visa. He hands the passport to me and I make copies. I hand the copies and passport back to Ty. Ty takes the passport and photocopies, opens his desk drawer, places the items in the drawer, closes his drawer and tells Sami he will be keeping his passport.

Without a word Sami casually gets up out of his chair, circles the desk to Ty's side, opens the drawer, takes out his passport, closes the drawer, circles back around the desk, sits down in his chair and puts his passport back in his shirt pocket. Ty shifts in his chair uncomfortably, jerks his neck to one side, straightens his tie and coughs. Ty has control over everyone's passports – mine, the children's and all the employees. No one ever stands up to Ty. I try hard not to show my delight watching my husband squirm in his chair. *What no ranting, no raging, no fists, no death threats? C'mon Ty, show Sami what you're really like. Oh that's right, you only beat up women and children, those who are physically weaker than you.* I like this new sparkly-eyed guy.

Sami immediately bonds with Justin. Justin and I work well together, but he told me he didn't think he could take much more after Ty blew up at us over a brochure we had created while Ty was traveling. We thought it looked good but Ty came in, saw it, and started screaming at both of us how bad and fucked up it was. We worked all day, and most of that night, re-doing everything for the presentation the next day.

After Ty presented his version to the client Justin and I went back and did a page-by-page comparison of our original. They were almost identical. Justin looked at me and said, "'E's a scunner!"

I don't know what that means but from the look on Justin's face it was an insult. I am hoping that with Sami's infusion of humor and lightness Justin may stay.

We have a major exhibition to prepare for. The next few weeks are a flurry of getting ready. I hate this annual show. This year we have guests coming from Europe – I hope Ty will keep his scaffolding securely in place.

We rent two apartments next to the convention center for the week. No one wants to stay in the apartment Ty is in, so we are alone in ours. On the third day of the show ten of us go to dinner. The evening is enjoyable with the three European guests. We all agree to meet and go swimming at the hotel pool in the morning. The next morning I get up and wake Ty to go to the pool.

"I don't want to go. You go." Ty rolls over and goes back to sleep.

I can't say I am unhappy about that. I put on my swimsuit and a sundress and walk down to the other apartment. No one answers. I start to walk away when Sami answers the door. He tells me to come on in and wait while he gets Justin and the others up. No one else wants to go so we walk down to the pool together to see if the European guests are there. Sami is walking barefoot, which is weirdly amusing to me. Ty does not allow the boys to walk barefoot, because he says they will catch diseases.

The pool area is already full. We look for the European trio from the night before, but don't see them. We swim and talk mostly about the other employees and guests. I decide not to spend too much time and risk getting in trouble, so tell Sami I need to go. He walks me back to the apartment.

Ty is still sleeping. He wakes when I come in the room.

"Did you have a nice time?"

"Yes, I did."

"Who was there?"

"Only Sami. No one else wanted to go."

Ty bolts up in bed. "You fucking mean to tell me you went alone to the pool with Sami?" He is roaring like thunder.

"I wasn't alone with Sami at the pool. The pool is full of people. We looked for everyone else, but they weren't there like everyone agreed last night."

"Why the fuck did you go to the pool with Sami if no one else went?"

"You could have gone this morning Ty. You didn't want to. You didn't say to me, 'don't go to the pool if only Sami is going to the pool'. There were supposed to be ten of us."

Ty lunges at me, picks me up and throws me on top of the bed. He holds my hands and arms down with his hands and body weight and repeatedly rams his knee into my stomach screaming, "Fucking American bitch whore!"

I don't know how many times he repeats the assault. I am screaming in pain begging him to stop.

"Get up!" he screams as he backs off of me and away from the bed. I am trying to catch my breath, my gut in pain. I climb off the side of the bed holding my stomach.

"Take your clothes off!"

I take my clothes off.

"Now stand in the corner!"

I stand naked in the corner.

In the corner right behind me there is a unit air-conditioner. He turns it on full blast to its coldest setting. The freezing air hits me like an ice cold shower.

"If you fucking move one fucking inch I will drive home and kill the kids one by one! Do you fucking understand me?"

I nod my head yes, tears streaming down my face.

"How fucking long were you at the pool?"

"Half an hour."

"Okay, so you can stand there in that fucking corner for one hour naked. Don't fucking move if you love you kids. Fucking American bitch whore!"

My stomach is pulsating with pain, but I don't dare move. My wrists hurt and the small finger on my right hand is throbbing.

I hate to be cold. Ty knows that. He bought me the black fur coat in San Francisco knowing how easily I get cold. Now he is using that knowledge to punish me. I felt this cold only once before – during the baptism in the basement of the Greek Orthodox Church. Ty keeps screaming bitch and whore over and over. My teeth are chattering. I am shaking uncontrollably – the second stage of hypothermia. Time feels distorted. I don't know if I have been standing here five minutes or one hour. I don't feel I am really here, everything feels dreamlike. I can see Ty's mouth distorted and mad, but I don't hear him anymore. My body isn't

that cold now, I just feel numb. I think I hear a phone ringing.

I see Ty answer his phone and I struggle to hear what he is saying.

"We aren't going to join you for brunch. Paula's not feeling well. She's having stomach issues."

The phone call seems to interrupt Ty's frenzy.

He walks over, turns off the air-conditioner, and sits down on the end of the bed. I don't dare move. He stares at the wall. The room is eerily quiet without the buzz of the air-conditioner.

"Haven't I done enough to you to make you want to kill me? Why don't you kill me? You need to kill me first, or I will kill you," Ty calmly makes a declaration.

He picks me up, puts me in bed and climbs in next to me. He rubs my body down to warm me up, kisses me on the forehead and strokes my hair. I feel I am in the most twisted episode of the *Twilight Zone* imaginable. Once I stop shivering he says, "Let's get dressed and join everyone for brunch. Would you like that?"

I am broken. Is that what he wants? For me to be broken? Kian's words echo in my head, *Ty's already stoning ye to death luv. He's just doin' it one stone at a time.* I think of Madeline's tea towel and wonder how much more twisting I can take.

We go to brunch. Sami is watching me.

"How are you feeling? I called Ty and he said you weren't feeling well," Sami questions me.

"She was fine at the pool this morning Ty, what happened?" he stares at Ty. Sami has no idea the terrain he is entering.

"Oh, she's fine, women's stuff, you know," Ty jokes.

We leave the restaurant and spend the day at the exhibition. Sami and Justin take turns talking to me, laughing and joking when Ty is engaged with a sheikh or other local celebrity. They know something is up, but I don't dare say anything.

The next day Ty and I have a business meeting at the Intercontinental hotel. I wander into a shop selling Persian carpets.

"Do you see one you like?" Ty asks, walking up behind me

"No, I don't," I respond. I don't want anything from him. It seems he saw me looking at one. Ty pulls out a stack of money and pays $2000 for the carpet.

We go home, picking the boys up from school on the way. We get into the house and Ty tells Sonata to go to her room and to not come out until he knocks on the door and tells her she can. Sonata looks at me, frightened.

Ty takes the carpet and lays it down on our bedroom floor next to the bed. He keeps fussing with it, making sure it is just the right angle to the bed, combing the fringe with his fingers until they are flawlessly even.

"What are you doing?"

"I want to make sure everything looks perfect when they find our bodies. Go to the dining room!" he commands.

He shouts at the boys and tells them to all sit at the dining room table. They obey like little soldiers. He goes into the kitchen and out gets three butcher knives, lays them on the table, and takes a wine cork and starts carving it.

"What are you doing, Baba?" Faris asks innocently. His beautiful brown eyes saturated with curiosity.

"I need to explain to you why Mama has to die," Ty states cold and calculated.

I don't wait to see the look on the boys' faces. I still have my shoes on and my handbag is on the entryway table. I bolt out the front door, fly down the marble staircase pushing the elevator button at each floor on my way down. I have money, a credit card and my passport in my bag.

I am dialing Ty's brother Ziad on my descent.

"God dammit Ziad! You need to get Ty under control! I told you before, he needs help!"

"Paula it's just the stress of you two working together."

"Bullshit Ziad! Bullshit! Ty's a fucking mental case. He needs to be institutionalized! You need to get over to the apartment now. He told the boys that Mama has to die and now he's alone with them!"

I hang up, catch a taxi to a cheap hotel Ty will not suspect I am staying in.

Ty keeps calling my phone. I don't answer. Ziad calls my phone. I answer.

"Are the boys alright?"

"Yes, they're fine. Ty admits he threatened to kill you, but he only wants to scare you. He wouldn't really do it."

"And that is acceptable to you, Ziad? It's acceptable for a man to threaten to kill his wife in front of his children as long as he is only doing it to scare her?"

"No, it isn't. Come home and let me sit down with you two and we'll talk about it."

"No way. Ty needs serious help Ziad." I hang up.

The next morning I take a taxi to the airport and catch a flight to Bahrain. Ty and I have a friend there, Habib. He is a normal person as far as I can tell, and the son of one of the ministers. He puts me in a hotel. He also calls Ty and tells Ty I am in Bahrain, but does not tell him where. I have no one else to turn to. I call Paul and Karen and tell them what happened. They offer to send me money to get an airline ticket to come home.

Not without my boys. I left to diffuse the situation. I had to get outside of Ty's control for a few days.

"No, you need to come home to the States!" Karen is crying. "He'll kill you!"

"If I come to the States he may cancel my visa and I won't be able to get back into the country. He is negotiating through Ziad and Habib right now for my return. Ty has eyes on him now. I have to go back and get the boys out."

Ziad and Habib guarantee that Ty will not harm me if I return. Ziad says Ty will agree to therapy if I come back. After a few days in Bahrain, I fly back to Dubai. Ty picks me up from the airport and acts as if nothing has happened. We get home and I notice he has flattened the tires of my car. He locks the house from the outside when he leaves; I am locked in until he thinks I am behaving well enough to be let out.

"Ziad said you agreed to therapy, Ty."

"What the fuck are you talking about? You're the sick one, not me."

Some help Ziad was.

"Where were you?" Sami asks suspiciously when I get back to the office.

"I wasn't feeling well, I stayed home for a few days."

"That's your story and you're sticking to it?" Sami suspects something. Justin and Sami must have talked. Sami walks back into the design studio to sit with Justin. When Sami started working for Ty he took my office, now I am in an office next to the design studio. The wall between my office and the design studio is partial glass.

I am at my desk when Ty comes in. He walks up to my desk and begins screaming at me – in one fell swoop he pushes everything off my desk and onto the floor, then screams at me to pick everything up. Justin and Sami watch Ty's performance through the glass.

When Ty storms out, Sami and Justin come in, nicely tell me to sit down and pick everything up for me.

"What the hell is wrong with him?" Sami asks.

"I don't know. All you Arabs are the same!" I declare condescendingly.

"No, we're not," Sami gently objects.

I realize I am out of line.

"Sorry, I had no right to say that."

"Paula, if you're in trouble we can help. Justin and I can help."

"You can't help me. But thank you for offering."

Anyone who helps me will put themselves in danger. All Ty has to do is accuse Sami or Justin of stealing from him and they will be thrown in jail. Ty can easily fabricate something. He will write a check to one of them for some reason. When they cash the check Ty will say they stole the money. I know him, he is ruthless. Justin is single, but Sami is married to a Lebanese woman and they have two children. He doesn't talk about her much, but he talks a lot about his kids. Ty would not hesitate to make their lives hell.

For the next month Ty takes me on all his trips to Qatar, Bahrain and Kuwait, keeping me close and under his watch away from Sami and Justin.

Both Sami and Justin quit. Sami goes to work for another company in Dubai and Justin goes back to Scotland. Ty has to go back to the UK for yet another lead designer. With Sami and

Justin gone Ty doesn't take me to London. I am relieved to be away from him and alone with the boys.

We are not allowed to celebrate Christmas. No tree, no presents – my punishment for embarrassing him by seeking help from Habib in Bahrain, his brother Ziad, and swimming at the pool with Sami.

Christmas Eve Ty announces we will go over to Sameer's house for Christmas lunch. At least the boys will get to celebrate a little.

The beginning of 1998 Paul, Karen and Rebecca are still working to get me out. We hope if we put enough pressure on a senator somewhere he or she will do something.

CHAPTER 15
God has Abandoned Us

ALTHOUGH IT IS ONLY MARCH THE STEAMING HEAT IS ALREADY seeping into the pores of the Gulf. The newspaper has an advertisement for a dolphin performance coming to Dubai. I want to take the boys. I gauge Ty's disposition for a couple of days and when I think he might be approachable, I take the advertisement to his office and sit down. Leo, our new lead designer from England, is in the design studio so Ty shouldn't physically attack me if this goes badly.

"Did you see this in the paper? This would be fun for us to do with the boys," I say it in a very cheerful voice as I show him the advertisement.

God only knows why I think asking if we can take the boys somewhere will have a good outcome.

"Are you fucking kidding me?" His lips seethe and boil. "You fuck up everything you do. You're the reason we're in so much fucking debt. You're so fucking unbelievable. You don't even fucking deserve to have kids you fucking cunt."

I feel my heart racing.

"I thought it would be something we can do as a family." I am already calculating I will not have time to go back and get my handbag and phone. I get up and back sideways out of his office.

His chair swings back and hits the wall from the force of his large body ejecting out of his seat, his feet hit the floor pounding with all too familiar 'I'm going to teach you a fucking lesson' angry footsteps.

"Are you fucking telling me I'm a bad father? Fuck you!" He is howling. His face is red, pupils dilated with rage. I am already next to the front door. If he tries to grab me I know I can outrun him. Then Ty does something that completely takes me by surprise. His face contorts in an ugly grimace, his lips purse together and he starts spitting on me. Not a big fat loogie, one-off kind of spit, but a sputtering sprinkler head spitting with the insult 'cunt' inserted in between, "... p-tew...cunt... p-tew... cunt... p-tew... "

I am shocked not only by the looks of him, but by how insulting it feels. I hesitate. He lunges. I bolt. The elevator door is closed. I run down the marble tiled stairs four flights to the lobby, out the door, down the sidewalk and towards the Corniche. I look back. He isn't following me. He doesn't need to. My boys are at home and that is where he will head. Spitting on someone is the ultimate insult in the Arab world. Fourteen months have passed since my family began their efforts to help me, and nothing. I think the only way I am going home is in a body bag.

I don't have my handbag or my cell phone. Who am I going to call anyway? The police? His brothers? The American embassy? I silently laugh to myself. I check my pockets and find a few *dirhams*. I sit on the grass for a while and watch couples stroll by, laughing, absorbed in each other's company, children running and playing without fearing they will get in trouble if they sweat, young mothers are happily pushing babies in strollers. No one is spitting, or hitting, or screaming death threats.

As the sun lowers I find myself in the middle of the *souk* without remembering walking there. The *souk* slowly blooms back to life after the midday closure with an orchestra of squeaky roll up metal doors, bantering traders and shrieks of barefoot boys running and kicking a soccer ball through the maze of shops. The shopkeepers sip Turkish coffee, still groggy from their afternoon naps, ready to once again sell their stocks of dresses, handbags, shoes and jewelry. They don't try to lure me into making a purchase, just stare silently as I walk by. I must look really bad. It is getting dark. My stomach is tied up in knots and the smell of

shawarma, sputtering on skewers above red-hot coals, makes me feel nauseous.

When darkness finally falls I walk back towards our apartment building until I can see the windows of the living room and dining room. Every light in the apartment is on. I am sure Ty is gleeful, finding my handbag and cell phone in my desk, 'Come here my precious'. I find a pay phone and call the home phone. I need to choose my words carefully.

"Come home now!" Ty answers sternly.

"I'm sorry I upset you. I didn't mean to offend you." I try to articulate how I am feeling.

"I'm fine. Just come home. The boys are happy and playing and they miss you."

It's a trap. Every cell in my body vibrates with impending danger.

I contemplate the filthy mix of rotting food and urine on the ground below the payphone. Ty is seething under his calm façade. He has probably sent Sonata to her room with instructions not to come out until he tells her she can.

I walk around the *souk* for another fifteen minutes. With every step that takes me closer to home, my heart rate increases a beat. I have to leave this in God's hands. If today is the day I am going to die, then so be it.

Like walking the plank, I walk into our apartment building, press the elevator button, the door opens and I step inside, knowing it is wrong, but my babies are in danger. I ride the elevator to the third floor and tiptoe up the last flight of stairs. The elevator makes a hollow, grunting noise and I do not want to announce my arrival. I listen though the front door. The boys are laughing and pounding pots and pans together. Ty never allows them to play with pots and pans and God forbid they should make any noise.

I feel dizzy. I lean against the wall and breathe deep, trying to lessen the crushing pressure and pain in my chest and stop the palpitations. He has threatened to kill us so many times, today might be the day. We are trapped. If I could get the boys out

maybe we could run down to the creek and beg one of the Iranian fishermen to smuggle us in the bowels of his *dhow* with a promise of a handsome reward. I silently laugh at the parody – I would rather take my chances with Somali pirates than enter my own home. *How many more women are there like me, trapped, fearing for their lives from the one person who should love and protect them?*

I knock on the door. Ty opens it, his face knotted into a dark scowl. I walk by him and sense the cold chill of his dark energy. I stop in the entryway. The boys start jumping up and down gleefully shouting,

"LOOK MAMA, we are playing with pots and pans Mama!" I scan the rooms. Every light is still on.

"Wow, it looks like you're having so much fun!" I feign excitement. I do not bend down to kiss or hug them as this will ignite Ty's rage in front of them. I don't want the boys to see whatever it is Ty is going to do to me. I leave the entryway, walk down the hall and turn into the hall leading to our bedroom. He is right behind me. A presence so dark and sinister I shudder. I know I am cornering myself but I want it over with, hoping if he expends his rage on me, he will be done and leave the boys alone.

"How dare you fucking tell me I am a bad father? You are so fucking stupid!" His entire being is consumed in rage, his red face contorted, lips twisting, spewing insults, threats and bursts of spit – a deranged Jack-in-the-Box venomously struggling to escape its tin enclosure.

He pushes me down on the bed and straddles my hips with his crushing weight. He holds my arms down and starts screaming inches from my face. His jowls jiggle, gravity makes his eyes and cheeks puffy like one of those dogs with way too much skin. Then his mouth opens and he screams for Faris.

Faris learned at a very young age that if you do exactly what Ty wants you can minimize your own suffering. I turn my head and see my beautiful Faris obediently arrive at the doorway in seconds, wide-eyed, and terrified. I want to shout to Faris to run, but it is too late. Ty's hands and fingers are already around my

throat crushing my windpipe. I decide not to fight. Faris might try to rush in and help me and Ty may kill him. If this is the moment I die, it is better Faris doesn't watch his mother flailing around like a fish out of water, unsuccessfully trying to stop the inevitable. Better to lie down and take it and slip into death quietly. Maybe I have given up. Maybe I want the nightmare to end in any way possible. I close my eyes wanting the last face I see to be Faris' beautiful, innocent face, and not Ty's ferocity, as I feel my consciousness slipping away. The helpless image of my son will be burned into my soul for eternity. I can't breathe. My chest feels as if it is going to explode. Then I am floating in sweet, silent, liquid darkness.

My first visual awareness is the blurry bright ceiling of our bedroom. My ears are plugged, my head hurts but feels numb. I am too frightened to move.

Faris, oh my God, Faris. Did Ty kill him? I shift my eyes to the left without moving my head. The doorway where Faris watched in horror is empty. The room is silent. I try to swallow, but raw pain consumes my throat. I cautiously prop myself up by my elbows. I am face to face with my fuzzy self in the wall mirror facing our bed. That is when I see Ty in the reflection. He is sitting behind me and to my left on his side of the bed, propped up against the headboard, arms limp at his sides, legs straight out in front of him. I blink several times. Perhaps the strangulation has cut off oxygen to my brain and affected my ability to not only see clearly, but to see color. Ty is solid grey – skin, lips, even his eyes. Grey like an embalmed corpse before the undertaker artistically applies rouge and lipstick to give life to the dead. His eyes are open, grey and blank, catatonic.

As if God himself, disgusted by this human being he has created, reached down in horror and yanked Ty's soul from his body for reprimand, leaving an empty shell.

He is sitting there as still and grey as a park statue. I imagine taking a hammer and chisel, striking the right spot on top of his head and him crumbling into a pile of concrete dust on the bed.

With a hand broom and a dustpan I sweep him up, dump him down the toilet and flush. He is gone, vanished.

I keep watching Ty's stone-still and silent reflection. Maybe he is dead. *Oh, please God let him be dead.* But then the grey concrete mouth unfastens and makes a chilling declaration.

"If you ever think you will leave me you are wrong. If you leave me and don't take the boys, I will do to them, every day, what I did to you. If I ever think you are planning to leave me and take the boys, I will take Tariq into the bathtub with a knife, I will slaughter him, put the knife in your hand, wipe his blood all over you, call the police and tell them you did it. You are just a woman and I am a man. Don't *ever* forget that. No one will ever believe you. You will be put to death and you will never see your kids again. If you leave and take the boys with you, I will hunt you down and slaughter you like animals, no matter where you are in the world."

Those words, so vile, so horrible, hurt more than my throbbing throat. I have no doubt he is serious. I sit staring at the cold, stone reflection. Time passes. Neither of us moves.

I gradually inch my body down almost undetectably until my toes touch the carpet, then slide a bit further, cautiously stand, and walk toward the door. *I have to find Faris. I have to hug him, smell him, kiss him, and give him false assurances, empty promises that everything is going to be okay.*

"You are not going anywhere. Get in bed!" The words boom from the concrete statue.

I freeze at first, then instantly obey. At the moment I thought I was dead I warmed to the possibility of death's peacefulness, but I don't want a rerun tonight. I go to my side of the bed, undress, and slip on the nightgown I keep under my pillow and climb into bed. My back to the horrible concrete monster, I close my eyes. I hear him get out of bed, shuffle around, then turn off the light. I feel the weight of his heavy body depress the mattress. Then I feel it against my butt. An erection? Absurdity. What does he think my response will be to him poking his erect penis against my butt?

Oh hey baby, yah, you just tried to kill me and threatened to kill my children, you are so hot!

I know any rejection of his precious penis at this moment will only result in another assault, and I am too exhausted and drained to fight. I need him to sleep so I can find Faris. The thought of facing him, feeling him on top of me and smelling his breath makes me want to retch. I adjust my nightgown and my body so he can enter my vagina from behind. I know it will take less than a minute. It is assisted masturbation. I could be a hole in the wall, it doesn't really matter. No emotion, no love, no passion, no sound. I am a convenient wet hole he can shove his penis into. The fear I feel gives way to anger and hatred welling up like a tidal wave inside me. With every thrust of his penis I feel more indignation. I clench my teeth, scrunch my eyes and silently weep into the pillow I am clutching for dear life.

I pray God will give him a heart attack. It seems futile to pray. God has abandoned us. I am praying to the air, thin, wicked, uncaring ether. Ty finishes quickly, pulls out and turns over. I stay as silent and still as possible, listening to my heart beat in my chest, my throat and my head. I can feel his sperm sliding down the inside of my thigh to form the wet spot on the bed. I want to swing my body around and punch him in the face with my fist, over and over again until his face is a bloody pulp. I want to scream at him how much I hate him. Scream at him how much his touch, his smell, his breath, his walk, his talk, his very existence repulses me. But I continue to lay agonizingly silent and still.

It doesn't take long for the snoring to start. I gently slip out of bed, tiptoe to the bathroom and shower. I want to find Faris, but don't want Faris to see me falling apart. Faris is alive or Ty would have paraded his dead body in front of me screaming, "Look what you made me do!"

I need to cleanse my body of every trace of him. The sound of the shower masks the waves of my gasps and sobs. Where is God? How can he let this happen? He didn't even send me an angel to give me hope when I was dead in limbo. My throat hurts, my head hurts, and my soul hurts. I step out of the shower and look into

the mirror. My hands shake as I gently touch the marks from Ty's hands around my neck. I can cover the marks towards the back with my hair. I can put makeup on in the front. I need to go find Faris, but I don't want him to see me crying. I take a deep breath and reprimand myself for crying.

"Enough," I quietly chant. "Everything is going to be okay. Everything is going to be okay."

I relapse into silent sobs and splash my face with cold water. Then repeat the chanting, the sobbing, and the cold water splashing, until I feel I can maintain some composure. I look in the mirror and the reflection confirms I look as bad as I feel. Twisted, destroyed, void of all color, all hope, as Madeline predicted. Ty has been stoning me to death like Kian said. This wasn't one stone though, this was a quarry.

I put on a bathrobe and listen carefully. Ty is still snoring. I ease down the hall to the boys' room. I climb onto Faris' bed, get behind him, pull him into me and hug him. A long deep 'I am doing my best to protect you' hug. He is breathing. He is alive. He is sleeping, or at least pretending to be. His seven-year-old little body is vulnerable; his seven-year-old mind processing the horror of the night in his sleep. I feel sick again. Mothers are supposed to protect their children. I can't protect them. I can't escape this dreadfulness. I chose this man and it is my fault they are suffering. I feel so sorry, so responsible, and so guilty their childhoods are being ripped apart. I want them to be happy, not to live in a nightmare. I have to end this for their sakes.

I fight back the tears for several minutes, but leave when I know I will not be able to contain them any longer. I carefully un-envelop Faris' body and climb out of his bed, creep out of the room and find my way to the dining room. The lights are off and all the pots and pans are gone. Faris must have put everything away. I open the window and gaze out to the Corniche, then down to the parking lot below. The earlier bustling of the evening has subsided. Is death the only answer? I stare down at the ground several stories below and for a fleeting second consider suicide. I will not give Ty the satisfaction of the role of grieving widower. I

decide, at that moment, Ty will never harm me or my boys again. I will kill him. Yes, this Catholic born and bred California farm girl will kill another human being.

"What do you think of that God?" I quietly scream. "Where are you? Why did you give me three beautiful boys only to have them tortured? You are a lie!" In surrender I slide down against the wall of the dining room onto the floor, resuming the roller coaster of gasps and sobs.

Ty is double my size and ten times my strength when his adrenaline makes him stronger than an ox. I visualize him sleeping – his big pasty white face and neck glowing in the moonlight. I take one of those big long knives, sharp edged, that he likes to threaten me with, and ram it into his jugular, twist and slide it across to the other side. He bolts awake, his eyes bug out in horror as his brain tries to process what I did. The hands he used to strangle me, to hit the boys, to tie ropes around their precious limbs, to bruise their bodies, grasp at his throat to stop the blood pulsing out of his neck and plug the hole in his windpipe. The despicable mouth that spews and sputters anger and rage and spit on me opens but no words come out, only gurgling gasps as blood fills his wind pipe. There is blood everywhere. Then his body goes limp and he is dead. Dead, dead, dead – his bug eyes still open in shock.

Ty doesn't go to the office for several days sometimes. I can call and cancel his appointments without raising suspicion. I can turn up the air-conditioner so his rotting corpse will not stink. I can tell his brothers he is on a business trip. I can get the boys and I back to the USA somehow before they find his body. Is there an extradition treaty between the USA and the UAE? At least the boys will be safe with my family.

If I am unsuccessful at getting out I will be arrested for murder. My family will have to fight for custody of the boys and get them back to America. But that will never happen. Ty's family will not allow the family of a killer to raise the boys. They will take guardianship over the boys under Islamic law. I will hardly be able to claim self-defense, killing my husband in his sleep, in a Middle

Eastern country. I will be stoned to death. But it will be worth it. I will die knowing Ty will never again raise his fists in anger to bruise their bodies, shred their souls and destroy their lives.

I think of the dead housemaid and how her sponsor said she had committed suicide because she was depressed. I could cozy up to Ty one night in something sexy, get him drunk on wine, and push his body out of the window. Say he has been drinking a lot. He was depressed. But what if he grabs me too and we both go out the window. How in the world am I going to get a two hundred and fifty pound man out of a window? I need an accomplice. I think of who I can call and say, 'Hey, I need a favor, can you come over tonight and help me push my husband out of the window. It won't take long'. No one comes to mind.

Poison – rat poison injected into bottles of red wine through the cork to kill a rat. That might work. I would have to be careful I don't drink the same wine. I needed to suddenly develop an affinity for white wine. I can tell Ty red wine is causing my migraines.

I don't know how long I have been sitting in the corner before I am able to lift my body off the floor and go back to bed. My plotting of the killing of Tysir Dasanti stopped the sobbing. I regained some power, albeit only in my head.

CHAPTER 16
Skin of an Onion

THE FOLLOWING MORNING FARIS DOES NOT SNEAK INTO THE ROOM and come and hug me before Ty wakes up. I get up and dress as quietly as I can, cover the marks on my neck with makeup and my hair, and leave the bedroom to prepare the boys for school. I put on my best fake cheerful face and hug them one by one. Sonata has already fed them breakfast and got them ready. She looks at me with knowing eyes, too timid to say the words out loud. We shuffle out the door, down the elevator and into the car in silence. Three little boys, aged three, five and seven sit in the back seat of the car absolutely quiet until we are about a mile from home.

"Mama, what Baba did to you last night made me sick to my stomach."

So many feelings and tears well up like a dam about to burst in my head and heart at Faris' words.

"Faris, I know, baby, I know. I'm trying to get us out. I promise I'm doing everything I can. There is nothing you could have done. It isn't your fault. I love you and I'm trying."

"Mama, what do 'fuck' and 'bitch' mean?" Samer chimes in.

"Why do you want to know sweetheart?"

"Because that's all Baba says to you. I don't want to live with Baba."

"I know, I know. I'm trying to get us out, I promise."

"When?"

"I don't know."

I drop the boys at school. The streets are crammed with early morning traffic. I wonder what the going rate is for a Pakistani taxi driver to help me push a drunken Ty out of our apartment window. They make about $300 a month. Would one year's salary be enough?

I call Paul from a pay phone after dropping the boys at school, sobbing, telling him everything and that I can't go on any longer. I know he cannot do anything, but I need to tell someone. I want to tell Paul my plan to kill Ty. It is the only way to stop our suffering. I decide against it. Paul says he will call the American embassy again. He reveals they are trying to hire an ex-FBI agent to extract us. That gives me a spark of hope.

I hang up and make another phone call to someone I know, who may be able to help me get some kind of drug I can use to kill Ty.

"There is something that will induce a diabetic coma. Is he overweight?"

"Yes, I think he would be considered obese."

"Acquiring the drug is the first step and will take some time."

"Getting it into Dubai will be harder. All the incoming mail is checked."

"Call me back in a month."

This person will have to fly in with the drug, but I don't have any money left in my trust – Ty spent every penny of it. Ty never gives me money. I think of the envelopes of money those men come to pick up. I can open an envelope, take money out and reseal it.

As time goes by I begin to wonder if I am really capable of killing Ty or if it is a fantasy I have created to try and make it through every damn day and night. After he strangled me he has mercifully begun to travel more without me. I start methodically searching the apartment and the office again for the boys' passports. After ten years of advertising projects there are thousands of files in the office. He may have given them to one of his brothers. He may travel with them. I just don't know.

Sami calls the office one afternoon to see how I am. He tells me someone he knows sees Ty at the technology exhibitions in

Europe. Ty plays up the wealthy, important Arab businessman façade to the pretty girls they hire at these things. He takes them out to dinner and gets laid. I'm not surprised and I don't care. It means he isn't bothering me for sex. Sami offers help as Kian did before. Since he strangled me, I believe Ty will destroy anyone who tries to help us.

We have the Internet now and I do some research on Ty's behavior thinking it may shed light on how to deal with him. Borderline personality disorder, narcissism, sociopath – my goodness, Ty is a *smorgasbord* of mental health disorders. He is a psychologist's dream case study, like a xeno-archaeologist discovering an alien.

One of the sheikhs wants to produce a private perfume brand, one for men, and one for women. Leo and I work on the design and marketing concepts. When it comes time to travel to France to visit the perfumeries, I want to go. Memories of my mother's fancy perfume bottles and their beautiful scents heighten my curiosity of the perfume industry. I can also see if my drug connection knows someone in Paris they can send the drug to, and we can rendezvous. Ty is always on his best behavior around Basil when we are in Paris so he won't risk getting me upset. If I say I want to go to France, Ty will not take me. I wait.

"I'm going to Paris for the perfume job, to visit the perfumeries and finalize the bottle and packaging." Ty announces over lunch.

The boys sit like perfect little soldiers cleaning their plates in silence. Eyes wide, not sure what might cause Ty to explode.

"That should be interesting for you. I hope you have a nice time."

"You don't want to go?"

"I don't think there's any need for me to go."

"Why the fuck not?"

"The artwork's approved for the packaging. Leo and I have at least half a dozen other projects we need to finish."

"I tell you what you can and can't do! You're going to Paris!"

Mission accomplished.

I call my drug connection, but they don't know anyone in

Paris. They say we should not send it in the mail, it needs to be hand delivered to Dubai. I don't think that can happen, but I tell them I will keep them posted.

We fly into Paris and stay at the small bed and breakfast close to Basil's home again. The following day a driver picks us up and we tour numerous perfumeries. We spend the afternoon blending scents and finalize five for men and five for women to take back to the client, based on the client's fragrance guidelines. The perfumer carefully packs the individual vials of delicate olfactory compositions into attractive wooden boxes lined with velvet to present to the sheikh.

We meet Ty's friend Basil for dinner. Basil has arranged a hotel for Ty and me for the weekend in Bordeaux. I thank Basil, but suggest we stay in Paris. Ty hates bugs and the countryside and it will be a disaster if Basil is not with us. I lose the argument. The next day we take the train from Montparnasse. Ty orders a bottle of Bordeaux wine on the train and pours us each a glass. He goes through three glasses, I barely touch one.

"What's wrong with you?"

"Nothing why?"

"You aren't drinking."

"I'm enjoying watching the French countryside."

"I knew I shouldn't have fucking brought you. You don't appreciate anything I do for you. I should have brought someone else."

He drinks more wine and sulks. By the time we get to the Bordeaux St Jean station he is giving me the silent treatment.

He unexpectedly suggests we rent a car to get to the hotel and I insist on a taxi. The last thing I want is déjà vu – to be in a car with him driving, speeding, and asking me if I am afraid to die.

We take a taxi to Chateau de Pitray. If I had been with anyone else, even the devil, I would be delighted to be at this magical estate. When I go to take my suitcase out of the back of the taxi Ty has a fit in front of the doorman.

"What the fuck is wrong with you. You can't even remove a suitcase from the trunk of the car properly!"

"Well, why don't you do it yourself Ty? That way it will be done properly," I say as sweet as pie, smiling.

We walk into the room. When the door closes and the doorman is out of hearing range, Ty goes into full blown fury throwing whatever he can get his hands on at me. I exit the room and leave him alone to execute his meltdown. I walk around the hotel grounds and sit under a tree. I breathe in the glorious evening air, warm and earthy. The summer full moon greets the vineyards and expansive fields. I stay for hours sitting against the tree wrapped in the peace and solitude of the silver-washed French landscape, wishing the boys were with me. We hold hands and walk deep into the countryside and leave Ty forever. By the time I get back to the room it is after midnight. Ty is asleep curled up in a fetal position.

The next morning Ty resumes his drama. Crying, sniveling, and asking me why I keep hurting him. He is several cards short of a full deck, and losing more all the time. On the outside patio he whimpers all through breakfast, head hanging down, tears and snot dripping onto his eggs. Killing him may be the most merciful thing I can do for his sake and ours. How can his family not see this man needs to be put away in an institution where he can get help? People at other tables are staring at his pitiful performance. I suggest we go back to Paris. He insists we stay.

The historic medieval village of St. Emilion is down the road. The hotel has bicycles we can ride but Ty never learned how to ride a bike. The summer air is alive with the scent of the rich soil, the buzzing of insects and melodious birds. As Ty and I walk down a dirt road flanked by vineyards, there is nothing between us but an empty black hole, probably the same one that exists within his soul, expanding outwards to devour me. The following day we take a taxi back to Bordeaux St. Jean. Ty tries to start another argument before we even get on the train. I refuse to engage. He isn't going to hit me, too many people around and we will be seeing Basil when we arrive.

We arrive in Paris, check back into the bed and breakfast. Basil meets us for dinner at La Place Saint Georges. It is one of my

favorite restaurants in Paris. Basil asks how Bordeaux was and Ty babbles about what a great time we had. I like Basil, but his admiration of Ty is irritating. It is not his fault. Ty keeps his scaffolding nice and tight in front of Basil. The following day we fly to Amman to visit Ty's parents.

I am happy to see Mama Wafa. I still love her. I think I know what Mia meant all those years ago, when she told me she would never accept a man who would treat her the way her father treated her mother. At dinner, Mama Wafa picks up an onion and shows it to Ty.

"*Shoof hadi'l basali?*" (Do you see this onion?)

"*Na'am.*" (Yes.)

"*Hadi basali mneeha, mazboot? Feek toutboukha.*" (This onion is good right? You can cook it.)

"*Hadi eshret el basali, mish mniha.*" (This is the skin of the onion, it has no purpose.)

"*Bidoud Paula, inta ishrit el basali.*" (Without Paula, you are the skin of the onion,)

Ty laughs but Mama Wafa is serious. Ziad must have told Mama Wafa that I told him I cannot take it any longer. No help offered, just another metaphor to add to my collection. We stay one night then fly back to Dubai.

Almost as soon as we get back to Dubai Ty travels again for a few days. I am able to take the boys to the pool and resume my passport search. The fall international technology fair rolls around, more drama, more insults from a man who is mentally circling the drain. Over one million dollars in business debt he has created himself, because of his habitual spending. Addicted to his image like an addict on crack, but blaming everyone else, especially me, for his failures.

At Christmas, unlike the previous year, Ty allows us to have a tree and presents. I cook Christmas lunch, which is a big hit with his family as I was not allowed to cook the year before. We feast on a traditional American Christmas menu. Ty does not go into a violent rage at Christmas, which means his tension is building.

Victor, Marie and the kids come to Dubai for New Year's Eve

and we hold the gathering at our apartment. Ty hasn't been mad all day and we are rounding three in the afternoon. I go back to the kitchen to cook the syrup for the *kanafe*. Ty busts into the kitchen demanding to know what I am doing.

"I'm making the syrup for the *kanafe*."

"You were supposed to do that an hour ago," he snorts.

I knew Ty not getting mad over the holidays was too good to be true.

"Well, I'm doing it now," I respond, as I take a deep breath.

"Why didn't you do it before? I wrote on the schedule that you would make the syrup for the *kanafe* at two o'clock and now it's almost half-past three!"

I should have known better, but I am feeling bold with his family in the apartment.

"So what Ty? So what if I am making the syrup for the *kanafe* at three o'clock instead of two o'clock. So fucking what?"

His eyes narrow and if his entire family wasn't in the apartment he would have attacked. Instead he gives me the 'you're going to be sorry' stare and walks away. I don't know where he went so I go back out and nervously sit with his family in the living room. After fifteen minutes everyone is asking where Ty is.

I walk into our bedroom and Ty is watching Faris play with a toy car. I tell Ty that everyone is asking where he is.

He methodically looks up at me with hollow, raging eyes. He hisses at me, "So what? So what? How dare you tell me so what? I should have fucking made sure you were dead when I strangled you. I don't want you around my kids. You are so fucked up!"

I know when his family leaves that will be it, I will be dead. I make another choice.

I grab my handbag and walk into the living room where his family is gathered and start screaming like a crazy woman. His family looks shocked and I unleash, telling them about the abuse, the strangulation, the death threats, his torture of the boys and our unbearable day-to-day existence. It is a tirade. Then I open the front door, walk out, and slam it.

I have no idea where to go and grab a taxi to a nearby hotel

using a credit card Karen sent me in case of an emergency. I call Marie on her cell phone and leave a message. About an hour later Victor calls. I answer. I agree to meet him and Marie the following day at their hotel.

I meet them for lunch. Marie tells me that after I left the family argued with Ty and Sameer went to hit him when he found out Ty had almost killed me and after Ty had said, "It doesn't matter. There were no witnesses." Ziad had stopped Sameer from hitting Ty.

Victor offers to give me money to buy a ticket home with the condition Ty doesn't find out. I don't want that. I want my boys and me out.

Victor is the one in the family who knows best what hell we live with.

"I want you to go to Ty, get the boys and their passports, bring them to me and buy us tickets to get out. Please!" I beg Victor.

"I can't do that, Paula," Victor apologizes.

"Why not? You know the terror we live with! Why the hell not?"

Victor looks away from me and doesn't answer.

"Fine, then I'll go back. He may kill me, but I'm not leaving without my boys!" I declare. Marie looks at me with tears in her eyes. I know her heart sank hearing my words. She fears for my life. The bond between the brothers is too strong, even in the face of the death of one of the wives or their nephews.

Ty is waiting for me in the boardroom of the office. I walk in and sit down. He has that cat that swallowed the canary look again. He has the boys' American passports arranged carefully on the table, like the magazines in the penthouse the first day I met him. He glares at me.

"When a man kills his wife and his kids and then kills himself people think the man is crazy. But he isn't crazy, he just gave up, and when you give up, you take everyone with you. That's not crazy."

He hands me the office phone.

"You will call every one of my brothers and their wives right now and tell them you had too much to drink. You will

tell them you are having some mental health problems and you will be seeing a psychologist. Then you will apologize for your behavior."

I obey. He leans back in his chair and gloats as I call each person, one by one, and repeat the script. He thumbs through the pages of the boys' passports like he is shuffling a deck of cards, mocking me, knowing he holds the ultimate control over me as long as he holds those three precious American passports.

It is January 3rd, 1999 and Ty is supposed to be leaving on January 17th for an extended business trip.

"After what you did to me New Year's Eve, I might not go."

I need him to go. For the next two weeks I behave like the perfect Stepford Wife. He has to leave. He has to. He screams at me, I take full responsibility for my inadequacies and apologize for whatever wrong I commit. He wants sex – I comply and fake orgasms. When he tells me to jump, I ask him how high. The boys seem to be following my lead and are like little robots.

A few days before Ty is due to leave he is with Faris in the kitchen. I am sitting in the entranceway and I can hear them talking, but I cannot see them.

"Do you see this?" Ty asks Faris whispering.

"Yes," Faris replies.

"You see the mold on this food. This is poison. Your mother wants you to eat this so you will die. Your mother does not love you, only I love you."

I feel as if someone stabbed me in the heart with a knife. My stomach flips. I slowly get up out of the chair so they can't hear me and go into the hall. Then I come walking out of the hall, through the entrance, and into the kitchen.

Ty and Faris don't say anything to me, but Ty puts the container with mold back into the refrigerator. He probably grew it in a petri dish himself and put it there.

My birthday is January 16th and Sonata makes a cake. Ty seems satisfied that my subservience means I have learned my lesson. I think my Stockholm syndrome simulation stroked his ego.

I drive Ty to the airport and go back to the office. With Ty gone the whole office is much more relaxed, including Leo. I begin where I left off searching for the passports. If I don't find them I will go back and re-examine the files I previously searched before Ty left, in case he moved them around.

A few days after Ty left he calls the office one evening exploding in fury.

"I was fucking robbed! I was on a train in Germany and when the train made a stop, a thief came by, grabbed my briefcase and ran outside. All my money is gone. My Palestinian travel document is gone!" Ty is livid.

"I'm so sorry Ty. That's awful! Do you still have your American passport?" I fake sympathy hoping he can't sense my insincerity.

"Yes, I still have the fucking American passport. Call Ziad and tell him I need money! Tell him what happened. Fucking thief!"

I am ecstatic. I know, I just know, the thief was an angel sent by God. What a sense of humor God has after all! I don't know what pleases me more, seeing Ty stripped of power for a brief moment in time, or giving me the opportunity to escape with the boys back home. I think of my prediction long ago, on our first date with Emma, that one day Ty would get robbed flashing his money around.

Ty still has his American passport, but cannot enter the UAE because his residency is on the Palestinian travel document. If he enters the UAE on the American passport they will take away his Palestinian travel document. With the American citizenship he is no longer a Palestinian refugee, but Ty wants both, knowing his American citizenship was not obtained legally. It will take several weeks or longer before Ty will be able to enter the UAE again.

We have a technology exhibition in Kuwait. Ty plans on flying into Kuwait on his American passport. Leo and I prepare for the exhibition, get all the equipment and materials sent, and I fly on January 26th to join him.

I spend twelve excruciating days in Kuwait with Ty. Leo and Krishna are with us for the exhibition. In the evenings we retreat

to our rooms after dinner, exhausted. Ty parades around our room naked with an erection, like a proud peacock. I don't think he has a clue how ridiculous he looks to me. As if he is the only man in the world with a penis. He doesn't attempt to poke me with it, which is all I care about.

We depart Kuwait on February 9th. I am going back to Dubai. Krishna has already returned to Dubai, and Leo and Ty are heading to Saudi Arabia.

In the airport Ty begins screaming at me and calls me names because, apparently, there is a right way to push a luggage cart and a wrong way to push a luggage cart, and I am doing it the wrong way. The Kuwait airport is small, unfortunately, and even though we are headed to different places, we wait in the same lounge. We sit down. When Ty isn't looking, Leo catches my eye and shakes his head from side to side, apologizing as if he has anything to do with it. I smile and nod in acknowledgement. When my flight is called I get up and walk to my gate. I don't say goodbye to Ty, I don't turn back. I know in my heart that God has given me an opportunity to escape. If everything goes right, I will never see his face again.

Back in Dubai the boys and I are enjoying our 'Ty free' existence. His brother Ziad keeps me posted on the progress of Ty's residency visa and it is a slow process. Knowing Ty cannot show up at the door gives me room to plan. I resume my methodical search though every nook and cranny in our apartment and the offices for the boys' passports. The weeks are slipping by and I am getting nervous. Sami calls the office from time to time to see how I am. I want to tell him I am trying to get out, but I am too afraid to say it out loud to him.

I go to the school for a parent-teacher meeting. All of Samer's teachers say he has no concentration except in French. Samer walks around the house speaking to me in French all the time, "*Oui Mama. Bonjour Mama. Je t'aime beaucoup Mama.*"

Faris is doing well in science and math. His PE teacher comments he has really improved over the past few weeks. This coincides with Ty's absence, which makes sense.

Tariq is still only in the second year of kindergarten. His teachers love his comical expressions and big ears that his face has yet to grow into.

As a reward for their good work I buy them two little parrots, which they name George and Ursula from the movie *George of the Jungle*, and a goldfish they name Lyle. Lyle spends his time watching George and Ursula from his fish bowl.

Knowing Ty can't surprise us is freeing. In the midst of planning our escape I drive to a multi-denominational church and ask to see a priest. I sit down with the priest and pour my heart out. I tell him everything, sobbing as he patiently hands me tissue after tissue. When I finally stop the priest looks at me and says, "An animal wouldn't treat you the way this man is treating you. You made a mistake, my dear. God does not want you to live with this mistake for the rest of your life. You need to go to the American embassy and get out. May God be with you and your children."

He tells me exactly what I needed to hear.

Every day Ty calls and screeches, "Get everything in order as if you won't be working anymore when I get back." I know this means Ty is either planning on deporting me or killing me.

I am running on adrenaline. Time is running out. I am beginning to think Ty took the boys' passports with him. They may have been in the briefcase and been stolen. Ty would never tell me that. One evening the boys are lost in childhood frivolity, ignoring my multiple requests for them to go and take showers. I am stressed and they are testing my patience. Finally, I walk into their room.

"I am running out of patience," I say sternly.

"C'mon Samer let's go!" Faris looks at Samer.

"Go where?"

"To the store."

"What for?" Samer asks.

"To get Mama some patience, she says she's running out."

Faris flutters off laughing and giggling with Samer and Tariq in tow to the shower, which makes me laugh. At least they are

heading in the right direction. Faris has a quick wit for an eight-year-old but does not express it when Ty is around.

I go to the American embassy again. This time I speak to a woman who is visiting from the State Department in Washington DC. Patty invites me to a private room in the embassy and I blurt out the whole story, like a runaway train. I start sobbing, regain my composure, and start sobbing again. She sits and listens patiently, and tells me she believes me. I feel a huge sense of relief.

Khalid walks in and looks at me. He has a file in his hand with all the calls from my family documented. He looks at me knowing I didn't have a friend being abused, it is me.

"We can issue passports for the children if you report them missing to the police. The problem is you won't be able to leave the country on those passports without new residency visas in them. It would not be possible to get the residency visas in them without Ty's signature and it will take weeks," Khalid offers.

Ziad, Ty's brother, is friends with the head of immigration so that won't work and I don't have much time left before Ty returns.

"Look Patty, there's a military base here. Can you please get us out on a military plane? I won't tell anyone I swear."

Khalid and Patty look at each other, then at me.

"If we help you it will create an international incident. Do everything you can to find the boys' American passports. If you cannot find them in a few days come back and see us."

I put all my time and energy into looking for the boys' passports. Sami calls the office one afternoon and asks if he can stop by. I welcome Sami's visit. We have spoken on the phone several times, but I haven't seen him for a long time.

"Okay, but it's better to wait until the staff leave in the evening. If Ty finds out you came to the office all hell will break loose."

Sami comes in, hugs me hello and I do not want him to let me go. I sob into his shoulder and he holds me. I feel warm and safe. I pull away, apologizing for my emotional outburst. But he, Kian, Justin and Leo and all the employees before them know the hell the boys and I live with. We sit and have coffee and I tell him everything.

"He's off his rocker Paula. Everyone who works with him knows it. People talk. Ty has a bad reputation in Dubai. I can help you look for the passports."

"Thank you!" I feel grateful for the help. I show Sami a cabinet in the design studio I have not looked through. I go back to the conference room.

I sit down in a chair and feel overwhelmed. Disclosing everything to Sami has opened a flood of tears. I sit hunched over with my head in my hands, rocking back and forth waiting for the tears to stop, praying to a God I seem to have an on/ off relationship with.

I hear a subtle voice inside my head saying, 'look there'. It is my own voice I hear in my head, but at the same time not my voice. I look at a file inside a cupboard I know I have looked in before. I carefully take out files. Inside of one of the files, inside an envelope, inside another envelope, I feel them. My heart is racing, my hands are shaking. I open the last envelope and shout to Sami.

"Sami! I think I found them!"

He runs into the conference room. Silently we open each passport one by one, checking the expiry date of the passport and the expiry date of the UAE residency. Both need to be valid to get out.

"They're all current, all valid! An angel whispered in my ear Sami, I swear. I know it sounds unbelievable, but I heard it!" I am crying.

We scan through Sonata's passport but her residency has expired, I will not be able to get her out.

Sami and I look at each other in disbelief. I am so happy to be able to share this moment with him. I haven't thought about what I will do past finding the passports.

"Remember Paula, Ty may have a travel ban on the boys at the airport."

"I need money and papers giving me permission to leave the country with the boys."

"I don't have money, but I can help with the papers." Sami offers.

"No, I can do that myself. I need to give you my sister Karen's phone number. I'll call you as soon as everything is in place."

He holds me and kisses the top of my head. I breathe him in. I feel his strong arm muscles around my body. I want him to take me, to make love to me. I feel alive again as my body responds to his warmth. With the boys' passports in hand and Ty locked out of the country my risk of getting stoned to death is minimal. I want to tell him, but the words will not come out.

Sami leaves and I call Rebecca in Portland, Oregon, collect.

"I have the passports!"

"Okay. When do you think you'll get out?"

"Within a few days. Rebecca, I think it's better no one else knows I'm coming to you in Oregon... for their own protection."

The next three days are critical to get out. I know where the company check book is. I write a check for DHS 18,500, the equivalent of $5,000 dollars, forge Ty's signature, go down to the bank and cash it. I have gone to the bank numerous times to cash checks for Ty for much more. There is the equivalent of $25,000 in the bank. I think about taking more, but if Ty checks the balance before I leave he will be alarmed if too much is gone. Only $5,000 he will not question, thinking a payment hasn't cleared or something.

I write a paper stating that the boys and I are traveling to New York to visit Ty who is already there, requesting the authorities override any travel ban on the children for that purpose. I take a copy of his American passport, along with the paper I have written, to the *souk*. I see a sign in a shop window that says 'Englihs – Arabic Translation', laugh to myself and go inside. After the translation is finished I leave and find a quiet corner, sign both the English and Arabic versions, and then find a notary. The notary examines both signatures, the copy of the passport and looks at me. I hand him DHS100 for a DHS25 job. He takes his stamp and notarizes both documents.

I purchase return airline tickets with the cash, departing just after midnight on April 2nd to New York, returning April 12th. Round trip tickets will substantiate my claim that we are

returning to Dubai if immigration control questions me. I take the boys shopping for some warmer clothes and shoes, as I know Oregon will be much colder than Dubai. They do not have a clue what is going on.

I call Patty at the embassy and let her know I found the passports and tell her when I will be leaving. It is all happening so fast. I still have to listen to Ty scream at me through the phone at least once a day, but soon I will never have to hear his voice again.

CHAPTER 17
Escape to Freedom

I settle the boys in bed, knowing in just over twenty-four hours we will be heading to Dubai airport, then boarding a plane to New York and freedom.

It is time to pack. I can only take two suitcases, one for each hand. I stuff one with cold weather clothes and shoes for the boys, and a few toys. The second, clothes for me and whatever important papers I can find. I contemplate which shoes to take. My favorites are my Bandolino flats, camel colored, woven leather, slip-ons, very comfortable. I like shoes with a bit of a heel, but married to Ty, flats were definitely the wise choice for me. Shoe shopping was a battle of wills.

"But dah'ling," Pierre, the salesman would coo. "These pumps would be just gorgeous on you!"

Yes, he was right, but I would quickly estimate how much the heel would slow me down if I have to run from Ty.

"Thank you Pierre, but I think I'll take the flats."

Pierre would retreat to the back room, rejected boxes of high-heeled shoes in tow, prattling in French. Without worrying about outrunning Ty in the States, I decide to take the flats and some shoes with heels.

Ty locked most of the photographs and video footage of the boys into a storage unit I am not allowed to access. I want to take my Daum crystal cat with the goldfish, and my porcelain Chinese sage statue, the only two items that have any sentimental value. Ty knows that too, so he locked them up.

I walk around scanning the apartment. Nothing else matters. Furniture, Wedgwood china, Baccarat vases, French linens, Christofle silverware, carved ivory, tapestries, collectibles from around the world, and every damn thing he bought for me in our fifteen year marriage, he can have it all. Except the Persian rug, I can sell that.

I roll up the rug and cram it in, close the suitcases and carefully place them back onto the balcony in their storage place, leaving no trace of my plans. I am pretty sure Ty cannot surprise me as his brother Ziad is keeping me updated on the status of Ty's new visa, but I am not a hundred percent sure I can trust Ziad. I grab the Halliburton case where my jewelry is kept. Ty changed the three-digit combination code before he left. I had tried codes for an hour the night before but was unsuccessful, tonight, after only half an hour, success.

I take the gold jewelry given to the boys when they were born. For me, a pearl necklace with an emerald pendant from Mia, a diamond, ruby and pearl ring from Madeline, a gold necklace and Swiss gold pendant from Nadia. I look at the ruby and diamond set Ty gave me in Geneva. I don't want it, but I might be able to sell it once I get home. Besides, I still think Ty bought it with my money. Any jewelry Mama Wafa gave me which was hers, and not store bought, I put back. I don't feel right taking them. I consider the diamond eternity wedding band Ty gave me at our wedding reception in Lincoln, the exquisite four-carat stones. Not so very different from the ones Kian said Ty is using to stone me to death. Ty needs both types of stones, beautiful and ugly – the beautiful ones to make him feel worthy, and the ugly ones he regurgitates from the depths of his barren soul.

I offer a covenant to God: *I will take the stones Ty threw at me, harvest them, and build a new life for myself and the boys. I will help other American women and children being terrorized in foreign countries by the one person who should have loved and cared for them the most. I will help them live in a home that is not the most dangerous place on earth for them, in the way I wished someone could have helped us. That is my promise to you, God, if you help us escape this living hell tomorrow.*

My thoughts go back to the diamond ring. He probably paid $10,000 for it. I could take it and sell it too. But no, the statement I will make by leaving it in the middle of the bed where Ty strangled me is priceless. I reset the combination on the Halliburton case to another code and close the lid. That will give Ty a little something to do one evening.

I barely sleep, reviewing over and over again how the next night may play out. Rehearsing in English and Arabic the answers to any possible questions I will be asked by immigration, in case Ty has a travel ban on the boys. I review everything I have done to make sure I haven't missed something.

I purchased round trip tickets to New York so I will not raise any suspicion at immigration control. I didn't purchase tickets to Portland, Oregon in Dubai so there will be no trace of where I go after New York. I have taken the equivalent of $5,000 from the bank and left $20,000. I have enough *dirhams* to get a taxi. I have $500 left in cash. Sami has the phone number of my sister. Once I am sure we are safely on board the plane I will call Sami and he will call Karen. Then I will destroy the phone chip. If the plane departs and Sami has not heard from me, then he will know I was arrested. He will still call Karen, but with a different message. This has to work. I don't want to kill Ty. I just want to leave.

I go to the office the next day, Friday, no one is there. I spend the afternoon organizing everything into envelopes and label them for Krishna, Leo and Ty. I place everything in order – keys, paperwork, passwords, instructions, and procedures. With the way I am leaving things Ty can hire someone and they can be up to speed in a month or so. I don't do it out of loyalty to Ty, but out of loyalty to our clients. They will never know, but it is important to me.

I leave a letter sealed in an envelope addressed to Ziad explaining that I had warned him we can no longer live with Ty's cruelty. I recommend they get Ty serious mental health help, but I am done for good. I leave it on Krishna's desk with a sticky note asking him to call Ziad and tell him there is a letter for him to pick up.

At eight o'clock I go home. The boys are already in bed and I sit down with Sonata.

"Sonata, I'm leaving and going to America. I'm taking the boys with me."

"Oh no, madam! Baba gets very mad!"

"I can't live with Baba anymore, Sonata."

"I know, Baba very bad. Please take me with you!"

"I can't Sonata. Here is your passport, your visa has expired. If your visa was not expired I would send you home."

"Baba say I have to call him if you go out of house with children, madam, without me. Baba be angry with me. Baba hit me. I afraid madam!"

"This is what you are going to tell Baba, 'Madam and children go to Bahrain to surprise you. I want to go, but madam say my visa expired. I did not call you, madam say no call Baba, it is big surprise for Baba in Bahrain'. Okay Sonata, you understand?"

"Yes, madam."

"I'm going to unplug the phone from the wall. So tonight phone no ring. Tomorrow at two o'clock in the afternoon you will plug phone back in. When Baba calls you tell him we go to Bahrain to surprise him. When he asks why you didn't answer the phone you tell him, 'Madam must have unplugged it Baba. I did not see it unplugged. When I see it unplugged I plug back in'."

Sonata is crying. I hug her tight.

"Be happy for us Sonata. Don't be sad. Baba will not be unhappy with you as long as Baba thinks I fooled you too. Okay?"

I wake up the boys and tell them we are going camping. Faris starts jumping up and down, singing, "We're going to America, we're going to America!"

"No honey. We're going camping," I object firmly.

I cannot risk running into one of his brothers and the boys telling them we are leaving for the US. Any male relative of Ty's can stop me from leaving the airport. Faris looks at me questionably, and then smiles knowingly.

"Yay, we're going camping in the desert. Okay let's go!" Faris is leading the charge. I tell the boys to take a backpack with

whatever they want, plus a change of clothes.

When it is time to go, the boys say goodbye to Sonata, the woman who has been their nanny and surrogate mother during the worst time of their short little lives. They love her and she loves them. It is heart wrenching knowing we will never see her again, but we make false promises that we will, to make the goodbye easier.

I drag the luggage down to the taxi and we all pile in the back. The minute we get in the taxi I feel terrified. The boys are glowing with excitement. I pray this will be the last time I ever see Dubai. The phone rings. It is Ty.

"I called the fucking house and no one answered! Where the fuck are you?"

"I am taking the boys and Sonata out for ice cream."

"This late at night?"

"It's only nine o'clock here. It's not that late."

"I need you in the office first thing in the morning! Do you understand?"

"Yes, I'll be there as soon as I drop the boys off at school."

He hangs up without saying goodbye. Oh the irony.

At the airport, the boys jump out of the taxi. Faris cries, "I knew it!" The three of them are holding hands and jumping up and down with excitement.

When we get inside the airport I get down on my knees and gather the boys around me.

"I need you to listen to me very carefully. Yes, we are leaving to go live in America with my sister Rebecca. But if anyone asks, we are going on vacation to New York to see Baba. It's very important you say we're going to see Baba, okay?" They nod animatedly, eyes wide and shining, like little bobble-head dolls.

Standing in line for immigration I feel faint. My heart is pounding in my head. Collapsing will draw attention to us. I don't want that. My hands are shaking. I take a few deep breaths.

Get it together Paula. You have been acting for years, pretending to love a man who terrorized us, you can do this.

It is our turn.

"Marhaba, Sabah al khair." (Hello, good evening.) The immigration officer greets us in Arabic so I decide to reply in Arabic.

"Sabah al nour." (Good evening to you.)

I hand him our passports.

"Sho, btahcky Arabi?" (What, you speak Arabic?) He smiles, his eyes sparkle in approval.

"Enna bajarib." (I try.)

"Wayne rayheen?" (Where are you going?)

"Nahna raiheen ala New York lanshoof jowzi." (We are going to New York to see my husband.)

"Sho helween el aulad." (Your children are beautiful.)

"Shookrun; Hada Faris ou Samer ou Tariq." (Thank you, this is Faris and Samer and Tariq.) The boys make cute faces.

"Emtan rajeen min America?" (When are you coming back from America?)

"Ashra ayam." (Ten days.)

"Wayn jowzic?" (Where is your husband?)

I already told him that.

"Whoa bi New York hella." (He is in New York now.)

"Min shan sho?" (Why is he there?)

"Schogal ou hella ejazah ma na." (Work and now vacation with us.)

"Andik tazaker rojoo la Dubai?" (You have tickets back to Dubai?)

"Akeed, bedak shoofhon?" (Of course, would you like to see them?)

"La, mish mishkully, tufuddalou." (No, not necessary, come with me please.)

Oh my God, why is he having us go with him? My heart is racing. The boys are chatting and holding hands skipping along. He takes us to a waiting area.

"Min shan el safar ala America, fi ghurfat intizar khasa, ma al salamah." (For flights to America we have a separate waiting area. Safe travels.)

He hands me back the passports.

"Shukrun kthier." (Thank you very much.)

I shuffle the boys to a corner and sink into a chair relieved. I need a minute to catch my breath and wait for my heart rate

to go back to normal. Ty didn't have a travel ban on the boys. Immigration control didn't ask for permission papers. So far, so good. Three more stages to go – getting on the plane, landing in New York and getting through US immigration into freedom.

We stroll through the opulent Dubai duty free and buy a small camera to begin documenting our journey. When we finally board the plane and the stewardesses are doing a final check I call Sami.

"We made it, we're on the plane."

"I'm so happy for you!"

"Call Karen and tell her we're on the plane. Tell her she can't know where I am for her own safety. Have her call Paul and Rebecca and tell them I'll contact them once I get to my destination. And Sami, thank you. I'll email you and let you know how we are."

"It was nothing. Keep in touch. Later." He hangs up. I wonder if I will ever see sparkly eyes again. I take the chip from my phone and ceremoniously break it in half.

The flight from Dubai to New York is almost fourteen hours non-stop. Each of us has our own television screen. The boys watch *Mulan* six times. I feel I am in a dream. This is too good to be true.

We land in New York. I am nervous going through security. Could I be stopped for some reason?

"Welcome to the USA!" a jolly female immigration officer greets us. "My goodness what handsome boys you are!"

The boys offer their cutesiest smiles once again. She stamps our passports and tells us to have a nice day.

We retrieve our luggage and walk outside into the morning New York commotion. I would kiss the ground if it wasn't so dirty. We need to find a flight to Portland, Oregon.

I forgot it is Easter Weekend. The only flights available to Portland are $500 each and I only have $500. The woman at the airline counter suggests we take the train across country. We take a bus to Penn Station. The boys see their first homeless person.

I call Rebecca.

"We made it! I'm going to take Amtrak to Portland."

"I was so worried. Okay, good."

I give Rebecca our arrival information. We will be on the train for three nights. I buy us a sleeper car the first night, as we are jet lagged and tired. The four of us squeeze into the two-person sleeper, Faris and Samer on the top bunk, Tariq and I on the bottom. The conductor is kind and funny. I am happy we are taking the train to Portland instead of flying. It will give me a chance to assimilate my decision with the boys. Not that they will have any objections I am sure.

At each stop I check the platform for Ty. Logically there is no way he knows where we are, but I am programmed to be hyper vigilant. I have existed on flight or fight for so many years I will need time to adjust.

Ty would have called the office by now and Krishna would have told him I never came in. He would have called my cell phone obsessively, but it would have kept going directly to voice message. He would have called Sonata constantly, but no answer. He would have worked himself into a ferocious rage by the time Sonata plugged in the phone. Finally she would answer and he would get the news we were with him, Sonata's sweet, innocent voice telling him, "They are in Bahrain with you Baba, surprise!"

Surprise indeed. Ty will roar with infuriation. He will tear apart whatever hotel room he is in, may the Lord help any woman he is with at that moment. He will curse himself for not putting a travel ban on the boys. He will curse himself for not having one of his brothers' lock the boys' passports up at their work place. He will call his brothers with earsplitting intensity and command them to interrogate their wives to find out where I am. The wives will be so happy for me. They will tell their husbands, "Good for her, finally, maybe they can have some peace in their lives."

Then the brothers will gather together in secret and come up with some kind of damage control, what to tell people, how to find me, how to convince me to come back. I have shamed not only Ty, but the entire family. They need to save face in society,

protect their image no matter what. But no one will know where we are. The boys and I vanished into the night.

Ty would know that David had beat Goliath.

"I win. I win, Ty," I think out loud. *The one you called idiot and stupid and bitch and cunt and whore and slut and hit and slapped and spat on and strangled, I win.* I want to scream it in his face louder than I screamed diving deep into the water at the women's beach. Scream that you will never, ever again hurt my three precious little boys, never again will your fists bruise their small bodies and ravage their spirits, never again as long as I live.

I lie on the bottom bunk listening to the boys playing on the upper bunk of the train car, giggling and laughing and happy without fear. No more fear.

Dinner in the dining car is included with our sleeper.

"Mama, this is so much fun!" Samer chants, and Faris and Tariq join in harmony.

I watch the boys' faces, so gleeful, as we have dinner together the first night of freedom on the train.

"Mama, look! Are those cows?" Faris' eyes are wide with surprise.

"Yes, those are cows." I smile. Those cows have no idea how happy they made three little boys.

The family in the booth next to us looks at us as if we have been living on another planet.

"Tonight we'll have the sleeper car, tomorrow night we'll have to sleep in regular seats, and then we can move back to a sleeper car for the third night. Sound good?"

"Yes!" They reply in unison digging into their macaroni and cheese.

"We need to have a buddy system – no one goes anywhere on the train alone. Only in twos."

"Yes, Mama," they cheerfully agree.

This is a wonderful adventure for them. I have never seen them so happy.

After dinner we waddle our way through the rocking train cars to the sleeper car and I take Tariq to shower. Showering on a moving train is an art. When the train rocks to the left, the water

trickling out of the showerhead swings to the right. You get dog-tired trying to get clean. Tariq makes a game out of it and his giggles are contagious.

Faris and Samer go to shower when Tariq and I get back. When we are all back, we huddle together on the bottom bunk of the sleeper car. I want to give them assurances and answer any questions they have.

"Do you have any questions you want to ask me?"

Tariq raises his hand like he is in school.

"Is Oregon big?

"Oregon is big with lots of tall trees."

"What is Rebecca's house like?" Faris asks next.

"My sister Rebecca lives in a house with her husband Mike and their daughters Emily and Megan. They have a dog named Luke and several cats. They have a yard with trees to climb and a pond with fish. Your room has two sets of bunk beds. I will have my own room right next to yours. We can live with Rebecca as long as we want." A promise I know I can keep this time.

"Will we go to school?" Samer asks.

"Yes, we'll rest for a few days, but then we'll need to get you into school. And I'll have to start looking for a job."

The rhythm of the train is lulling them to sleep. They are fighting to keep their eyes open. Samer and Faris climb up to the top bunk. Tariq snuggles against me, content and safe.

I wake in the middle of the night and pull back the small window curtain. The full moon illuminates the breathtaking scene before me. A small river winds alongside the tracks, towering pine trees stand silhouetted against the night sky. Snow blankets the hills, weighs down tree limbs, and lays on huge boulders in the river like frosting on cupcakes. It is the most beautiful scenery I have ever seen. In my mind's eye I can picture us tucked away in a log cabin by this river, fire crackling in the fireplace, warm, cozy and safe, drinking hot cocoa. I want to show them, but don't want to wake them from their peaceful slumber.

The next morning the boys are bundles of energy and excitement. It is Faris' ninth birthday. After a big pancake

breakfast in the dining car, we pack our bags and get ready to change trains in Chicago.

When we board the new train we find the children's car with a clown and a magician. They meet other kids and play Pokémon. Sitting in regular seats, dinner is not included. I have enough to buy us two hot dogs to split between the four of us. I am keeping $50 to the side, all the money I have left, reminding me that my trust fund is gone thanks to Ty.

"Remember you agreed any money you borrowed from my trust fund you would pay back? When do you want to start making payments?"

"Why the hell should I replace it? You benefited. You flew first class, stayed in five star hotels and ate in elegant restaurants. You have expensive jewelry and clothes."

"But we talked about it and you promised each time you borrowed money, you would replace it."

"I changed my mind. Deal with it."

That was that, tens of thousands of dollars pilfered away by a pathological liar.

After three days on the train we are looking forward to getting off in Portland. Mike picks us up from the train station and drives us to their home. Portland is green, fresh and more beautiful than I remembered. Rebecca and Mike's house has three levels, with six bedrooms and three bathrooms on one acre of land, which has a view of Mount Hood. It is heaven on earth to us. The boys have never been allowed to touch a dog, so when Luke bounds towards them in canine exuberance they are terrified. The cats are more elusive. Tariq excitedly chases them around the house wanting them to cuddle with him.

Rebecca prepares a wonderful meal for us, and a birthday cake for Faris. We sit in her dining room – a birdcage in the corner, houseplants, fresh flowers and a big picture window reveals the loveliness of our new life. I haven't seen Rebecca since Mom's funeral. She hasn't changed much. Her blond hair is shorter. Her quick wit and sense of humor is refreshing and she makes us laugh.

That night, after the boys go to bed, Rebecca patiently listens as I tell her the horrors the boys and I have been through with Ty. When I am done, she says she has something to tell me.

"Ty's already in California, Paula. Karen called me and said there was a knock on the door. She looked through the keyhole and there was a flower deliveryman. When she opened the door, Ty was also there and pushed his way into her house, demanding to know where you and the boys are."

"That's why I don't want her to know where I am. He would have gotten it out of her. How did he know where she lives?"

"Earlier in the day Karen got a call from the florist saying there were flowers for her and they needed her address. Ty followed the flower truck in a taxi."

"Is Karen okay? Did Ty threaten her?"

"No, he behaved like he's worried and concerned. He wanted to make sure you were all okay."

"I'm sure he played the concerned father and husband like a star. I told Karen not to speak with him under any circumstances. She'll think he's asking innocent questions, but he'll be gathering information with every word."

"Ty tried calling Paul, but Paul hangs up."

"Good. He won't come here Rebecca. He won't even think of you. I know him."

I go to bed feeling vulnerable. Rebecca's home is the perfect place for us, but knowing Ty is one state away is unnerving. That night I have my first nightmare. We are trying to escape Dubai, but Ty catches us. I jolt from my sleep, heart racing and sweating. It takes me a few seconds to realize where I am and I lay back in relief.

Paul wires $5,000 to Joe, a friend of Mike's in Chicago, and then Joe wires the money to Mike. I know it is an extra step, but I don't want to reveal my location to Paul for his sake. It is enough to get the kids into Montessori school, pay a legal retainer to a lawyer and help Rebecca out with groceries. The public school refuses to register the boys under false names and I cannot risk a private investigator uncovering that information.

Samer and Faris start Montessori the following week and I find a small pre-school for Tariq. I get a cell phone and a PO Box. I find an attorney, Lois Frazer. Rebecca's daughter Emily is overseas for a semester in college and I use her car.

At my first meeting with Lois I am surprised I have to tell Ty where I am.

"Why would I tell Ty where I am? I just fled half way around the world to get away from him?"

"He has as much right to the children as you do in the eyes of the law, until we prove otherwise."

Lois suggests I try to file for a restraining order against Ty in addition to filing for custody of the boys and separation. She goes down with me to the courthouse and the judge examines my paperwork.

"I'm sorry about what happened to you and your children Ms. Lucas, but I have no jurisdiction to issue a restraining order, because the abuse did not occur in Oregon."

I don't understand what this has to do with anything.

"If your husband comes to Oregon and tries something I can issue it then."

Lois prepares the separation and custody papers. We find an attorney in Dubai and Ty is served shortly thereafter. As Ty will know we are in Oregon, I tell Paul and Karen where we are too. It seems Ty has written me a thirty-page letter, a manifesto, which he photocopied and sent to Karen, Paul and Norm. Karen sends a copy to me in Oregon. I am hoping Ty might have admitted to some of the things he did, but he doesn't. He apologizes for 'everything' but doesn't say what everything is. The rest is a bizarre epilogue of his alternate reality.

Love letters from Ty start arriving addressed to me care of Lois's office, along with letters from his brothers promising me money and guarantees of safety if I go back to Dubai.

"Why the hell would I do that? I'm already in the USA. Not in a million years. They had their chances. I will *never* go back."

"Well, they're desperate. They lost control. They want to get it back." Rebecca confirms what I already know.

Lois calls.

"Ty called and told me he is not going to fight you. He said he isn't even going to hire a lawyer, but is going to represent himself. I think he was drunk when he called."

"Don't believe him Lois. Ty will fight me. He's fooling you."

"Well, he has thirty days to respond officially to the courts from the day he was served, so he has ten more days."

"He'll respond the last day. He'll make us think he's not going to fight until the last minute. Mark my words, Lois. I was held prisoner by this man for years, I know how he thinks."

CHAPTER 18
Homeless, 40, Three Kids

It is a beautiful Saturday afternoon. The boys are playing in Rebecca's backyard with the garden hose, spraying each other and laughing hysterically. They run and jump on the wooden play structure Robert had built for Emily and Megan when they were little. They swing on the swing set and jump off, rolling in the grass. They play with Luke and take him for walks down the dirt road to see the horses in the neighbor's field. Their faces beam with joy. They are free to be kids for the first time in their lives.

I email Sami and tell him we are all fine. He emails back, *Ty called me. He said you and the boys went on vacation to the USA for the summer. You will be back in September when school starts.*

So that is what the brothers' came up with to save face. That is why they wrote me letters bargaining with me to come back promising me the moon. I like how money is only offered if I return. If they can send me letters they can send money to make sure the boys have everything they need. But all they care about is their precious image.

Lois calls me ten days later.

"You were right. Ty hired an attorney in Portland and responded one hour before the deadline. I have two more things to tell you. One, get out of your sister's house – Ty tried to hire a private investigator who happens to be a good friend of mine. She called me and said something didn't feel right. Even though she didn't take the case another PI will. Second, Ty is fighting you for jurisdiction."

"What does jurisdiction mean?"

"It means Ty is going to legally fight you to force you to take the boys back to Dubai."

Her words burn though me like hot coals.

"You've got to be kidding me! You mean after everything I've done to get us out, Ty can try to get a court here in the *USA* to force me to take my *American* children back to Dubai?"

"Yes."

"That's a death sentence Lois! We're *American*. This is our home. How can this be possible?" I am crying, shaking and the room is spinning. I sink down on to the living room floor.

"That's how it works. He'll try to force you to take the children back to their place of habitual residence to determine custody there."

"The UAE is a Muslim country. The men get custody of boys there when they turn seven years old. Their custody determinations have nothing to do with who is the better parent. I won't go back Lois, I won't. He can fight all he wants, but I will never take the boys back."

I hang up the phone and stare out the window at Mount Hood. I mean it. I will never take the boys back. The following day I take the boys to school, meet with social services and get emergency money for the hotel, and set us up on the Oregon Health Plan, OHP, for medical insurance.

"Do you want to sign up for TANF, (Temporary Aid for Needy Families), and food stamps now?" the social worker asks.

"Like welfare? No, I don't need to do that. We'll be fine. I just need help paying for the hotel," I haven't been on welfare in my life. I am not going to start now. I can take care of the boys. I just need to get over this jurisdiction thing with Ty and find a job.

"Paula, you qualify for the help. The paperwork only takes a few minutes."

"Not now, but I will think about it."

She leans back and looks at me.

"You're the first person I've ever met who turned down government assistance."

I pick up the boys from school, take them to a park and give the news that we have to leave Rebecca's house.

"Mom, you promised we could stay with Rebecca. You promised!" Faris' eyes fill with tears. Samer hangs his head and starts crying, Tariq tucks himself in close next to me.

"I know I promised. I'm so sorry. The important thing is we stay hidden and Baba knows now we are in Oregon. School is almost out and the hotel has a pool," I offer as a consolation prize. Faris is angry with me and I don't blame him. He will be okay. He will understand one day.

We leave Rebecca's house and check into the hotel. I ask to meet with the manager. I explain the situation and make sure Ty's picture and description are at the front desk with instructions to call me if he shows up. The staff is completely supportive, always checking up on us to make sure we are fine.

When I got the call from Lois telling me Ty is in Portland demanding to see the boys I almost faint.

"Absolutely not Lois! He *cannot* see the boys."

"If you don't let him see the boys it'll make you look uncooperative."

"Look uncooperative? I *am* uncooperative! That monster lost his right to see his children a long time ago!"

"Not yet in the eyes of the court. Look Paula, I'll tell his lawyer, Keith, that Ty can see the children supervised. He won't be alone with them. He'll have to have a social worker there."

"A social worker is no match for Ty, Lois."

"That's the best we can do."

"Ty needs to understand this is a visit with the boys only. He can't use it as a means to find me, or make contact with me."

"I'll make sure Keith knows the conditions."

Arrangements are made. I have to tell the boys. I tell them the afternoon before the visit.

"Baba came to Portland and he wants to see you. You won't be alone with him so he can't do anything to hurt you. A lady named Mary will be with you the whole time."

"What if we don't want to go?" Samer has tears in his eyes. Faris looks stunned.

"Mary will be there. You'll be safe. Baba won't hit you if someone else is there. Rebecca and I will wait in the car and you can come out anytime you want. Tonight we'll go to the house and you'll meet Mary and see the room where you'll visit with Baba tomorrow."

Meeting Mary and seeing the house before the meeting helps the boys feel safe and comfortable. That night I dream Ty is parked in front of the hotel in a red car. I wake up sweating, my heart racing.

Rebecca picks us up and drives us back to the house in southeast Portland for the visit. Knowing Ty is inside the four walls of the house, so close, makes me feel vulnerable. Samer vomits on the sidewalk as soon as he gets out of the car. I cannot believe the boys have to do this. Rebecca and I wait out the hour parked half a block down the street where we can see the boys when they come out, or see Ty with the boys if he manages to overpower Mary, the social worker, and walks out with the boys.

"I had no rights in the UAE, yet Ty can come here and have equal rights and nothing he did to us in the UAE matters. I'm frightened Rebecca."

"I know. But Ty is bound to do something he shouldn't. He thinks he's all-powerful. That might work in the UAE, but not here."

"Well, he's good at fooling people. He's a pathological liar."

The boys walk out of the visit with flowers and balloons and toys, excited with all of their loot. Rebecca doesn't go straight back to the hotel but drives around for a while making sure we aren't being followed. She drops us back at the hotel. The boys chat excitedly and show me all the stuff Ty gave them. I check the toys for tracking devices but don't find anything.

"Baba was so nice Mama! He gave us so many toys. He says he loves you. The flowers are for you." Faris is over animated.

We are watching television in our room when the phone rings. It is the manager.

"Paula, your husband just tried to check into the hotel. I told him we're full. He's sitting in the lobby with our phone book pretending to look for other hotels."

"Damn, did you notice what color car he is driving."

"Yes, red. Call your sister and have her pick you up at the back door. I'll call you if he leaves."

I feel the adrenalin surge through my veins. All I can think of are Ty's words after he strangled me, *I will hunt you down and slaughter you like animals no matter where you are in the world.*

I call Rebecca and she says she can be at the back door of the hotel in ten minutes.

"Boys, listen. We have to go. Baba is in the lobby and Baba was told by his lawyer he can't try to see you except with Mary. I need you to pack a set of clothes in your backpacks and a few toys like you did when we left Dubai. Don't bring anything Baba gave you today."

"But Mama... " Faris and Samer are objecting. I am trying to stay calm but my voice is shaking.

"Rebecca will get the rest of our things later and bring them to us once we know where we're going to be."

Rebecca calls and says she is waiting at the back door. I open the hotel room door and check the corridor. It is clear. We run as fast as we can to the back door and jump in her car.

"Rebecca, I don't know how he found us! He didn't follow us back to the hotel. I can't find a tracking device in the toys, but I left everything he gave the kids in the hotel room. Where should we go?"

"I called some friends. They said you can sleep on the couch in their den for a few nights, and the boys can sleep on the floor until we figure something out. I brought some sleeping bags."

Rebecca's friends are an older couple, Ralph and Marge. They are wonderful hosts, but our limit is three nights. I don't mind if we live like gypsies for the next few months, a moving target is harder to find. The kids are out of school for the summer. I call Lois and leave a message. I call the police. A female officer comes and takes a report. She offers to go with me to get the restraining order on Monday and picks me up in her squad car. It is a different judge this time, but he grants it.

Lois calls.

"Paula, I know Keith told Ty the rules about only seeing the boys while they are supervised. He made it clear to Ty that he cannot try to make contact with you."

"Ty is not going to follow anyone's rules Lois. Ty will tell Keith everything Keith wants to hear, then he'll do whatever he wants."

"Well, Keith is no longer his lawyer. Ty will have to find someone else to represent him."

"I'm sure Ty will burn through many lawyers by the time this is over."

Rebecca calls and says another couple she knows is on vacation and we can stay at their home for a few days. Their little house is off Hawthorne, close to shopping. It is perfect.

When it is time to move again the boys and I take the train overnight down to southern California to stay with my step-brother, Norm, and his wife, Dot. They sold their expansive home in Chatsworth and downsized to a condo community in Camarillo. The boys share a room and I have my own room. The amenities include a swimming pool and the boys spend the days with their five second cousins swimming and playing Pokémon every spare second they have. We go to Universal Studios for a day. Dot has all eight kids wear yellow baseball caps so we can keep count.

After a week I can sense it is time to go. My three boys are very well behaved, but they are still three boys with a ton of energy. Dot drives us up to Santa Barbara and we meet Karen and her husband Robert in a park. We have a nice picnic, say goodbye to Dot, and stay at a hotel overnight in Santa Barbara. The following day we head up to Arroyo Grande with Karen and Robert for a few days, where the boys get more Pokémon cards and Tariq gets a Furby. I don't want to stay there too long as Ty had shown up there before.

Lois calls and reads from a letter Ty's new lawyer wrote to her.

"When Ty saw the boys they looked ill. Paula is not financially capable of taking proper care of the boys and he wants to know where they are living, where they are going to school, if they are being properly clothed and he wants a doctor's report on their health."

"The boys have never been healthier or happier Lois. He won't give me any money to help support the boys so he can accuse me of not being capable of taking care of them." I laugh at Ty's distorted thinking and thank God, once again, I am out from under his control.

"You won't need to comply. Not with the restraining order. He has to be served before it's valid though."

We take the train back up to Oregon and stay at an old friend's house in Eugene. Again, I can sense when people need their own space, and it is time to hit the road after a week. I call Rebecca and she has arranged for us to stay in Tillamook, in a mobile home on acreage out in the middle of nowhere. The couple who own the place only stays there on weekends.

The boys have the time of their lives. The couple take the boys fishing on the property, let them ride ATV's, collect eggs from the chickens, let them have a lemonade stand, and pitch a tent for them so they can experience camping for the first time.

It is the best summer the boys ever had, but the gypsy lifestyle is wearing me out and we are running out of places to stay. After two weeks it is time to move on. Rebecca gives me the telephone number for a domestic violence shelter. I call, but they are closed to residents during their annual cleanup.

The couple drives us back to Portland to Rent-a-Wreck and I get an old beater car for a week. Norm gave me $1,000 after finding out Ty had spent all the money from my trust. I pay for the car and for five nights in the hotel with it. When we are down to $500 it is time to move.

We check out of the hotel and pack our stuff into the old jalopy, but have nowhere to go. We spend the afternoon at the hotel pool. Early evening it is time to go. When I start the car, the back bumper and the rear view mirror both fall off, almost simultaneously. The boys are in the back seat worn-out after a day at the pool. I am in the driver's seat *craffing*, a cross between a cry and a laugh. This is the first time a place to stay has not materialized for us. I have no idea where I am going to go with my three boys for the night. I decide to find a Goodwill and see

if I can buy a tent, have Rebecca meet me somewhere with the sleeping bags, then find a campsite. A tent site is $35 a night. With food we can last about ten days. If I can't find a tent we can still go to a campsite and sleep in the car.

I tie the bumper back on with the twine that had been holding it in place, but cannot get the rearview mirror to re-stick. I need some divine intervention. I get in the car and drive. My phone rings.

"Hi, is this Paula?"

"Yes, it is."

"This is Tara from Raphael House Shelter. You called us to see if we had space, but we were closed. Do you still need a space for you and your boys?"

"Yes I do! When can we come in?"

"Can you come in now?"

"Yes!" She gives me the address. I hang up the phone and thank God.

Raphael House is a wonderful place. An old home in Portland within walking distance of everything we need. The boys and I have our own bedroom. They have reopened from their annual closure and the walls are freshly painted and carpets cleaned. Beds neatly made with soft sheets and homemade quilts. Their children's playroom is bursting with toys and books. Downstairs is a large kitchen, dining room and living room. The outside play area is small, but there are parks nearby. I happily return the tin lizzie I rented.

The shelter caseworker convinces me to go back to social services and get on TANF and food stamps. I agree this time. My dignity can only take me so far.

The downside to being in downtown Portland is that Ty might see us if he is here. After a couple of weeks we transfer to another shelter out in Washington County. It is not as clean as Raphael House, but with a little elbow grease we are able to get our room up to par. To Ty the suburbs are below his social level and he will not try to find us outside of the city. We feel safe at the new

shelter. I don't have a car so we walk down to the grocery store dragging a little red wagon to hold our shopping. I feel self-conscious pulling my Oregon Trail Card out to buy groceries.

We also take the little red wagon with our clothes in it to the Laundromat when the shelter washer and dryer stop working. With a public swimming pool, library and park close by I am able to keep the boys occupied.

We are a hodgepodge of diversity at the shelter. Residents include Abigail, a midget woman with her midget daughter, and a robust African American woman named Sandy, with bleached blond hair. Tariq ran up to her and asked if she had a baby in her tummy, but Sandy just laughed and said, "No baby doll, that's all me."

Sue is a timid woman with her two sons, and several single women come and go quite quickly. The limit on staying at the shelter is thirty days, but I'm given an extension until I find out if Oregon is going to give me jurisdiction for custody of the boys. If not, I will change our names, go underground and disappear forever. I don't know how we will live, but I would rather live in a gutter with my boys than take them back to Dubai. Ty is indeed living in an alternative universe if he thinks I will ever return the boys to his diabolical control.

A local nonprofit donates backpacks and supplies to all the children at the shelter for the approaching start of the school year. We get used clothes at the nearby Goodwill or from the cardboard box in the basement of the shelter. At first the boys, especially Faris, are taken aback by the thought of wearing clothes other people have worn.

"I'm not going to wear anything used. I get my clothes tailored in Paris!" Faris announces.

"You used to have clothes tailored in Paris, sweetheart. Not anymore. Either you get clothes from Goodwill or the basement or you'll have to go to school without pants."

That opened up a whole string of complaints from my little trio. *We want our stuff. Baba said he would send us our toys. I want a bicycle. When are we going to have our own apartment?*

I think constantly being on the move and living with other people is getting old for all of us. We have stayed at eleven places in less than six months. My nerves are wearing thin under the uncertainty of our future and I find myself being crankier with the boys. I feel like I need a good cry, but I share a room with the boys and I have to be strong for them.

In the evenings after all the children are put to bed, the women of the shelter gather on the front porch of the old house and talk. Most smoke cigarettes, but walk to the end of the driveway to puff away. One night one of the women pulls out a pen. When you hold the pen in writing mode, it shows a good-looking man, shirtless with jeans on, but tip the pen in the other direction, the jeans vanish and there he is naked, erection and all in his full glory. We take turns turning the pen up and down, laughing until our stomachs hurt and tears flow down our cheeks. Laughing to relieve the pain and suffering of loving men who should have protected us from the world, not the other way around. Laughing because we are homeless and have left every possession we own behind, laughing mostly because if we didn't laugh, we would cry.

I lie in bed and contemplate the juxtaposition of being homeless. On the one hand it is unsettling not having a home of our own. On the other hand, it is freeing. We can pack up and go anywhere, anytime we want. I have no bills except for my mounting legal fees.

A Labor Day barbeque raises our spirits. No alcohol allowed so we buy marshmallows as comfort food – our sex placebos we unanimously declare. Everyone dances to *Smooth* by Rob Thomas, over and over again on the sunset drenched porch – the midget, the black woman with bleached blonde hair, the white women, the Hispanic women. What a strange sight our dancing motley crew must be.

The judgment from the court has not come down by the time school starts. With the boys in school, I start talking to people about my idea to start a nonprofit to help other American women

and children abused in foreign countries. The response is pretty much the same from everyone.

"What are you thinking? You're homeless with three boys. You're living on welfare and food stamps. That's something you can do a few years from now, once you're financially stable."

I understand their logic, but I am alive and my boys are alive only by the grace of God. Women and children are being murdered every day by their husbands and fathers. We got to live. I promised God I would harvest every damn stone Ty had thrown at us and build a foundation to help others. I am obsessed.

My sister Karen buys me a laptop in support of my quest. While the boys are in school I go to the local library, study the Nonprofit Oregon Book and begin drafting the necessary documents to establish a charity in Oregon.

The legal battle is taking so long. Ty has provided letters from his brothers, Sonata, and his employees, stating he is a wonderful father. It seems I have a problem with alcohol and mental health issues. This is news to me. I am especially impressed at how Sonata's English has improved. For a woman with no knowledge of written English only months before, she wrote an eloquent letter of support for Ty that could have qualified for a college entrance essay. My, my, my. The best though, was Victor when he wrote, *I noticed the children's relationship with Ty was very strong, almost to a worship level. This feeling between them was mutual, which often made Paula somewhat uncomfortable and she often commented and wondered about this magic between them... I guess Paula felt she was losing the children to their father and therefore has given herself the right to satisfy her selfishness. She could no longer bear to share the children with their father, her husband, whom they adore.* Traitor.

I had countered Ty's letter with letters from Rebecca, Mike and others – people the boys had spontaneously disclosed the abuse to. I also took the boys for a child abuse evaluation when I first arrived in the USA. Sami, Justin and Michelle wrote letters describing what they witnessed in Dubai.

One afternoon Lois calls.

"The judge has granted you jurisdiction! We won this round. But Ty is filing a *Writ of Mandamus* to the Oregon Supreme court."

"What's that?"

"Ty's saying the judge did not rule correctly and is asking an Oregon Supreme Court judge to reverse the ruling."

"Is this ever going to end? How long will that take?"

"It shouldn't take long. I don't think he'll be successful. We should know in a week or two."

Ty lost. We won. He is used to having power and control, but in the USA we are given equal power in the courts. He thinks he can drag me back to the place where he has ultimate power and control, but he lost. I tell the shelter we have a couple more weeks to go, but it is looking good.

I speak to the director of the shelter about my plans to help other battered American women and children in foreign countries.

"You should go see Louise Bauschard. Louise helps women in prison who've killed their abusive spouses get clemency. She wrote a book, *Voices Set Free*, and runs a nonprofit by the same name."

I shudder how close I came to being one of those women. I call Louise and make an appointment to see her. I don't have a car, but I borrow a bicycle from the shelter to meet her.

From the second I lay eyes on Louise we have a connection. She is older than me, lovely white hair, as divine as an angel. I introduce myself, give her the abbreviated version of my story, and my vision, my covenant with God to help others in gratitude for our lives. Louise looks at me and says, "Well, let's do it!" I hug her and cry. She believes in me. She believes in my dream.

I ride the bike back to the shelter rejoicing in the Oregon fall. Green leaves are turning to brilliant red, orange and yellow. The chill in the air is brisk and refreshing on my face. I feel alive. I see the flocks of geese flying south for the winter and listen to their honking. How lucky we are to live in such a beautiful place. How lucky we are to be alive. How lucky I am to find Louise. I am so thankful to the thief in Germany, to the judge who gave me jurisdiction and to Louise. My holy trinity.

When Lois calls and says the Supreme Court judge upheld the ruling we won, I can't stop crying. Then I can't stop laughing. Then I cry again. Lois patiently waits on the other end of the phone for me to stop blubbering.

"So, what this means is the boys can stay in Oregon with you. You have jurisdiction for custody and divorce, but not for alimony or child support or half your marital assets. Legally Ty doesn't have to pay you a penny to help you."

"I understand. That's okay. I have my boys. That's all I need."

"Well, you can keep them with you in Oregon but Ty is planning to fight you for custody now."

"What? I don't understand. He doesn't live in Oregon. How can Ty fight me for custody in Oregon when he lives in Dubai?"

"Ty says he's moving here and buying a house in Lake Oswego."

"That's bullshit Lois."

"Bullshit or not, he's going to continue to fight every legal battle he can possibly fight with you."

"How long will that take?"

"Hopefully not more than a couple of months. Meanwhile, you can move out of that shelter you're in. Congratulations! And Paula... you still owe me $30,000."

"I know, I know. I will pay you. I just have to get my feet back on the ground."

Some people have nice $30,000 cars. I have my children safe. I can't put a price on that. Paul has already paid $10,000 in legal fees and private school for the boys. Karen bought me a computer, helped buy things the boys needed and helped make some payments to my lawyer. I need to get into housing, start our lives, establish the charity and start working.

I tell the boys the good news first. They are so excited. I tell Paul, Karen, Rebecca the staff at the shelter, the other residents at the shelter, Louise, the guy that delivered backpacks, the teller at the drive-up window at the bank. Everybody.

I apply to be in the transitional housing program at New Beginnings, a one-year program to help survivors of domestic violence. On the day of my interview I ride the bicycle down

to their offices. It rains and I arrive shivering, cold and wet. I apologize for being disheveled to the four-person panel, blaming my mode of transportation. I think the interview goes well. By the time I get back to the shelter I have already been accepted.

The boys and I move out of the shelter and into our first apartment on October 22, 1999 almost seven months after arriving in Oregon. It feels good to think we will be in the same place for one year, give us time to stabilize. The shelter also gives me a car that has been donated. It is an old blue, beat-up 1987 Mazda 626. I am able to get a grant from social services to fix the catalytic converter and get new brakes. They also give me money to buy the boys some new socks, t-shirts, underwear and some household items.

The donated furniture is old and worn, but I don't care. Samer and Faris each have a room and Tariq and I share. We have one bath upstairs with the three bedrooms. Downstairs a half-bath, a small kitchen and one room for the dining and living. I make a corner in the living room my office where I will begin my mission. A sliding glass door opens to a small concrete patio and a common grassy area with trees. Grass – we can walk outside and go barefoot in the grass. There are no pets allowed – the boys are not going to get a puppy or kitty yet.

We start out with one couch, a dining room table, four dining chairs and three mattresses. Rebecca gives me a desk, kitchen supplies, glasses, cups, dishes, towels, sheets, blankets and pillows. The shelter gives us a good supply of toiletries.

The boys have to change schools again, but they don't seem to mind. They make friends in the apartment complex. Every night I read to them from the *Chronicles of Narnia*. They want me to read *Harry Potter* next. Life is simple. I have to get ready for the next legal fight with Ty. I know there is no way a judge will give Ty custody. Oregon is not a shared custody state, which means the judge will have to choose between Ty and me as I will never agree to share custody. I will get custody, but I don't know what hoops Ty will have me jump through to get there. And, if he loses, he will do everything he can to abduct the boys to Dubai. I sigh. This is not over.

HOMELESS, 40, THREE KIDS

It's Halloween. The boys carve pumpkins for the first time, wear costumes and go Trick or Treating. I watch them as they empty their Halloween candy onto the dining room table and bargain back and forth, exchanging their favorites. Their world has been transformed in the past seven months.

CHAPTER 19

Without Her Consent

It is April 1, 2000, seven in the morning, a Saturday. It is our first *anniscapery*, a lovely little euphemism Karen coined to commemorate our clandestine escape from Ty last year. The effects of the nightmare are similar to the others. On a scale of one to ten, we probably hit an eight on the physiological Richter scale. Jolted from my sleep, my body and mind are experiencing the response of intense fear – my heart is racing, I think I stopped breathing. There is pressure in my chest, confusion in my head.

I hear Sami grinding coffee beans in the kitchen. I call out to him and he sprints back up the stairs. He gets in bed and lies next to me, gently but firmly locks his arms around me and tucks me close into his body. A nightmare has ripped through and shattered my precious reality and once again, Sami is there to sooth my psyche.

No one has a knife in their hand. Ty is not here. He is not going to kill me. He is not going to kill the boys, safely asleep in their beds. It is springtime. I am in the quiet suburbs of Portland, Oregon, not in Paris or London or Dubai or Singapore. The cool morning breeze carries the sounds of birds singing though the bedroom window. The smell of freshly brewed coffee arrives at the top of the stairs.

My eyes continue to scan the bedroom as my mind runs a final reality check. There is a pile of clean laundry in the corner I need to fold and put away. Conscious thought takes a controlling grip on innate reaction – the danger was only perceived. My heart rate

239

continues to decelerate. Sami embraces me. I embrace the quiet normality of our lives.

I contemplate hypnosis. Not to erase the memories, because I believe our experiences shape who we are, but to extract the threads of trauma woven into those experiences so we can look back at them without re-experiencing them. So they do not come tearing into our dreams and our existence like wildfire, momentarily obliterating the contentment of the new lives we have struggled to create, years after the danger has passed.

I ponder the effects of long-term trauma. I thought once I escaped Ty and got back to the USA that would be that. I was wrong. I survived on adrenaline for so long, when I finally slowed down the nightmares started. Ty is still fighting me like hell for custody of the boys in Oregon.

God gave me three angels, my sons, Faris, Samer and Tariq. Then he gave me three more, the thief in Germany, the judge who gave me jurisdiction and Louise.

Then he gave me one bonus angel – sparkly eyes. Sami was immigrating to Canada after his divorce; he and his wife just grew apart from each other. He came to Portland to testify at the custody hearing for my sons that hasn't happened yet, because Ty keeps postponing it. I wasn't looking to be in a relationship but, without the fear of being stoned to death, Sami's visit turned into a passionate lovemaking marathon after which we decided we wanted to be together. My family just about died, "Can't you find a nice American man to be with?" I understand their concern but there are good men in every culture, and there are abusive men in every culture. Sami is a good man.

If Ty wasn't fighting for custody of the boys Sami would have never come to Portland and I wouldn't be with the love of my life. Sami is everything Ty is not – passionate, kind, funny, and especially real. What you see is what you get. No arrogance or air of superiority. Sami is the same person whether he is at a fancy dinner party in a suit and tie, or sitting next to a campfire in jeans and t-shirt eating pork and beans out of a can. I should thank Ty for bringing Sami and me together if I ever see him again. Sami has

custody of his children, but believes children should be with their mother. Sami's ex-wife has no idea how lucky she is. He misses his son and daughter terribly. We hope we can bring them to live with us once my divorce is final and we can get married, then Sami can start working.

We are taking the boys to Home Depot today for their kids' workshop to make birdhouses, then we will go to Rebecca's for *linner*, a late lunch, early dinner. Life is good.

I am sitting on the living room floor in late June opening a large envelope I received in the mail from Lois. Inside is an Islamic divorce decree in Arabic, translated into English.

"Wow," I think out loud. "Ty divorced me last month in Dubai."

Then I looked again at the date, May 23, 1999. "May 1999?"

Ty was still sending me love letters begging me to come back to him in June 1999. Funny, he never submitted the decree to his lawyer. He even used his American passport as his form of identity, giving him more respect in the courts than a Palestinian refugee would receive. I read the decree silently, then out loud, in disbelief.

"I hereby confirm the divorce of Tysir Dasanti from his wife Paula Mary Lucas. A first revocable divorce, therefore, as long as she is in her viduity period, he may take her back without her consent and without a new contract and dowry. She may start her viduity period as of the date of divorce."

"What the hell is a 'viduity period'?"

I call a friend of mine who knows about Islamic law.

"A viduity period is three menstrual cycles."

"A man can take a woman back without her consent? Barbaric." I call Lois.

"Did you read the Islamic divorce decree?"

"Yes, barbaric!"

"That's the same exact term I used when I read it!"

"How long's Ty going to be able to drag this out Lois? I've had jurisdiction since October, eight months later we're still fighting for custody? This is exhausting."

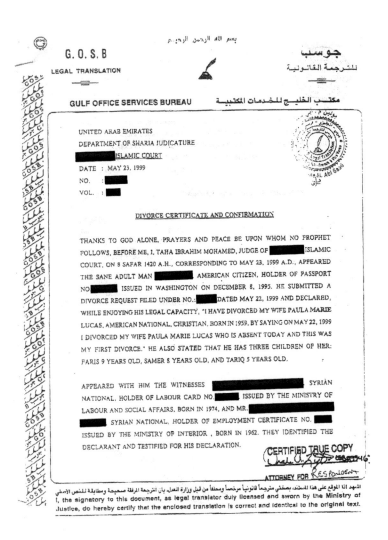

Divorce certificate page 1

WITHOUT HER CONSENT

- 2 -

IN TESTIMONY WHEREOF, I HEREBY CONFIRM THE DIVORCE OF ▮▮▮▮ FROM HIS
WIFE PAULA MARY LUCAS A FIRST REVOCABLE DIVORCE. THEREFORE, AS LONG
AS SHE IS IN HER VIDUITY PERIOD, HE MAY TAKE HER BACK WITHOUT HER CONSENT
AND WITHOUT A NEW CONTRACT AND DOWRY. SHE MAY START HER VIDUITY
PERIOD AS OF THE DATE OF DIVORCE.

PEACE BE UPON OUR PROPHET MOHAMMAD, HIS FAMILY AND FOLLOWERS.

SIGNED BY:

REGISTRAR DIVORCER DIVORCEE WITNESSES

SIGNED & STAMPED BY:
THE JUDGE.

ATTESTED BY :
- MINISTRY OF FOREIGN AFFAIRS - UAE.

Divorce certificate page 2

"I told Ty's lawyer Ty needs to commit to his meetings with Dr. Brown for the custody evaluation. You're done with your meetings, right?"

"Yes, we did everything we're supposed to do. I jumped through all the hoops."

"Don't worry, you will get custody."

"I know, but Ty needs to get supervised visitation of the children. If he gets unsupervised visitation we're in trouble."

Louise calls to check in and see how things are going with the charity.

"I have a handful of clients and we're communicating by email. I thought once we were tax deductible funding would come in to support the mission. I guess I had no idea how hard it is to get people to care about Americans abused overseas. It's like, out of sight, out of mind. Every funder I've spoken to says, 'Great program! We never thought of that population needing help before!' But they won't support domestic violence programs serving people outside the USA, even if they are American citizens."

"Hang in there, kiddo. You have to be in this for the long haul. You're a trailblazer like me!"

"Thank you Louise. You're my biggest fan and cheer leader, I need that right about now."

I hang up the phone and sigh.

Ty finally comes to Portland in July to conduct his part of the custody evaluation, including seeing the boys with Dr. Brown. Louise, Karen and Rebecca take the boys to Dr. Brown for me, and Sami waits with me at the Starbucks at Pioneer Courthouse Square.

After the visit Rebecca herds the boys to her car, and Louise and Karen walk to meet Sami and me at Starbucks, towing the large bunch of helium filled balloons Ty has given to the boys. I know the balloons are a beacon for whoever Ty has hired to follow them.

By now that person has reported to Ty where we are. Sure enough, Karen and Louise spot Ty driving in circles around Pioneer Courthouse Square, passing the Starbucks. On the next pass, Sami stands on the corner. Ty sees him and takes off. Sami gets the make, model and license plate number of the car Ty is driving. I call the police and report it. Because Ty has not yet been served the restraining order it doesn't count as a violation. Dr. Brown said we could not use the custody evaluation visitation to serve any papers on Ty, but Ty was not supposed to use the custody evaluation visitation to stalk me.

We go back into Starbucks and think about what to do next.

"Ty won't stay in Portland. He'll stay across the river in Vancouver, Washington State, because he doesn't want to get the restraining order served on him. Ty won't understand he can be served in Washington by Vancouver Police."

"Are you sure?" Sami looks at me quizzically.

"Yes, I'm sure."

"Alright, I'll take the restraining order and drive around the parking lots of Vancouver hotels by the river."

After about an hour Sami calls.

"You were right. He's at the Red Lion Inn. I called Vancouver police and they're on their way. How did you know?"

"I had to keep the boys and myself alive for many years. You learn how your assailant thinks."

After another hour Sami calls again.

"It's done. They went to the hotel and served him with the restraining order." Oh my gosh! Finally, we get some legal protection from Ty sixteen months after escaping his despotic grasp.

Lois calls me on Monday.

"Sounds like you had a busy weekend."

"Yes, we did. What did you hear?"

"Ty called his lawyer screaming that you went against Dr. Brown's instructions and used the visit to have him served with a restraining order."

I told Lois what happened.

"If Ty had left Dr. Brown's office and not tried to find me at Starbucks, we'd have never gotten the license plate of his car, Lois. Ty made his bed – let him lie in it."

Lois laughs.

"There is something else. Ty found out during this custody evaluation visitation, and after seeing Sami in front of Starbucks apparently, that Sami is with you in Portland. He told his lawyer he wants to file adultery charges against you. His lawyer told him we don't have that here. I think the last prosecution for adultery in Oregon was 1912."

"Typical Ty – he'll try anything to make my life more difficult. Does Ty need a copy of his Islamic divorce decree from May 1999 as a reminder we are already divorced in his world?"

"But you're not divorced yet in the USA. That should happen soon."

"Define soon."

"Within a few weeks, a month at the most, even Ty's lawyer has had it with him, Paula. We all want this to end."

A few weeks later Dr. Brown comes out with his custody evaluation report.

"Listen to this!" I am reading the evaluation out loud to Sami in bed. "Dr. Brown calls me histrionic. What does that mean?"

"I don't know. Let's look it up!" Sami kisses me, jumps out of bed and trots downstairs to look histrionic up on the Internet. I keep reading Dr. Brown's report. He trots back up the stairs five minutes later.

"It means you dramatize and exaggerate your difficulties!" Sami is laughing and shaking his head at the absurdity of such a declaration and flops down on the bed.

"Damn. Well, I guess Dr. Brown never lived under the control of a madman for over a decade, in the Middle East, as an American woman."

"That's so strange. I'd think a psychologist would be more on the ball and be able to recognize a psychopath. *'How could such a gentle, caring man have done all those things Paula says?'*" Sami is mocking what he thinks Dr. Brown must have thought.

"I hereby double-dog dare Dr. Brown to go live under Ty's tyrannical control in the Middle East for twelve years and see how sane he is at the end of it!" I joke to Sami.

"He says he recommends Paula get full legal and physical custody of the boys, and Ty gets supervised visitation, leading to unsupervised visitation. What? Is he nuts? Giving Ty unsupervised visitation?"

"That's based on the belief Ty is living in Oregon, which he is never going to do Paula, you know that, and he has to meet certain conditions." Sami is trying to reassure me. "Don't worry. I'll make sure nothing happens to the boys. Do you believe me?" Sami rolls over and hugs me tight.

"Yes, I do believe you."

Now that Ty knows Sami is with me he'll be more determined to get the boys back to Dubai. But I know Ty fears Sami and that's a good thing.

On the day of the final divorce and custody hearing, on September 10, 2000, Lois and I are in the judge's chambers with Judge Seal and one of Ty's lawyers. Ty appears by phone. Before we began, Lois leans over to me.

"I have a message for you from Ty."

"Pray tell."

"Ty says he will still take you back if you want."

"What? Are you kidding me?"

"Just wanted to let you know you still have a chance."

We try to stifle our laughter in front of the judge, but oh my goodness we laugh, $50,000 worth of legal fees laughter. When I hear Ty's voice over the phone for the first time in eighteen months I feel sorry for him. I mentally slap myself, because actually slapping myself in the face in the judge's chambers will surely raise some eyebrows. *Snap out of it Paula!* Without any power over me Ty sounds broken, pathetic and weak. The tables have turned, I am now the strong one.

Later that night, I lie on the floor downstairs while Sami and the boys are asleep upstairs, and write a letter to Ty that I have no intention of sending.

'In the fifteen years of our marriage, what made you think that when you told me how to walk, how to talk, when to sit, when to stand, how to stand, when to eat, what to eat, how to dress, what to say, when to say it, how to say it, you were striping away layers of who I was – not painting me with layers of what you wanted me to be?

What made you think that when you hit me, pushed me down, threatened to kill me, threatened to kill the children, put a knife to my throat, strangled me, spat on me, threw me against the wall, insulted me, screamed at me, mocked me, locked me in the house, locked me out of the house – I would not leave you?

What made you think that when you locked the boys in the closet, tied their wrists and ankles with ropes, forced food down their throats, forced them to eat their own vomit, tied them up in plastic garbage bags, belittled them, slapped them, refused to let them hug me or kiss me or told them that I did not love them – they would still love you?

What made you think that when I smiled, or laughed, or ironed your shirt, or cooked your favorite food, or had sex with you that I was doing it because I loved you – not because I was buying time while I planned our escape?

What made you think that I would miss seeing your face searing with anger, your eyes scorching with rage or miss hearing the children sobbing in their beds when your fury had bruised their small bodies and snarled their spirits?

What made you think that beautiful bouquets of flowers, smiling greeting cards, letter after letter with declarations of undying love, begging for forgiveness – would make me forget your brutality?

What made you think that by not paying child support, or alimony, or forcing my legal fees into the tens of thousands of dollars – you would force me to go back to you?

What made you think that I would not swallow my pride and go on welfare, and food stamps, and wear used clothes from old cardboard boxes in the basement of the shelter we lived in, so we could survive?

What made you think that I would not, one by one, strip off the layers you painted on me, in a small, sparsely furnished apartment with bare walls, and rediscover who I am and what I am capable of?

What made you think I would not take each stone you threw at

me and harvest it to build a better life for myself and other American women and children oppressed and beaten by tyrants like you?

What made you think that my strength was measured by how well I could stand up to you – not by how long I was willing to crawl on my belly until I was strong enough to stand up again?'

Harvesting Stones – Epilogue

WOMEN ARE BEING STONED TO DEATH ALL OVER THE WORLD, figuratively and physically. We have the power to rise up, pick up those stones and rather than throwing them back at those who have harmed us, harvest those stones and make a better life for ourselves and for others.

I believe each of us is capable of completing a mission bigger than we think we can. Some people may find their calling, their life's purpose, without having many stones thrown at them. For me, it was a fourteen-year international journey of slowly being stoned to near-death, but now, fourteen years later, I couldn't be happier. I discovered who I am and what I am capable of. My work, our supporters, staff and volunteers, my sons Faris, Samer and Tariq, and my husband Sami have made my world a fabulous place to exist. They have empowered me to harvest the stones Ty pummeled me with and build a foundation and infrastructure to help American women and children suffering overseas, fulfilling my covenant with God the night before I escaped.

The fourteen-year evolution of the Americans Overseas Domestic Violence Crisis Center from a fledgling, grass roots movement in my living room to a globally recognized award-winning organization would not have been possible without those who believed in me and the mission. While the organization was founded upon what I wished had been available to me and my children when we were victims in the UAE, it has evolved based on the increasingly complex circumstances of the victims who contact us for help.

When I was overseas I didn't know there was a name for what we were going through: domestic violence. I didn't learn this until we fled back to the USA. I suspect there are thousands of victims suffering today who don't understand the dynamics of domestic violence and blame themselves for their abuser's behavior. There are many people who blame the victims and not the abusers. I also learned I was not alone as a battered mother being called histrionic by a psychologist. It is so common for mothers to be portrayed as emotionally unstable and histrionic in custody battles that it is alarming.

There is a misconception I would have been able to leave my marriage if I had not been in an Islamic country. This is not true. The problems I faced with the children's passports are obstacles every American victim faces anywhere in the world. The American embassies cannot issue American passports to minor American children without the permission of both parents, except in very extreme cases. Most of the victims who contact us for help are trapped in European countries. And when we help them get back to the USA, they have to defend *Hague Convention Petitions* to fight for jurisdiction to keep their children safe, as I did. We are collaborating with many others in the field to implement legislation that will put more provisions in place to help protect battered American mothers seeking safety at home with their children. In fourteen years we have built the strongest safety net possible to help American victims succeed and be safe whether back home or overseas.

Our fabulous crisis response team works 24 hours a day, 7 days a week providing life-saving services to American victims of domestic violence and sexual assault overseas, via an international toll free crisis line, 866-USWOMEN (866-879-6636), an online live chat on our website, www.866uswomen.org, and crisis email, crisis@866uswomen.org.

We serve populations estimated at 7.6 million Americans living overseas, 65 million Americans traveling overseas annually

(http://travel.state.gov/pdf/ca_fact_sheet.pdf). We also serve the 1.1 million American military personnel and their dependents living overseas (based on the 2010 census). Extrapolating abuse figures for female victimization from the Center for Disease Control and Prevention, CDC, for the US, estimated victimization for Americans overseas populations are 49,400 cases of domestic violence and 7,600 cases of sexual assault annually for Americans living overseas. For Americans traveling overseas, 422,500 cases of domestic violence and 76,000 cases of sexual assault would occur annually. However, because Americans traveling overseas do not typically spend one year traveling, it is hard to estimate if a violent episode would occur overseas. Assuming there is a 1/12th (8.3%) chance of a violent episode occurring, that would translate to 35,000 episodes of domestic violence and 6,330 episodes of sexual assault of Americans traveling overseas. These figures do not include male victimization statistics.

Our case managers and advocates receive over 3000 incoming calls, chats and emails per year helping over 550 victims, most with children, providing advocacy, safety planning and long term, on-going, intensive case management lasting from several months to years. Compared to the number of victimizations annually, we are serving the tip of the iceberg. While victims who contact us are mostly American women being abused overseas, American male victims of violence also contact us for help.

Wrap-around services include:

- Danger to safety relocation including airline flights back to the USA and ground transportation
- National *pro bono* legal network providing legal consultations and legal defenses for child custody and jurisdictional issues, including The Hague Convention on International Child Abduction. This program provides hundreds of thousands of dollars per year of legal services to victims
- Payment of legal retainers and consultations overseas and in the USA where we do not have *pro bono* lawyers

- Protecting Pets Program to ensure pets can stay with victims when they seek safety at home in the USA or in the foreign country
- Sexual Assault Support And Help For Americans Abroad Program, SASHAA Program
- Emergency cash assistance to pay for passports, certificates of birth abroad, shelter, rent, utilities, medical needs, baby food, diapers and other needs on a case by case basis
- Professional counseling over the phone or in person

Our expert staff members are available for trainings and workshops both overseas and in the USA on issues that affect Americans experiencing domestic violence and sexual assault overseas.

This journey, like most, has not always been easy. Twice I almost gave up:

- In 2003, after working for four years as a full-time volunteer Executive Director – believing not enough people cared about American women and children being abused in foreign countries to support the organization. I was working another job full time, exhausted and disillusioned. More and more victims were begging for help, but I couldn't find the money to keep the mission afloat.
- In 2006, after being diagnosed with rheumatoid arthritis – a brutally painful disease, not unusual for women who have suffered long-term abuse – I was unable to go to the office. I worked, unpaid, from my bed at home for another year, charging over $12,000 on personal credit cards to cover the expenses of the organization, making sure my employees were paid and trying to keep the lights on. By early 2007 both my health and personal finances were ravaged. I lay in bed sobbing, in agony, on the verge of foreclosing on our home and filing for bankruptcy, telling Sami we should invite Dr. Jack Kevorkian ('Doctor Death'), over for dinner. (Sami did not think inviting Jack over for dinner was as funny as I did.) Sami and I agreed it was time

for me to relieve myself of the burden of the organization. I had done my best and helped thousands of victims to the detriment of my personal circumstances. But I could not get the victims who needed help out of my head and my heart.

Both times generous individual donors, foundations and corporations – including the Oak Foundation of Switzerland, Yoko Ono, Doris Buffet, Jette Parker, Altria, Volvo Cars of North America and Richard Branson of Virgin Atlantic Airlines – gave me the resources, hope and determination to push forward with the mission.

In 2008 we received a two-year capacity building grant from the Oak Foundation of Switzerland, enabling us to expand our direct service team and launch our Global Campaign to Empower Americans Abused Abroad, a global outreach and education program to reach more Americans abused overseas.

In 2010 we won the *National Crime Victim's Service Award* from the US Department of Justice, Office For Victims of Crime. This award honors extraordinary efforts in direct service to crime victims. That same year we were awarded a competitive three-year demonstration project grant to develop a model to serve Americans experiencing domestic violence in foreign countries. We already had the model in place and were able to build capacity and strengthen our infrastructure.

Unfortunately we are now facing another crossroads. Our three-year demonstration project grant from the US Department of Justice, Office For Victims of Crime, has come to an end. No new federal government funding streams have materialized to support services to Americans abused overseas and, with the current government sequestration and budget cuts, the future of government funding to serve this growing population is bleak.

As I finalize the words of this epilogue, the Americans Overseas Domestic Violence Crisis Center, AODVC, and our Sexual Assault Support & Help for Americans Abroad program, SASHAA, must become a community supported organization through corporate

partnerships and sponsorships, foundation grants and individual donors to sustain operations and life-saving services.

We need to strengthen our coordinated community response to sexual assault and domestic violence in American overseas communities. We must form closer partnerships with government agencies, service providers and other expat groups to expand our outreach and education efforts and strengthen the safety net available for victims.

It is my hope that this book will help raise awareness of the plight of Americans abused overseas, and raise the funds desperately needed to continue our mission.

To My Mom

I have been on a journey.

Wanting to understand who and what it is I am has been an incredibly hard passage.

Images and haunting memories beckon me to let them take grasp – easier than facing them.

Lamenting moments of defeat, I urge forgiveness on myself for letting those manifestations of the past take hold.

Lacerating through the layers in which I cocooned myself, like a baby bird pecking through its shell to be born.

Hearing the voice of the child inside, besieged by the darkness, no longer trembling in fear, but in realization of his true strength.

Armed with your love, I guide the young boy within to the light I feel piercing through the walls that once confined me.

Ramparts falling as waves of warmth crash down into my soul.

Vehemently snuffing the remnants of the blackness from every nook of my being – my body once laden beyond its limit lifts from the ground.

Eagerly, I peer out of the prison that constrained me, using my eyes as if for the first time.

Standing now on my own feet, free of the grip of the past, I feel the universe flow through me.

Trials come to an end in time, and in their ending bright new beginnings emerge.

I Promise.

With all my love, Faris

Fig 1. Paula by the pool. 1968

Fig 2. Paula in Ty's apartment. 1983

Fig 3. Paula and Paul after Mom's death. 1986

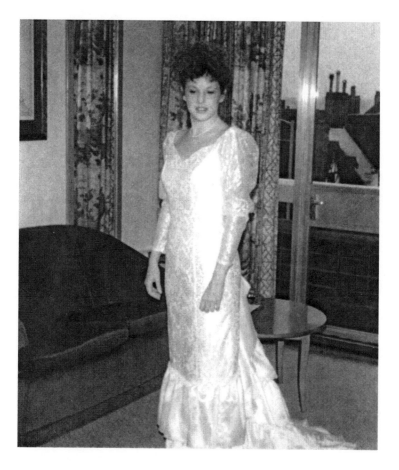

Fig 4. Paula in wedding dress. 1987

Fig 5. Samer, Tariq and Faris. 1995

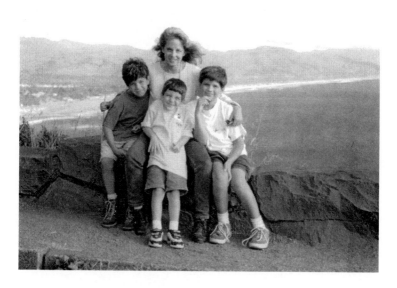

Fig 6. Paula with boys, homeless in Oregon. 1999

Fig 7. Paula and sons. 2011

Resources for Americans
Living or Traveling Overseas

Americans Overseas Domestic Violence Crisis Center
www.866uswomen.org
International toll free: 866-USWOMEN (866-879-6636)
Please reference website for dialing instructions
Crisis email: crisis@866uswomen.org

**Sexual Assault Support & Help For Americans Abroad,
SASHAA Program**
www.sashaa.org
International toll free: 866-USWOMEN (866-879-6636)
Please reference website for dialing instructions
Crisis email: crisis@866uswomen.org

**Resources United, Women in Lethal Danger
(Forced Marriage of Americans Overseas)**
International toll free: 877-RUN-WILD
Please visit AT&T website for dialing instructions:
http://www.att.com/esupport/traveler.jsp

The National Sexual Assault Hotline
1-800-656-HOPE or online at www.rainn.org
For members of the military community: Safe Helpline is
available worldwide, 24/7 at 877-995-5247
http://www.safehelpline.org/
You can call for free from anywhere in the world through the Safe
Helpline app, available in the iTunes app store or Google Play.

Directorate of Overseas Citizens Services
Bureau of Consular Affairs
US Department of State
www.travel.state.gov
1-888-407-4747 (toll free in the US or Canada),
or 001-202-501-4444 from overseas, international tolls apply

Hot Peach Pages
http://www.hotpeachpages.net/
An international list of country specific resources

Signals for Concern

Mr. Gavin de Becker outlines the following signals for concern in his book, *The Gift of Fear and Other Survival Signals that Protect Us From Violence* (Dell, 1999), Chapter 10, Intimate Enemies (Domestic Violence).

They won't all be present in every case, but if a situation has several of these signals, there is reason for concern.

1. The woman has intuitive feelings she is at risk.
2. At the inception of the relationship the man accelerated the pace, prematurely placing on the agenda such things as commitment, living together and marriage.
3. He resolves conflict with intimidation, bullying, and violence.
4. He is verbally abusive.
5. He uses threats and intimidation as instruments of control or abuse. This includes threats to harm physically, to defame, to embarrass, to restrict freedom, to cut off support, to abandon, and to commit suicide.
6. He breaks or strikes things in anger. He uses symbolic violence (tearing a wedding photo, marring a face in a photo, etc.).
7. He has battered in prior relationships.
8. He uses alcohol or drugs with adverse affects (memory loss, hostility, cruelty).
9. He cites alcohol or drugs as an excuse or explanation for the hostile or violence conduct. ('That was the booze talking, not me; I got so drunk I was crazy').
10. His history includes police encounters for behavioral offenses threats, stalking, assault, battery).

11. There has been more than one incident of violent behavior (including vandalism, breaking things, throwing things).

12. He uses money to control the activities, purchase, and behavior of his wife/ partner.

13. He becomes jealous of anyone or anything that takes her time away from the relationship; he keeps her on a 'tight leash', requires her to account for her time.

14. He refuses to accept rejection.

15. He expects the relationship to go on forever, perhaps using phrases like 'together for life' 'always', 'no matter what'.

16. He projects extreme emotions onto others (hate, love, jealousy, commitment) even when there is no evidence that would lead a reasonable person to perceive them.

17. He minimizes incidents of abuse.

18. He spends a disproportionate amount of time talking about his wife/ partner and derives much of his identity from being her husband, lover, etc.

19. He tries to enlist his wife's friends or relatives in a campaign to keep or recover the relationship.

20. He has inappropriately surveilled or followed his wife/ partner.

21. He believes others are out to get him. He believes that those around his wife/ partner dislike him and encourage her to leave.

22. He resists change and is described as inflexible, unwilling to compromise.

23. He identifies with, or compares himself to, violent people in films, news stories, fiction or history. He characterizes the violence of others as justified.

24. He suffers mood swings or is sullen, angry, or depressed.

25. He consistently blames others for problems of his own making; he refuses to take responsibility for the results of his actions.

26. He refers to weapons as instruments of power, control or revenge.

27. Weapons are a substantial part of his persona; he has a gun or he talks about, jokes about, reads about, or collects weapons.

28. He uses 'male privilege' as a justification for his conduct (treats her like a servant, makes all the big decisions, acts like the 'master of the house').

29. He experienced or witnessed violence as a child.
30. His tells his wife/ partner he will injure or kill her. She has discussed this with others or has made plans to be carried out in the event of her death. (e.g., designating someone to care for the children).

For an in-depth threat assessment if you or someone you know is in a relationship that may be abusive, please visit https://www.mosaicmethod.com.

* Reprinted with permission from *The Gift of Fear and Other Survival Signals that Protect Us From Violence*. De Becker, Gavin. Dell Publishing, 1999.

10 Things Men can Do to Prevent Gender Violence

1. Approach gender violence as a MEN'S issue involving men of all ages and socioeconomic, cultural, racial and ethnic backgrounds. View men not only as perpetrators or possible offenders, but as empowered bystanders who can confront abusive peers.
2. If a brother, friend, classmate, or teammate is abusing his female partner – or is disrespectful or abusive to girls and women in general – don't look the other way. If you feel comfortable doing so, try to talk to him about it. Urge him to seek help. Or if you don't know what to do, consult a friend, a parent, a professor, or a counselor. DON'T REMAIN SILENT.
3. Have the courage to look inward. Question your own attitudes. Don't be defensive when something you do or say ends up hurting someone else. Try hard to understand how your own attitudes and actions might inadvertently perpetuate sexism and violence, and work toward changing them.
4. If you suspect a woman close to you is being abused or has been sexually assaulted, gently ask if you can help.
5. If you are emotionally, psychologically, physically, or sexually abusive to women, or have been in the past, seek professional help NOW.
6. Be an ally to women who are working to end all forms of gender violence. Support the work of campus-based women's centers. Attend 'Take Back the Night' rallies and other public events. Raise money for community-based rape crisis centers and battered women's shelters.

If you belong to a team or fraternity, or another student group, organize a fundraiser.

7. Recognize and speak out against homophobia and gay bashing. Discrimination and violence against LGBTQ people is wrong in and of itself. This abuse has direct links to sexism (e.g. the sexual orientation of men who speak out against sexism is often questioned, a conscious or unconscious strategy intended to silence them. This is a key reason few men do so).

8. Attend programs, take courses, watch films, and read articles and books about multicultural masculinities, gender inequality, and the root causes of gender violence. Educate yourself and others about how larger social forces affect the conflicts between individual men and women.

9. Don't fund sexism. Refuse to purchase any magazine, rent any video, subscribe to any website, or buy music that portrays girls or women in a sexually degrading or abusive manner. Speak out about cyber-sexism and misogynist attacks against women on social media sites such as Facebook, Twitter and Tumblr. Protest sexism in new and old media.

10. Mentor and teach young boys about how to be men in ways that don't involve degrading or abusing girls and women (or men). Volunteer to work with gender violence prevention programs, including anti-sexist men's programs. Lead by example.

Jackson Katz.
MVP Strategies, a gender violence prevention education and training organization. www.mvpstrategies.net.

Resources in the United States

National Domestic Violence Hotline
www.thehotline.org
1-800-799-SAFE (1-800-799-7233)
1-800-787-3224 TTY
Hotline advocates are available for victims and anyone calling on their behalf to provide crisis intervention, safety planning, information and referrals to agencies in all 50 states, Puerto Rico and the US Virgin Islands.

Futures Without Violence
www.futureswithoutviolence.org
info@futureswithoutviolence.org
For more than thirty years, Futures Without Violence has led the way and set the pace for innovative educational programs, public action campaigns, policy development, and leadership training designed to end violence against women and children throughout the world.

National Network to End Domestic Violence, NNEDV
http://www.nnedv.org
NNEDV is the leading voice for domestic violence victims and their allies. NNEDV works to make domestic violence a national priority, change the way communities respond to domestic violence, and strengthen efforts against intimate partner violence at every level. NNEDV does not provide direct services except through www.WomensLaw.org

Women's Law

www.womenslaw.org

Provides legal information and support to victims of domestic violence and sexual assault.

National Coalition Against Domestic Violence, NCADV

www.ncadv.org

(303) 839-1852

Advances transformative work, thinking and leadership of communities and individuals working to end the violence in our lives.

TAHIRIH Justice Center

Protecting immigrant women and girls fleeing violence.

www.tahirih.org

(571) 282-6161

About the Author

Paula Lucas founded the Americans Overseas Domestic Violence Crisis Center, AODVC, in 1999 while homeless and living in a shelter. In 2012 Paula also launched the Sexual Assault Support & Help For Americans Abroad Program, SASHAA. The crisis center is a national award winning, internationally recognized program operating 24 hours a day, 7 days a week.

Her team serves the 7.6 million Americans living overseas, the 65 million Americans who travel overseas annually and the 1.1 million military personnel and their dependents overseas. Wrap-around services are provided via an international toll free hotline, 866-USWOMEN. Website www.866uswomen.org.

Paula trains nationally and internationally on issues facing American victims of domestic violence and sexual assault overseas. She conducts workshops on empowerment and overcoming life's obstacles. She has appeared on the *Today Show* and was featured in *Reader's Digest* magazine (where she was described as an 'International Angel') along with other television, radio and print media in the USA and overseas.

She and her team have won numerous awards over the past thirteen years for their groundbreaking work in victim's services, including the National Crime Victim Service Award from the US Department of Justice, Office For Victims of Crime.

Paula is also a Certified Aromatherapist. She is studying Ayurveda as a natural healing modality for her rheumatoid arthritis and

plans to return to India in 2014 for further Ayurveda treatment and training. Her family continues to live in the Pacific Northwest with their old Golden Retriever, Buddy, and a rescue cat, Amira T-Bo Kitty Kitty. Paula enjoys gardening, making natural perfumes and essential oil products under her brand, Akeso's Garden, and spending time with her family and friends.

To request Paula to speak and/ or for book signings:

Phone: USA (503) 203 1444
Email: Paula@harvestingstonesbook.com
Website: www.harvestingstonesbook.com
Facebook: www.facebook.com/HarvestingStones

Also Published by **summertimepublishing**

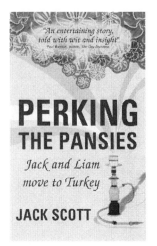

"An entertaining story, told with wit and insight"

PERKING
THE PANSIES

Jack and Liam move to Turkey

JACK SCOTT

SUNSHINE
SOUP

NOURISHING THE GLOBAL SOUL

Jo Parfitt

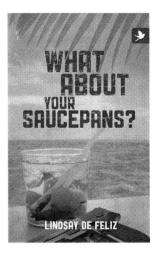

WHAT ABOUT YOUR SAUCEPANS?

LINDSAY DE FELIZ

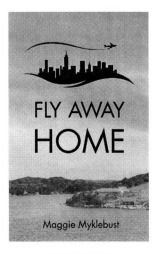

FLY AWAY
HOME

Maggie Myklebust

CPSIA information can be obtained at www.ICGtesting.com
Printed in the USA
LVOW12s0413170214

373971LV00001B/1/P